Sam Hyde Harris
1889 – 1977
A Retrospective

A Pictorial Biography of His Life and Work

Edited by Maurine St. Gaudens
Curated by Maurine St. Gaudens
Presented by Maurine St. Gaudens Studios & the Pasadena Museum of History
Essays by Marian Yoshiki-Kovinick
& Gary Lang
Photographed by Dr. Martin A. Folb

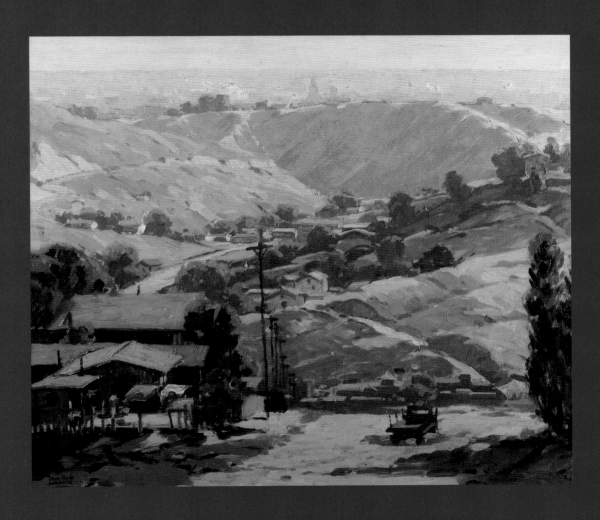

Schiffer Publishing Ltd®

4880 Lower Valley Road, Atglen, PA 19310 USA

Library of Congress Cataloging-in-Publication Data

Harris, Sam Hyde, 1889-1977.
 Sam Hyde Harris, 1889-1977 : a retrospective : a pictorial biography of his life and work / edited by
Maurine St. Gaudens ; curated by Maurine St. Gaudens ; presented by Maurine St. Gaudens Studios &
the Pasadena Museum of History ; essays by Marian Yoshiki-Kovinick & Gary Lang ; photographed by
Martin A. Folb.
 p. cm.
 ISBN 0-7643-2591-4 (hardcover)
 1. Harris, Sam Hyde, 1889-1977--Themes, motives. I. St. Gaudens, Maurine. II. Yoshiki-Kovinick, Mar-
ian. III. Lang, Gary, 1950- IV. Title.

ND237.H328A4 2006
759.13--dc22 2006024283

Cover design by Bruce Waters
Type set in ITC New Baskerville

ISBN: 0-7643-2591-4
Printed in China

Detail of tablecloth design.
Private collection.

Published by Schiffer Publishing Ltd.
4880 Lower Valley Road
Atglen, PA 19310
Phone: (610) 593-1777; Fax: (610) 593-2002
E-mail: Info@schifferbooks.com

For the largest selection of fine reference books on this and related subjects, please visit our web site at **www.
schifferbooks.com**
We are always looking for people to write books on new and related subjects. If you have an idea for a book please
contact us at the above address.

This book may be purchased from the publisher.
Include $3.95 for shipping.
Please try your bookstore first.
You may write for a free catalog.

In Europe, Schiffer books are distributed by
Bushwood Books
6 Marksbury Ave.
Kew Gardens
Surrey TW9 4JF England
Phone: 44 (0) 20 8392-8585; Fax: 44 (0) 20 8392-9876
E-mail: info@bushwoodbooks.co.uk
Website: www.bushwoodbooks.co.uk
Free postage in the U.K., Europe; air mail at cost.

Dedicated to Marion Dodge Harris

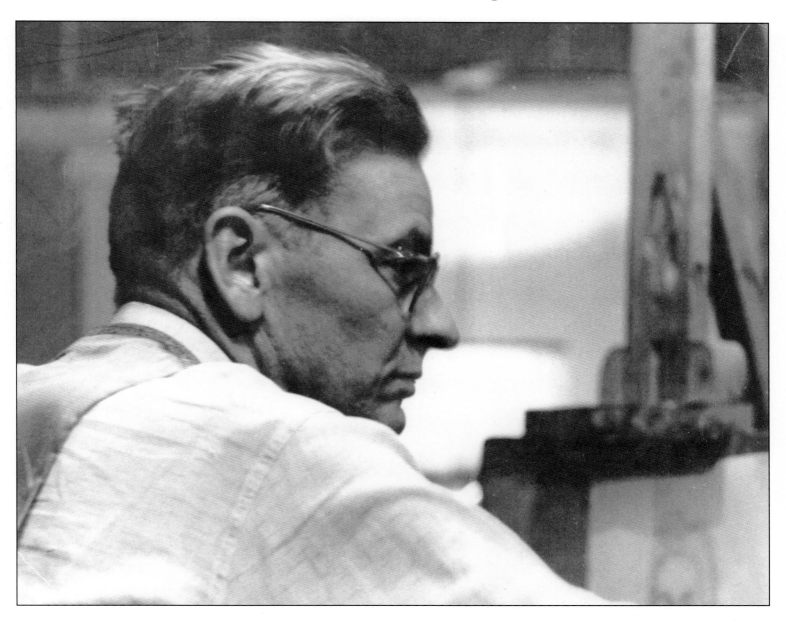

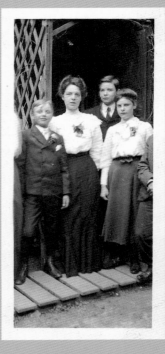

Sam at age 10 with sister, Nellie, brother, Herbert, and sister, Dora. *Collection of Harris Family.*

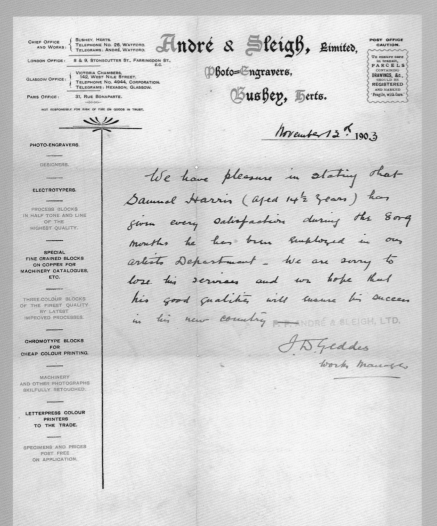

Copy of a letter from André & Sleigh, Limited, received at age 14. *Collection of Harris Family.*

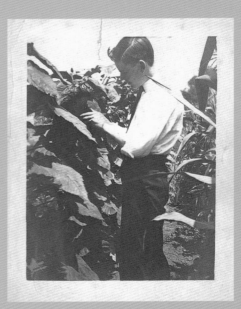

Sam at age 14, studying a sunflower. *Collection of Harris Family.*

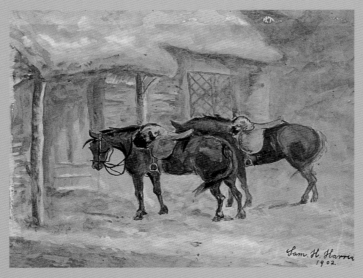

Watercolor painted when Sam was 13 years old in 1902 in England. Watercolor. 9.5" x 7.5". *Collection of Harris Family.*

Contents

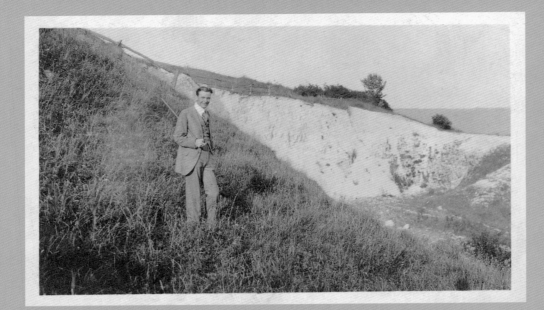

Sam in England, c. 1913.
Collection of Harris Family.

Sam to the right, with friends.
Collection of Harris Family.

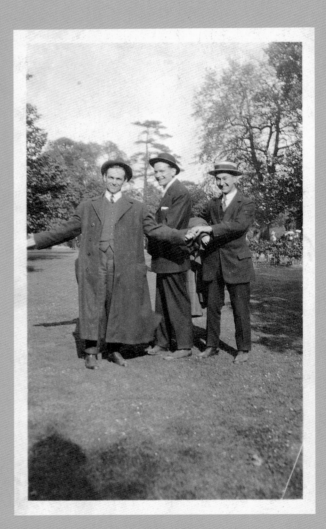

Sam with male friends. *Collection of Harris Family.*

Acknowledgments

It takes many people with like goals and stamina to put together an exhibition of this size, let alone an accompanying book. You cannot have an exhibition without objects and inspiration, therefore, I feel compelled to start saying the many words of thanks with Marion Dodge Harris. Marion was completely devoted to Sam and to his legacy. I had the great pleasure of knowing her in her later years and of understanding the pieces in her vast collection. Her collection was left to nonprofit organizations that have had the foresight and sense of responsibility to continue the use of the collection to further an understanding of Sam Hyde Harris and at the same time provide funds for just causes. Thank you National Mustang Association and Harris Art Works, hereafter, referred to as Harris Estate.

Objects and inspiration are one concern, but what to do with the objects is the next big hurdle. The Pasadena Museum of History with its wonderful staff, volunteers and beautiful new museum was an ideal site. We are so grateful for their involvement, once again, in a grand project and their faith that as a team we can be successful.

Next, is the ultimate treasure, a record of the images, a book/catalogue, which was a dream. With a limited time frame and no previous knowledge of publishing, entry into the "publishing, distribution" world was foreign and forbidding. A special thank you to Douglas Congdon-Martin, and Peter and Nancy Schiffer of Schiffer Books for their belief that we could produce a good product and it would be fun. Thank you to Gary Lang, The Harris Estate, Charles N. Mauch, and others for the financial ability to go forth.

A very special personal, as well as professional, thank you to the individuals without who's support and endless work this project would not have succeeded goes to Kevin Casey and Karen Hackette of Tirage Gallery, Jo Dunn, Judith Leavelle-King, and the Harris family. Dr. Martin A. Folb for his photographic and artistic skills and undying patience, Marion and Phil Kovinick not only for their masterful research and writing ability but their valued friendship. Kumiko Zitter without whose skill and imperturbability this book would not exist. Gary Lang, Thom Gianetto and Edenhurst Gallery, Charles N. Mauch, Roger Renick, Kirk and Linda Edgar, and Jim Konoske for their support, encouragement, friendship and involvement in a project, which at times seemed overwhelming. Thank you to my family and all my friends for always being there and, of course, a final acknowledgement to Sam.

Thank you, one and all,

Maurine St. Gaudens

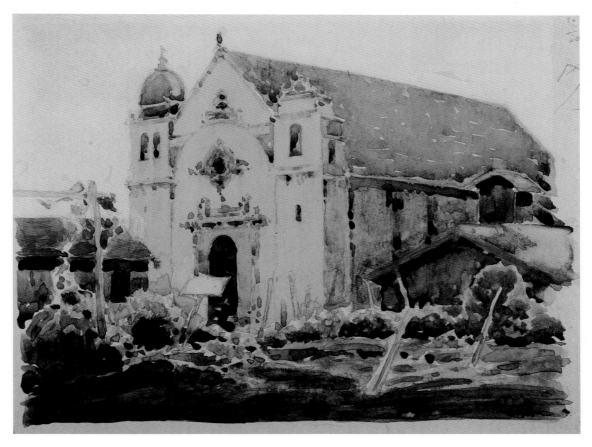

"Carmel Mission." Watercolor on paper. 8" x 10". C. 1925. *Collection of Roger Renick.*

Lenders

The art works and related materials were provided by so many generous people and organizations. Thank you for your gift of sharing:

California Railroad Museum, especially Ellen Halteman & Steven Drew
Harris Estate
Charles N. Mauch
Gary Lang
Charles F. Redinger
Jim Konoske Consulting
Judith Leavelle-King
Harris Family
David Adams
Vic & Carol Buccola
De Ru's Fine Art, Laguna Beach
Richard & Christina Doren
Edenhurst Gallery
Linda & Kirk Edgar
Mr. & Mrs. Thomas A. Giovine
Jean Parsons Harris
Ellen & Randy Lunn
Ed & Kelli Mace
Moe Parniani
Peggy & Joel Peña
Oltman Retirement Plan
Private collectors
Howard & Elizabeth Randol
Roger Renick
Maurine St. Gaudens
Maurine St. Gaudens Studios

Detail of tablecloth design (*see page 52*).

Preface
The Culmination of a Dream

This work is at best an incomplete examination of the complexities of a particular artist through his oeuvre. With time and dedication, the story of this individual can reach a more scholarly depth. By sampling Harris across the broad spectrum of his talents, this exhibition becomes a visual framework for the future study of his place and importance in the world of American art. Keeping that goal in mind, it is important that this book and exhibition also reflect the artist's persona as well as his work. Sam Hyde Harris, at six feet three inches tall, was aptly described by Virginia Key of the *Pasadena Star News* as "big, colorful, radiating magnetic warmth and force". In trying to keep those elements together, the exhibition was created to be an interesting and fun experience with a little bit of discovery of "Who Was Sam?" for everyone.

The book and exhibition are the culmination of the dream Marion Dodge Harris and I had of bringing together a selection of all aspects of Sam. After many years with the collection, what became apparent was that Sam was about STYLE rather than periods. Sam Hyde Harris had a number of distinct styles, which he used throughout his career. They include the atmospherically dominant paintings from 1918 thru the 1950s and the many subdued, hazy, soft desert scenes of his later years. His use of extreme horizons, both high and low, to create a composition started in the 1920s and was still being used with great dramatic effect in his last desert paintings. His application of paint to a surface was spontaneous and exacting, there is rarely an unsure stroke on any easel or commercial work. His paintings often depict the rural or working areas he frequented. We almost never see ladies relaxing on verandas or strolling through spring gardens with their parasols; in fact, we almost never see people.

There are, of course, changes, experimentation, and adopted new conventions, without which an artist does not evolve. There is a combining of styles; the size of this brush changes slowly over time getting progressively larger as does the size of the works. He does not frequent the coast as often after his marriage to Marion, as she preferred more arid environs, and capturing the desert was a new challenge for him. However, even with the new concentration on deserts in his later life, there are also paintings of the Morro Bay and Carlsbad areas into the 1960s and there are deserts as early as the 1930s. Subjects change, equipment changes, but the styles, which are distinctly Sam Hyde Harris, are continual, as can easily be seen when one is exposed to the full spectrum of his work. A new appreciation of the unique Sam Hyde Harris is what Marion Harris hoped for and it is the "Why" behind "Who Was Sam?" The material for that new appreciation is what many devoted people and I have tried to present for your experience in the exhibition and in this book.

Maurine St. Gaudens, 2007

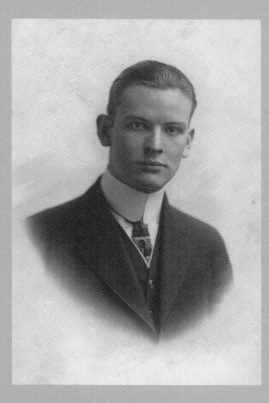

Sam, 1907. *Collection of Harris Family.*

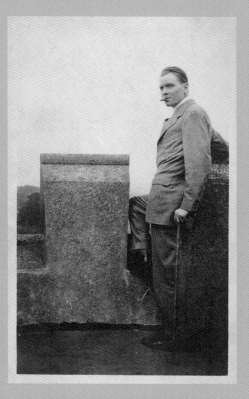

Sam standing by turret wall in England, 1913. *Photograph collection of Harris Family.*

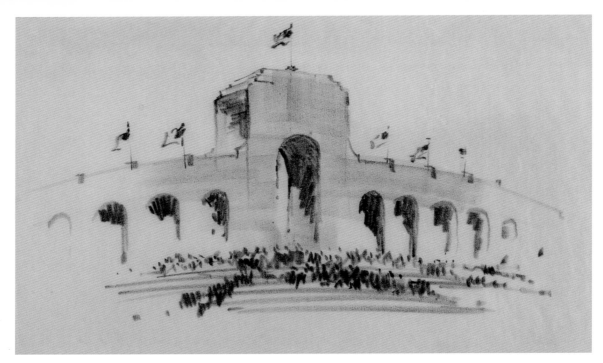

"Los Angeles Colosseum." Pencil on paper. 6" x 10". *Collection of Charles N. Mauch.*

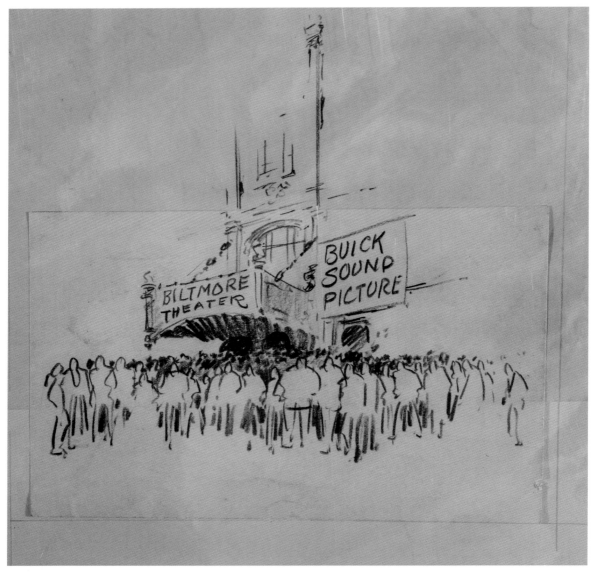

"Biltmore Theater." Pencil on paper. 8.5" x 8". *Private collection.*

"Sketch Pad." Oil on board. 12" x 16". C. 1918. *Collection of Linda and Kirk Edgar.*

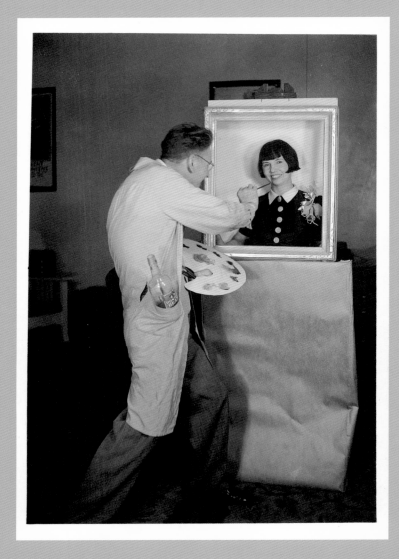

A costume party. Sam Hyde Harris and artist, Orpha Klinker. *Photograph collection of Harris Family.*

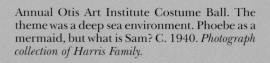

Annual Otis Art Institute Costume Ball. The theme was a deep sea environment. Phoebe as a mermaid, but what is Sam? C. 1940. *Photograph collection of Harris Family.*

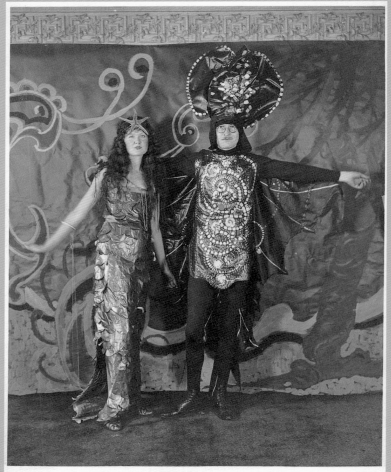

Sam at the Otis Art Institute Costume Ball, c. 1940.

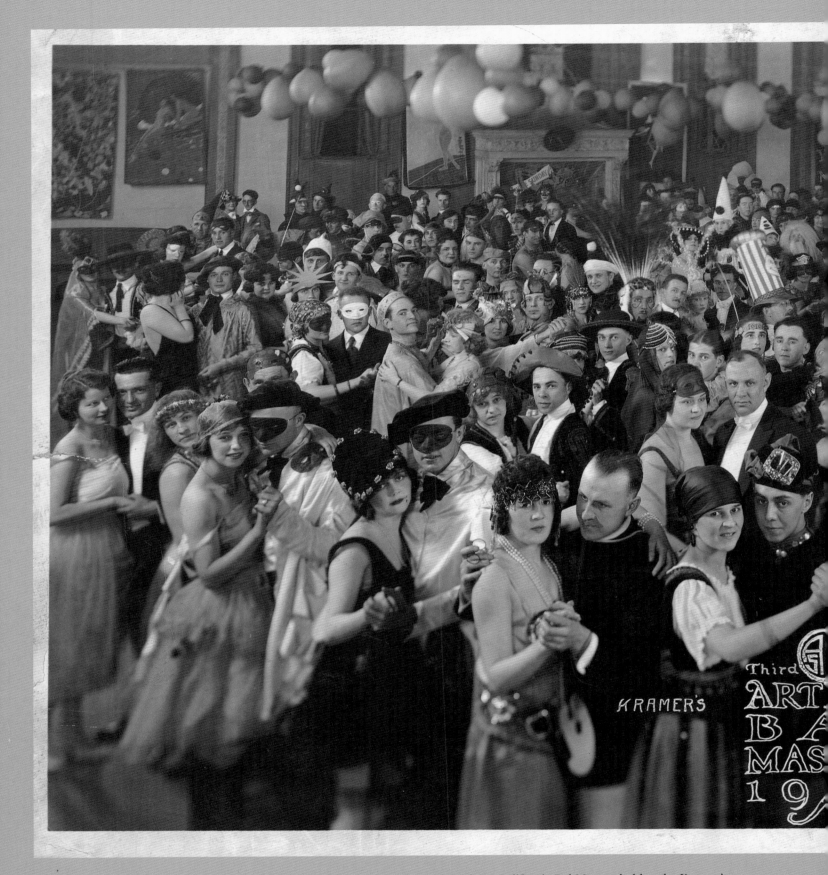

Another costume party. 3rd Annual Commercial Artists Association of Southern California Bal Masque held at the Kramer's Studios 1921. Sam was president of the organization in 1920 and 1921. *Collection of Maurine St. Gaudens Studios.*

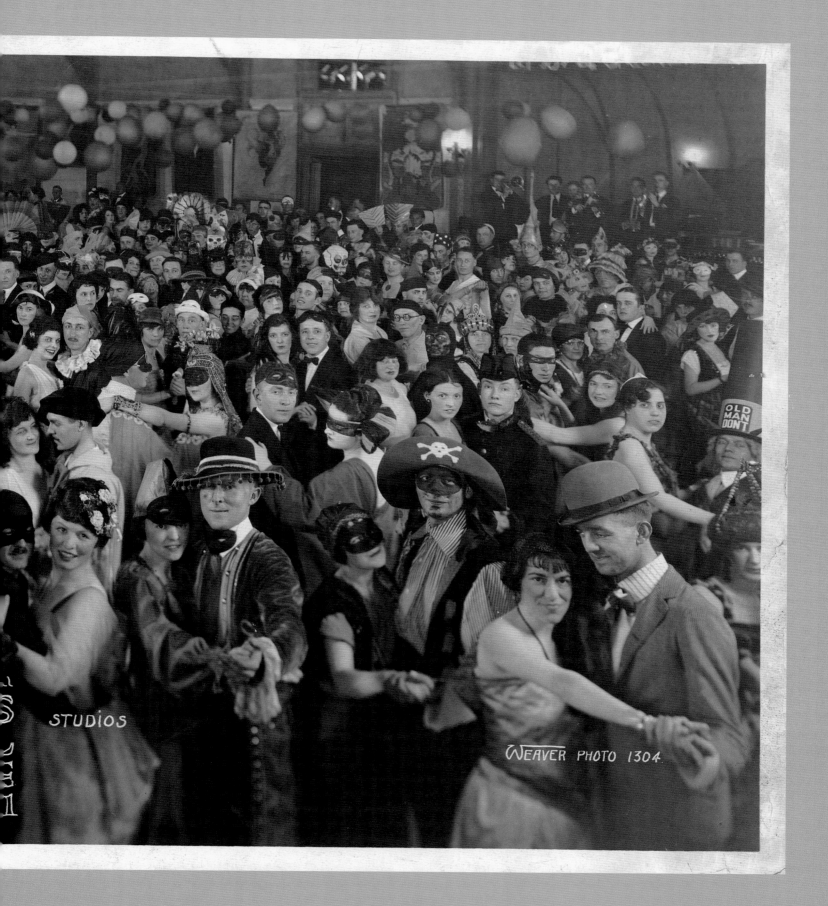

STUDIOS

WEAVER PHOTO 1304

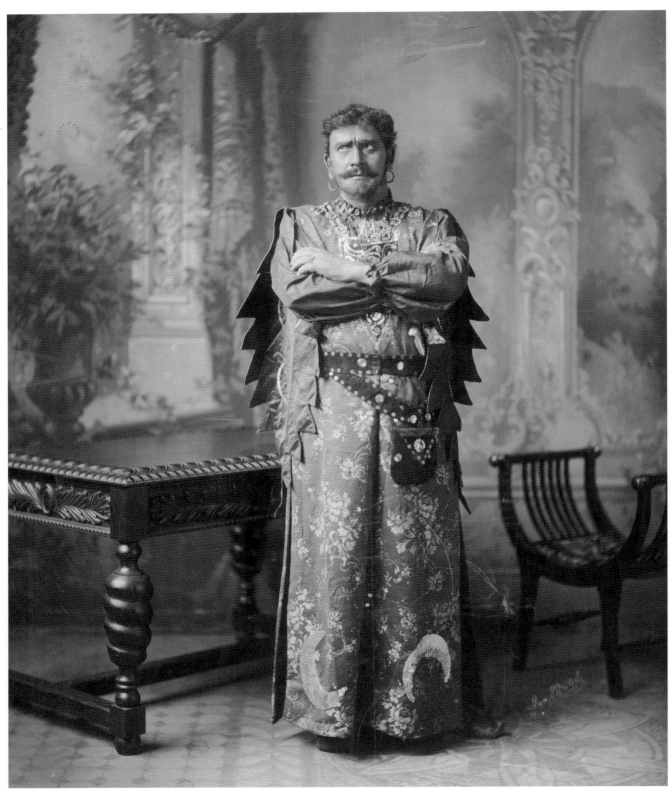

Sam in costume. Date unknown. *Private collection.*

Section I: Sam Hyde Harris

Who Was Sam Hyde Harris?
Marian Yoshiki-Kovinick

The Smoke Still Rises!

"Do you really know your Fellow Artists? See if you can guess who this is. Ah, they say that youth has spunk humor, imagination, critical analysis, and a true love of people. Yes, this artist has carried these traits with him all his life – commendable, yes! His father died[1] when he was three years old, and he was raised by his sisters. Oh, what a great choir boy he was! And in his younger years he smoked a pipe, but as time passed he gave up the pipe for bigger and better things – a cigar. So you see the *smoke still rises!* He has designed some of the "logos" that are well known to many people in Southern California. His paintings have been reproduced in many magazines, one of the most recent being 'American Art Review.' The list of his awards could fill Santa's stockings…"

—San Gabriel Fine Arts Association
Newsletter, July 1975

Art critics and historians have used various adjectives to describe the work of Sam Hyde Harris, among them being poetic, lyrical, atmospheric, authentic, strong, spacious, and colorful. Some would describe his wonderful sculptured depictions of the eucalyptus, oak, sycamore, and smoke tree as "Sam Hyde Harris trees." Expressive as they are of his paintings, however, their many depictions fail to delve into the question: Who Was Sam Hyde Harris, this multi-talented artist who was able to work at his chosen crafts as a commercial and as a fine art artist for over seventy years? What were his politics and did they play into his selection of subject matter, such as the working boats of San Pedro Harbor and the subtle inclusion of the oil rigs and industrial buildings that dotted the landscape near the harbor on Signal Hill? Was this a matter associated with his beginnings from an English working class family or social consciousness, or an affinity towards the fishermen and canneries that occupied the life of the harbor? With the rise of modernism encroaching upon the art aesthetics of Los Angeles, how did he remain true to his convictions toward his *en plein air* style of painting?

Highly recognizable because of his six- foot-three stature and cigar, Sam Hyde Harris was known for his jovial personality and his love for his adopted California and her landscape. He was unaffected by his popularity or success as an artist, and was once described by a *Los Angeles Times* writer as "… the most 'unarty' painter around. He never goes off into aesthetic burbles about mysterious objectives.

He is as 'depressed' about modern art as the next guy. And he works unaffectedly in a mechanic's smock with a dead cigar in his mouth."[2] The late Tom McNeil, an early collector of California Impressionists and an historian who was Harris's contemporary, recalled from a visit in 1972, "He is tall, slightly stooped, full head of white hair, sharp brown eyes, a strong, sometimes obscene sense of humor, modest of his accomplishments, and proud of his best oils." McNeil added, "He loves his martini at the El Poche Restaurant."[3] Among others on the Harris "bandwagon" were Earl McClannahan, who wrote in the BMAI *Art Beacon*, "To most of us Sam Hyde Harris IS Southern California, but though he never stops boosting our Southland, he paints with the best, jokes with the worst, is a sincere friend to all,"[4] and *Los Angeles Examiner* art editor, Howard Burke, who commented in 1960, "If popularity makes a painter, and art is a catalyst, then Sam Hyde Harris is one of the finest artists in the Southland. … His paintings are of a quality that classifies him among the choicest. This debonair artist has a sunny personality that is transmitted directly to his paintings, reflecting the light, atmosphere and cheerful California scene to the fullest."[5]

Born in Brentford, Middlesex, England, on 9 February 1889, the fifth child of David Remnant Harris (1854-1919) and the eldest of his father's second wife, Eliza Hyde Harris (1859-1892), Harris, as a youth, found employment in the Artists Department of Andre and Sleigh, Limited, Photo-Engravers, Busbey, Herts, London. And as he said of himself, "I have made a living with pen, pencil, and brush since the age of fourteen."[6] Soon after leaving Andre and Sleigh, Harris and his entire family boarded *The Cedric* in Liverpool and sailed to America, landing on Ellis Island on 7 November 1903. The family then moved to Los Angeles, where his father and brothers established a slate tile and roofing business and he first gained employment in 1906 with Charles R. Mogel and Aaron E. Kilpatrick as a painter of, as he would say, "everything from signs, designing billboards and hand-lettering show cards." Among his assignments, he decorated walls of buildings sometimes six stories high with lettering six feet tall. In a short time, due largely to the quality of his work, that was of such a high standard that it gained notice from many in the commercial art field, particularly for skills shown in his calligraphy and exquisite lettering, he established his own commercial art business at 113 West 6th Street in Los Angeles.

In the midst of his burgeoning career, on 15 January 1917, he married Phoebe Katherine Mulholland (1896-1978), the daughter of Hugh Patrick Mulholland (1857-

1918) and Mahala Alice Bodine Mulholland (1864-1951). Hugh Mulholland was the younger brother of William Mulholland (1855-1935), the founder of the municipal water and power district of Los Angeles and "the man who brought water to Los Angeles." Soon there were three sons, Donald Hyde (1918-1997), Samuel Hugh (b. 1919), who is an artist of portraits and figures, and Bruce Richard (1921-1994), and, in 1919, the relocation of his commercial business, advertised as Sam H. Harris, Posters, Art Titles, Letterings, to the 6th floor of the Realty Board Building, 631 S. Spring Street. There it would remain until a fire destroyed the structure in 1938.

Harris's commercial career received a tremendous boost when, in 1920, the Atchison, Topeka, and Santa Fe Railway Company resumed its poster advertising, following the lifting of government control during World War I, and hired him to continue the work in Los Angeles. It was a real "feather in his cap." The Santa Fe had a colorful history dating back to the 1830s. Its earliest posters, designed to provide announcements of destinations, schedules, and timetables, were of various sizes. By the late 1890s, the more decorative designs, using color lithography, measured 30" x 40", a size determined by the size of the lithography stone, "thereby creating a standard dimension and designation, the 'single sheet' poster."[7] The opening of the twentieth century saw the development of a growing middle class, an increase in leisure and vacation time and the rise in competition from the automobile, prompting the railroad to increase its network of ticket offices and to accelerate the marketing of its product, with the rallying cry, "Take the train."

Harris's contributions to the railroad's advertising efforts were noteworthy. "He created colorful, beautifully balanced renditions of romantic Southwest scenes.... His posters of the line's emblematic Navajo weaver and Grand Canyon offer color perspectives...."[8] Continuing the traditions of earlier Santa Fe commercial artists, Louis Treviso (1888-198) and Oscar Bryn (1883-1967), Harris developed a style and design distinctly his own by 1925, "which used brilliant red, blue and yellow highlights to dramatize the figure of the Indian flute player,"[9] that Santa Fe reproduced in its advertising booklets, posters, and newspaper ads. Speculation as to how Harris was chosen by Santa Fe revolves around his association with Hanson Puthuff, who earlier was employed by the Santa Fe to paint background landscapes and the fact that his office on Spring Street was located only a few blocks away from Louis Treviso's.

As with the Santa Fe, Harris had a long involvement with Southern Pacific, which "By the late 1920s, ... was spending over $1 million each year to promote its passenger trains. Local and national campaigns emphasized the many attractions along Southern Pacific's four primary routes,"[10] which had offices and agencies from California to New Orleans and a steamer line between New Orleans and New York City, writes Ellen Halteman, California State Railroad Museum librarian. The major portion of the advertising appeared in brochures, magazines, and newspapers, but local advertisements were in the form of billboards and hand-painted posters that appeared in de-partment stores, banks, displays in windows, and bulletin boards in ticket offices and lobbies. Harris was responsible for the posters, including many that are currently in the collection of the California State Railroad Museum, which in 1997, held an exhibition, *Sam Hyde Harris: Railroad Advertising Artist*. He continued his association with the Southern Pacific throughout World War II and "some of the most striking posters are those relating to Southern Pacific's wartime accomplishments."[11] One, for example, depicts a young soldier carrying a rifle with a backpack and the wording on the poster states, "Think before you travel. You can speed his visit home by giving up your summer train trips."

Afterwards, from the 1920s to the 1940s, Harris's commercial business concerned itself mainly with assignments from major railroad companies. However, it also involved work for local entities, most significant among them, from a personal point of view, the Pacific Electric Railway, known nostalgically in Los Angeles as the "Big Red Cars." The company, advertising itself as the "World's Greatest Electric Railway System" and "A Climb from Sea Level to Cloudland by Trolley Through America's Greatest Scenic Wonderland," traversed Southern California with over one thousand miles of standard trolley lines and ran 700 scheduled trains daily.[12] Coincidentally, it was the Red Car that would provide Harris with the transportation that allowed him to have his commercial art studio in downtown Los Angeles and to live in San Marino, Sunset Beach, West Los Angeles, and Alhambra, for he never learned to drive a car. His daughter-in-law, Jean Harris, wife of Bruce R. Harris, remembers when they lived with him during the early 1940s, every morning he would get up and go to his office in downtown Los Angeles traveling on the Red Car.

Harris, himself, realized that his works had a great influence on those who viewed them. In an unidentified note, he wrote, "On Spring Street one forenoon, a Poster Artist, a member of the Tripolay Club, met an old friend, an architect, whom he had not seen for several years. After the usual greetings were exchanged, the architect said: 'Well, I finally married, and my wife and I are making a trip to New York, we are going by rail and steamer and I think you'll be interested to know just how that happened. I was glancing through an Art Magazine and came across a reproduction of an *old* poster of yours advertising – 'One Hundred Golden Hours At Sea – New Orleans to New York.' You remember that poster! It naturally made quite an impression upon my wife and I, and we decided after some discussion to take the trip. I've already purchased the tickets and we're leaving this week.' Just one of those very rare incidents, of course but an interesting example of a Poster – years after it's original purpose had been served, still bringing returns to the advertiser."[15]

In addition to his work for the railroads, Harris's name is associated with one of the most recognizable logos in Los Angeles, the Van de Kamp Holland Dutch Bakers' Blue Windmills. In the mid-teens, his office was located near the company's first store on Spring Street, when Lawrence Frank, co-owner of Van de Kamp's, approached him to design show cards for the windows of the store, which, at the

time, produced Sarasota potato chips, S-shaped macaroons, and salted pretzels. Harris came up with a design depicting a Dutch boy saying, "Ya, I luf dos pretzels!" with a windmill in the background. Thereafter the Blue Windmill was incorporated into the trademark of the company for use in store signs, stationery, packaging, truck identification, and general advertising. The first Windmill store designed by film art director, Harry Oliver (1898-1973), opened in 1921 on Western Avenue and Beverly Boulevard.

Harris, a great believer that an artist never stops learning, early gave evidence where his great love lay. Not long after his arrival in Los Angeles, he began formal art training in evening classes taught by Hanson Puthuff (1875-1972), who would remain a life-long friend and painting companion, in his studio on Avenue 5. There, in 1906, Puthuff and Antony Anderson (1863-1939), *Los Angeles Times* art critic, established the Art Students League of Los Angeles, later moving it to a larger facility in Blanchard Music Hall on Hill Street in Los Angeles. He continued with the League until Puthuff's departure in early 1907, since its format fit perfectly into his schedule as a commercial artist – stressing informal instruction and offering afternoon, evening, and Saturday classes to individuals unable to attend an academically structured school. Several years later, sometime between 1910 and 1913, he studied at the Henry W. Cannon Art School, which was also located in Blanchard Hall. Then, in 1913, at age 24, he left for Europe with the intention of viewing and studying the works of the Great Masters in galleries and museums throughout England, France, and Belgium, remaining abroad for five and a half months. Subsequently, his formal art training continued intermittently until the 1940s. His instructors during that span included Lawrence Murphy (1872 -1947), F. Tolles Chamberlin (1873-1961), Will Foster, ANA. (1883-1953), and Stanton Macdonald-Wright (1890-1973). It was Macdonald-Wright who gave him valuable criticism, which allowed him to separate his professional work from his fine art paintings. He said that Macdonald-Wright advised him to slow down and think, and to make a sound composition and color in a small area rather than complete a canvas. Unlike his commercial work, where speed was essential, his easel work was created with Macdonald-Wright's words in mind.[16]

Harris held the opinion that "natural talent is highly overrated. The maxim in painting is correct training and a heck of a lot of application. A person can dig it out for himself, but if he does he'll waste a lot of valuable time learning the preliminary mechanics. You've got to study before you go on your own, that's very important."[15] Throughout much of his career, he maintained a close association with teaching. In 1935 he taught at the Chouinard School of Art and, in later years, led classes for private organizations, such as the Ebell Club of Los Angeles, the Spectrum Club of Long Beach, the Friday Morning Club of Los Angeles, and the Tuesday Morning Club of Glendale. In addition, he had a long, sustaining association with the Business Men's Art Institute where he taught landscape painting, along with Christian von Schenideau (1893-1976) William J. Harrison, and Will Foster, ANA. BMAI was located at

905 S. Beacon Avenue in Los Angeles and was organized to provide cultural relaxation for active and retired businessmen of that area. Its membership included bankers, movie stars, merchants, mechanics, doctors, lawyers, and men of other professions. Its motto was "Paint Your Way to Health and Happiness." It was as part of this group that Harris found a rich and rewarding experience that was equally beneficial to his students.

According to his son, Sam Hugh, Harris would work all week at his office and spend every weekend out sketching and painting. He recalls that his father had little time to spend "playing catch" with his three sons. With this strong work ethic, he was able to maintain both his commercial and fine art careers at the highest level. In 1920, he served as president of the Commercial Artists' Association of Southern California. In the same year, he joined the California Art Club, gaining membership at the same time as Conrad Buff (1886-1975), Alson S. Clark (1876-1949), J. Bond Francisco (1863-1931), John Frost (1890-1937), Paul Lauritz (1990-1975), and DeWitt Parshall (1864-1956). Subsequently he held membership in other art groups, among them the Artists of the Southwest, Mid-Valley Artists' Guild, San Gabriel Fine Arts Association, Glendale Art Association, Valley Art Guild, and San Fernando Art Association, and served as president of the San Gabriel Artists' Guild, Laguna Art Association, and Whittier Art Association. His honors included recognition as a fellow of the American Institute of Fine Arts and life membership in the California Art Club.

As early as 1920, Harris began exhibiting his art, hanging *Sand Dunes* at the California Art Club's 11th Annual event at the Los Angeles Museum of Science, History, and Art. He continued to do so for the next fifty-plus years, winning countless awards in hundreds of exhibitions throughout Southern and Northern California. His last showing, a one-man retrospective exhibition at the Alhambra Community Hospital, opened twelve days before his death.

Harris preferred painting *en plein air* to the studio, saying, "I love the outdoors. I don't belong to any church, but I approach my work with reverence. You have to want to paint landscapes, you must love the outdoors and you have to be willing to sweat." He was faithful to the elements of a successful landscape: composition, drawing, values, color, and feeling. He taught his students that composition was the most important factor in the development of a painting, what he referred to as the "backbone of art" and also often quoted one of his teachers, Lawrence Murphy, "[Composition is] the intelligent breaking up of space." He always maintained that selection is "not how much, but how little and at all times in the back of our head is the warning, 'Keep it simple,'" while creating an atmosphere with the subtleness and misty haze so identifiable with the Southern California landscape. *Los Angeles Times* art critic, Arthur Millier, in a review of his solo exhibition at Armand Duvannes Galleries in 1941, wrote, "Harris's finest piece is *Rain*, a scene of hills under cloud and sun. It achieves dignity through fine space composition and variety through color and atmosphere. This Southland painter knows trees, as the poetic *The Grove* and *Arcadia* testify. His best pictures

present broad effects. When he overcrowds with details the results are less distinguished. Harbor and city provide subjects which he paints descriptively and poetically."[16]

Throughout his long career he withstood many economic changes, including the Great Depression. Although his business suffered some setbacks, he was able to keep his office in Los Angeles, but, finding it necessary to leave San Marino, he moved his family to Sunset Beach. Economically it was easier to survive in the beach community and the Red Car line enabled him to continue to keep his downtown office. The thirties brought about not only some financial changes in his life, but also his concerns with the encroachment of modernist trends in art and its influence on the art community and exhibitions. He observed the changes in the art world toward modernism as more and more modernist were included in exhibitions. "The modernists rule the roost now," he once said. "I won't even enter some of my paintings in their contests. I've seen some I liked, but most of it is non-understandable. There are three criteria for judging a painting. What did the artist have to say, did he say it and was it worth saying. If an artist can answer those three questions then he has a work of art."[17]

By the early 1940s, his marriage to Phoebe was in a state of deterioration, due to their strong personalities and continual disagreements. They parted and soon Phoebe remarried to Reuel Kennicott (1892-1973), later moving to Carmel Valley. Eventually their three sons chose to leave Los Angeles and relocated to the Monterey Peninsula. Harris's contact with his family became estranged. His granddaughter, Judi Leavelle Harris King, recalls that she rarely saw him and only remembers him as "Grandpa Peanuts." Later in her life, she re-connected with her grandfather and after his death, she and Marion, his second wife, visited often. They maintained a warm friendship and mutual love of animals.[18]

It was also during the 1940s that he met and became friends with Jimmy Swinnerton (1875-1974), who had gained notoriety as a Hearst newspaper comic strip artist for "Little Jimmy," "Little Tiger," and "Canyon Kiddies," and as a pre-eminent painter of the desert. The effervescent Swinnerton had gone to the California desert in 1903 to recuperate from tuberculosis and never left. Gaining renown as the premier desert painter, Swinnerton had a great influence on Harris. Soon Harris spent much of his time in the area around Palm Springs and La Quinta, painting and sketching with Swinnerton. He admired Swinnerton and described him as "a poet, philosopher, and painter." Arthur Millier wrote, "Swinnerton has lived his Grand Canyon, his Arizona desert, his California mountains. He has the right to paint them. Downright realism marks his work. He paints things as they are. If you are incredulous in the presence of these paintings it is because you have never climbed to the viewpoints, have never attended these pageants of natural architecture, these incredible sunburnt distances…. Moran saw the West as a magnificent fairyland. This man sees it as the hard, glorious country it is."[19]

Harris, too, soon found that his desert paintings were gathering the admiration of many critics, one commenting that, "Harris manages to capture the magic of sun, sand,

and stone in a degree of beauty and realism that is rare in the profession."[20] After retirement, Harris was known to be in one of two places, either in his studio on Champion Place or in the desert. He and Marion shared the love of the desert and they spent much of their time there.

After World War II, even though the art community in Los Angeles began to embrace modernism, he remained faithful to the traditional styles and continued to enter and jury exhibitions in Los Angeles and San Gabriel Valley. During the forties and early fifties most juried exhibitions were judged in two categories, modern and traditional. He was strongly aligned with the Society for Sanity in Art and formed a branch in Southern California, later to be renamed Artists of the Southwest. Josephine Hancock Logan founded the Society for Sanity in Art in Chicago in 1936. It was opposed to all forms of modernism, including cubism, abstract expressionism, surrealism, fauvism, and other art movements that were popular at that time. Branches of the group established themselves all around the country. In 1939, a western branch of the Society changed its name to the Society of Artists, and later to the Society of Western Artists, which resulted in the largest representational art society west of the Mississippi.

The year 1945 marked a turning point in Harris's life, for it was then that he met Marion Dodge (1904-1998), a U.C.L.A. librarian, in one of his evening art classes. They were married on 8 August 1945. He always said that she was the "love of his life," and she reciprocated with an equal affection and admiration.

The other change in Harris's life came when he moved from West Los Angeles to Alhambra. By 1946 he and Marion were living at Hidalgo Street in Alhambra, a residence they would keep until his death and Marion's move to an assisted living retirement residence. During the 1920s through the 1940s, Alhambra had become its own artist colony. Jack Wilkinson Smith (1873-1949), Frank Tenney Johnson (1874-1939), Eli Harvey (1860-1957), and Clyde Forsythe (1885-1962) purchased studios along Champion Place, and this soon became known as "Artists' Alley." *Los Angeles Times* writer William McPhillips described it in a 1975 article, titled "Artists' Alley: A Tranquil Place," stating, "Bisecting the center of Alhambra and San Gabriel just north of where Main St. becomes Las Tunas Drive is a quiet, tree-lined little lane…. Not too fanciful, ready, for when these now-sturdy trees were but half-grown, Champion Place was know as 'Artists' Alley,' a block and a half and ending in the magnificent vista of the San Gabriel Mountains. Barely 15 feet wide, it once housed painters and sculptors as famous as any whom later inhabited such places as Carmel-by-the-Sea and Laguna Beach. Most of them were western painters, who followed the setting sun across the vast Mojave looking for a snug haven in which to record their impressions. Perhaps the most famous of the lot – and the one most responsible for transforming Champion Place into the Little Bohemia of the 1930s – was Frank Tenney Johnson."[21] It grew as a gathering place for artists and movie figures that included such luminaries as Charles Chaplin, Gloria Swanson, Tom Mix, Will Rogers, and Norman Rockwell. Rockwell became a regular visitor

to Alhambra, staying with Forsythe or Harvey and sharing their studios. In 1950 after the deaths of Jack Wilkinson Smith and his wife Emma, Harris purchased Smith's studio at 16 Champion Place. When he died, an era came to an end, for he was the last artist on "Artists' Alley."

Harris spent his life seeing and capturing the early scenic sites of California, including the Los Angeles and San Gabriel Valley, the Arroyo Seco, Los Angeles Harbor, Sunset Beach, Laguna Beach, Newport Beach, Morro Bay, Monterey, the back country of San Diego county, and the expansive desert country of California, Arizona, and Utah. An apt description of his work used in the brochure of his retrospective exhibition states that "His canvases have the smell of mesquite in them, the clean air of high Western desert and mountains, the breath of the rugged California coast, the loneliness of a long-deserted railroad station, the battered beauty of a farmhouse, the low skyline of the Los Angeles of a half-century ago – the simple, beautiful face of the 'unadorned West.'"[22]

Much of what he chose to depict exists today only on his canvases, having been replaced by civilization and urbanization. For example, his landscapes of Chavez Ravine, made over a half-century ago, include the surrounding areas where the Dodger Stadium now stands. One can only speculate as to his affinity to depict the San Pedro fishing boat scenes. He was politically conservative and had very strong feelings against the New Deal and WPA projects, so why he chose the working boats of the harbor one can only suppose that the misty, atmospheric subtle tones of the harbor led him to find the beauty in the local community that inhabited the harbor district. Again, these paintings were created during the first part of the last century, when San Pedro had a thriving fishing and cannery business that have since been shut down by industrialization and a global economy.

After 1955 his retirement years found him doing those things that continued to give him the most pleasure – teaching, painting and sketching *en plein air* in the desert, exhibiting in local exhibitions, telling stories, and chewing on a dead cigar. He especially loved looking at the view of the San Gabriel Mountains from his Champion Place studio. Marion stated in a talk "Sam Hyde Harris: A Short Biography," that she gave in 1973, "Now, on one of those rare clear days, he will look up at the beautiful mountains towering over San Marino, Arcadia, Sierra Madre and Monrovia and say with great pride and affection, 'They're my mountains!' And, I think, they really are!"[23]

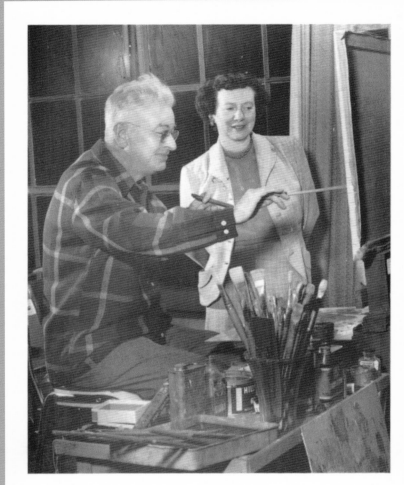

"Studio Evening"

"Studio Evening." Sam and Marion. *Collection of Harris Family*

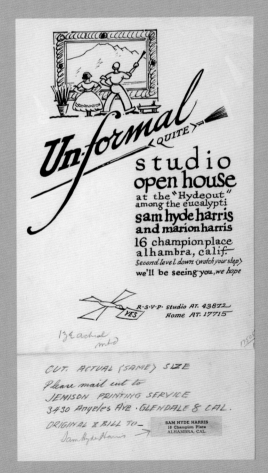

"Studio Opening" invitation – work up.
Tempera on board. 14" x 7.5". *Collection
of Charles N.Mauch.*

Sam Hyde Harris:
A Short Biography

Marion Dodge Harris
A lecture presented on March 14, 1973

Before I tell you about Sam Hyde Harris and his paintings, I'd like to say a few words about the particular school of painting to which he belongs. He is perhaps one of the last two of the celebrated group of Southern California landscape who flourished in the "teens", 20s, 30s, and 40s of this century and whose works may be seen in museums and private art collections.

Some of these giants in landscape painting are: William Wendt, Jack Wilkinson Smith (whose studio on Champion Place, Alhambra, we now own), Victor Forsythe, Edgar Payne, Hanson Puthuff, and Orrin White, to name a few and no longer living.

They recorded the natural beauty of the California landscape, especially in Southern California, when it was still unravished by bulldozers, and when the atmosphere was clear and beautiful. Much of this early scenery is gone, but we can still get a nostalgic look at it in the magnificent paintings which these men have left as legacies. Thus, in a sense, Sam Hyde Harris and the others have produced valuable historic records as well as scenic works of art.

Sam Hyde Harris was born in Brentford, Middlesex, England, and as he says of himself, has made a living with pen, pencil, and brush since the age of fourteen.

In 1904 his family immigrated to California and he grew up in Los Angeles along with the city.

He entered the field of advertising art about the age of 21 and became one of the top men in the business. His lettering and many of his poster designs have been used as illustrations in textbooks on these subjects. At one time he taught adverting art at Chinard's Art Institute while maintaining his own studio.

Among his early clientele was Lawrence Frank of Van de Kemp's windmill. He was their first artist.

He, also, created posters for the railroads: Union Pacific, Santa Fe, Southern Pacific, and Pacific Electric (the celebrated old red cars of fond memory). He was handling the Southern Pacific poster work as recently as the 1950s. His posters are collectors' items today.

During these early years of his career, San Hyde Harris was constantly studying painting as a fine art. He studied at the Art Students' League of Los Angeles, and under such great artists and teachers as: Lawrence Murphy, S. McDonald Wright, Frank Tolles Chamberlain, Will Foster, A.N.A., and Hanson Puthuff.

In 1913 he went to Europe and spent many weeks studying the works of the masters in London, Paris, and Amsterdam.

He has won well over 100 awards and is still winning them as recently as this month (March, 1973). A number of his paintings are in the permanent collections of schools and colleges such as Pierce College, Los Angeles, Dixie College, Utah, San Pedro High, Clearwater High, Gardena High, Alhambra High, and Berendo Junior High, Los Angeles. Three hospitals in Southern California own his paintings. At the San Gabriel Women's Club you may see two of his paintings, which were purchased, as permanent memorials for the club.

By the way, Sam Hyde Harris is an avid collector of the works of other artists and owns originals of such great men as Frank Tenney Johnson, the great western painter of cowboys, Norman Rockwell, Jack Wilkinson Smith, and Will Foster.

He has been listed in *Who's Who in American Art* and *Who's Who, Western Division*.

He is a member of some ten art associations and is a life member of seven, including the Laguna Beach Art Association of which he has also been a director. He is a Fellow of the American Institute of Fine Arts, an organization composed of many celebrities in all fields of the fine arts and in public service.

Sam Hyde Harris has lectured extensively on art for many organizations, and his painting demonstrations have been legion. In fact, he was one of the first artists to use this device as a learning tool for art students and art devotees.

He entered the field of art teaching largely by accident and soon became famous for his unique and successful teaching techniques. He has taught the Business Men's Art Institute of Los Angeles, as their landscape instructor, the Spectrum Club of Long Beach, and the art sections of the Friday Morning Club of Los Angeles, the Los Angeles Ebell Club, the South Pasadena Women's Club, and the Glendale Tuesday Afternoon Club. This latter group he has taught for 29 years and it is the sole art class, which he still teaches. He has also had his own private classes in outdoor landscape painting. Recently, he has done some critique work for individuals and art organizations.

Many of Sam Hyde Harris's students have achieved distinction in their own right and are now "big names" in the local art world. Many of them have been influenced by his methods and philosophy. Often, people will see a painting in a gallery and say: "That's a Sam Hyde Harris." However, it will very likely turn out to be a painting by someone who has studied with him.

Perhaps, some of you may know Lester Bonar who taught art at Alhambra High and was, later, head of the Art Department at Mark Keppel High and who is now one of the finest water colorists in the West. He received his early art training working in Sam Hyde Harris's advertising art studio way back after World War One.

I won't attempt to tell you about his philosophy of art in a brief length of time.

One point, however, I'd like to emphasize. He considers composition the most important factor in a painting. He calls it "the intelligent breaking up of space" and his watchword to students is: "Keep it simple!" That is to say: Never have two or more subjects of equal importance in one painting. Just choose one.

Before I show you examples of his work I'd like, also, to quote a favorite statement of his which he uses to define a good painting: "What is the artist trying to say? Has he said it? Is it worth saying?"

Sam Hyde Harris has painted in various western locales: Utah, Arizona, Wyoming, and, in California, Morro Bay, Monterey, Newport, Laguna, San Pedro, the back country of San Diego, Carlsbad, Palm Desert, Palm Springs area and practically all of the Coachella Valley, and Baja California around Enseñada. By the way, the great western artist, Jimmy Swinnerton, who is celebrating his 97th birthday Sunday, was a pioneer in painting the desert. I must add here that the desert, as a subject for a landscape, came along much later than other areas in Southern California, probably in the 1930s, at the earliest.

Verdugo Woodlands and Arcadia, in the vicinity of Santa Anita, before World War II, were among his favorite locations. In fact, most of the one time scenic locations in and around Los Angeles County, were subjects for the brush of Sam Hyde Harris and his fellow artists in those days.

Now, on one of those rare clear days, he will lookup at the beautiful mountains towering over San Marino, Arcadia, Sierra Madre and Monrovia, and say, with great pride and affection: "There're my mountains!" And, I think, they really are!

Sam and Marion.

24

Direct Painting Versus Underpainting
Sam Hyde Harris
An article written in 1949

A fine opportunity for discussion or argument; both methods have these advantages and drawbacks. For the experienced painter working in the studio on a large canvas, with ample information in the sketch or sketches made directly from the subject, underpainting is at times a timesaver and valuable in planning and starting the big canvas.

To the young painter or even the beginner, who is just starting to struggle with the great outdoors. For him I would recommend Direct Painting, in other words stay out of the "soup" or medium, just dip the brush in occasionally so your color works freely. Paint with paint, not turpentine.

Going on the assumption the student has given some thought and consideration to the composition and drawing, has it "fixed" and ready to paint, the question arises where to start. There is no fast rule, start any place you like, if the barn is an important element in your canvas start with the barn, a mountain picture start with the sky and relate the mountain color to it.

Here is the important thing. Take plenty of time with that first spot of color, get it as near right as possible, in both value and color. That first spot determines the key of your whole painting. Select the second area, right next to the first, relate the one to the other. Mix it on your palette, if it is sound on your palette it will be sound on the canvas. Don't be stingy with paint, mix up plenty of color for the various areas. Use as large a brush as possible, and don't choke it, clasp the end of the brush not the ferule, arm length too, if possible.

Coming back to the first and second steps, before going any further, check your sky color with the actual sky for value and color. The horizon is usually the lightest part, take one of those rare days when we have a blue sky without clouds, start with white, a whisper of pale lemon yellow, with cobalt blue added. Note, as you go up with the sky, a little less yellow, whisper more cobalt. Next, the mountain color, depending on how clear the atmosphere is, start with white, cobalt, and alizarin, this gives you a lavender or purple, just a trifle raw, add a touch of pale lemon will gray or modify it and give it a little more quality. A touch of blue mixed with your mountain color will give a slightly darker and cooler value for the shadows of the mountain.

Here particularly, when we try to arrive at the more delicate, subtle tones, does the value of the WHITE palette assert itself, if it is sound on the white palette, it will be on the white canvas.

Take your time, don't hurry! One of the great minds said, "I would better see a sound composition, a reasonable drawing with four or five spots or areas of color **right** next to each other, and the rest of the canvas clean, than a whole canvas covered, with little or nothing right!"[24]

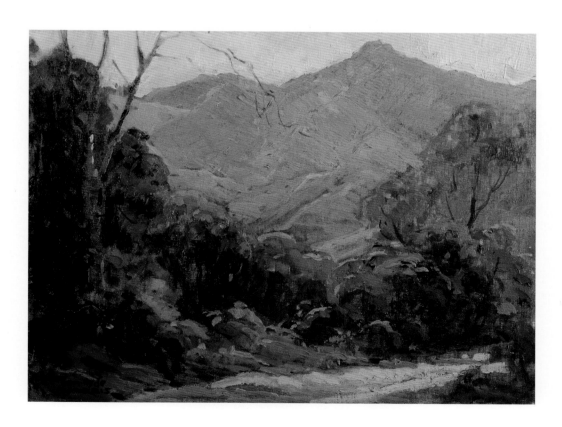

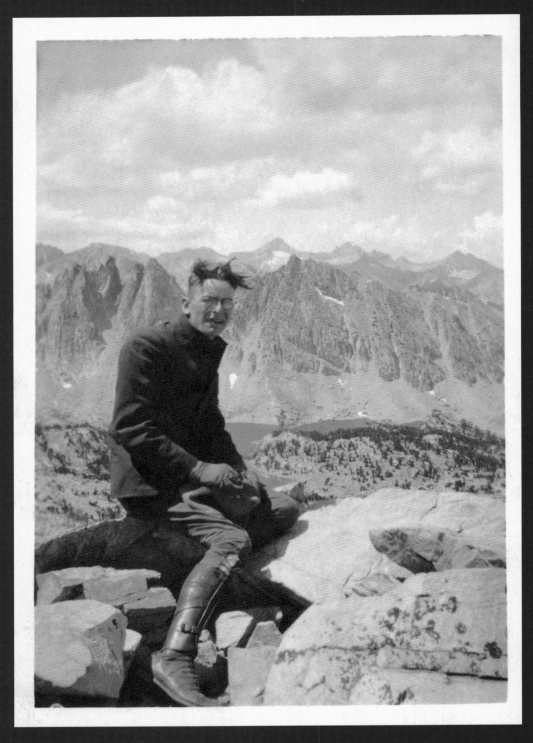

Sam in the High Sierras at age 20. *Collection of Harris Family.*

Section II: The Beginning: Early Bright Impasto Style, circa 1915-1935

Sam Hyde Harris's easel paintings start early and parallel his entire commercial career.

Some Examples of his Early Classic Academic Work, c.1905.

28

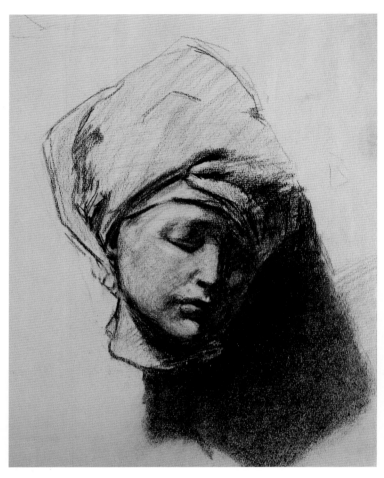

Head study of a woman. Charcoal drawing on paper. 10" x 12". *Collection of Harris Estate.*

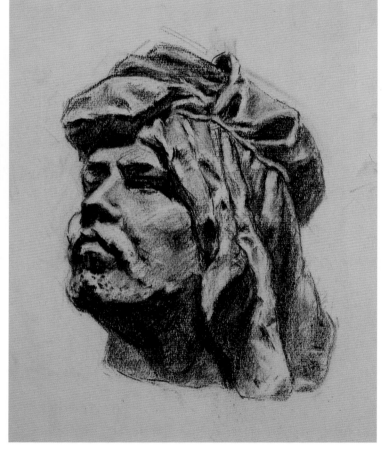

Head study of a man. Charcoal drawing on paper. 10" x 12". *Collection of Harris Estate.*

Study of cement relief of an angel. Charcoal drawing on paper. 13" x 12".
Collection of Harris Estate.

Head study of a male with pipe. Charcoal drawing on paper.
14" x 10.5". *Collection of Harris Estate.*

Head study of a male in cap with pipe. Charcoal drawing
on paper. 19" x 14.5". *Collection of Harris Estate.*

Sam married Phoebe Mulholland, niece of William Mulholland, Los Angeles Water District giant, in 1917.

"Phoebe in the Garden." Oil painting. 14" x 11.5". *Collection of Judith Leavelle-King.*

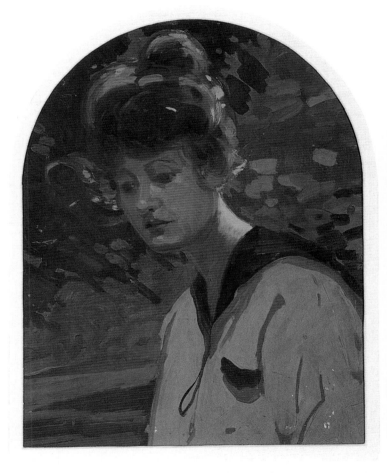

"Phoebe." Oil painting. 13" x 9.5". *Collection of Jean Parsons Harris.*

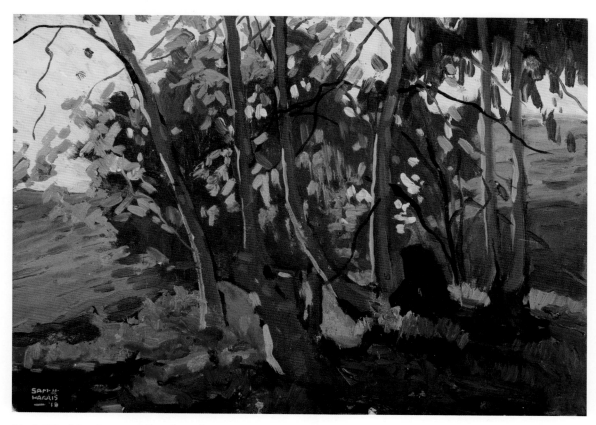

"As It Was," landscape. Oil on board. 10" x 14". Dated 1918. *Collection of Gary Lang.*

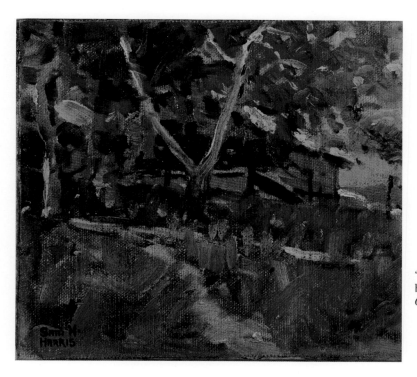

"House in Landscape." Oil on board. 6.75" x 7.5". C. 1915. *Collection of Charles N. Mauch.*

The earliest paintings, basically from 1912 to 1925 (some even later) are usually small oil on cardboard or brown Epson board. They are filled with complex, bright, wonderful color applied in thick dashes and dabs, there is no hint of hazy atmosphere in these works. He captures many areas of Arcadia, Eaton Canyon, San Gabriel, Glendale, Laguna Beach and the Grand Canyon. He keeps this style of dashes and dabs, while using less paint and a larger than quarter inch brush, even into the desert scenes.

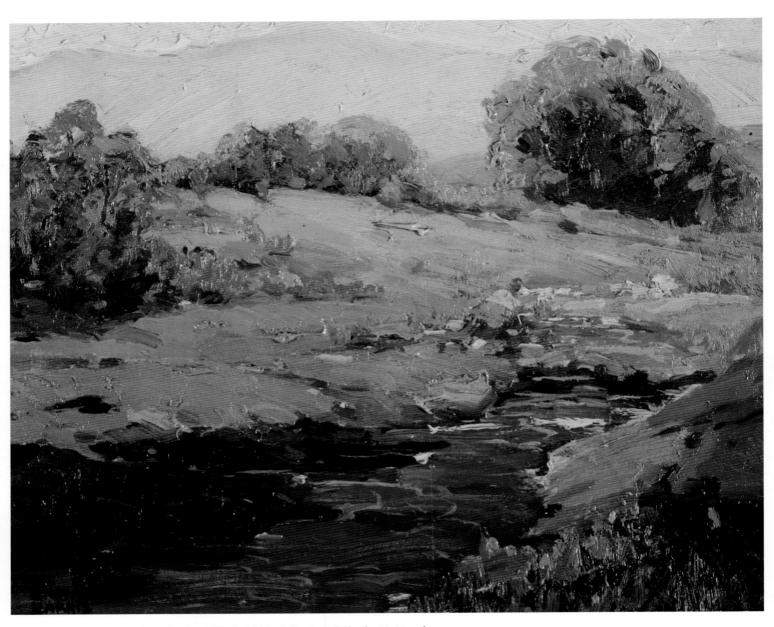

"Eaton Canyon." Oil on board. 8" x 10". C. 1918. *Collection of Charles N. Mauch.*

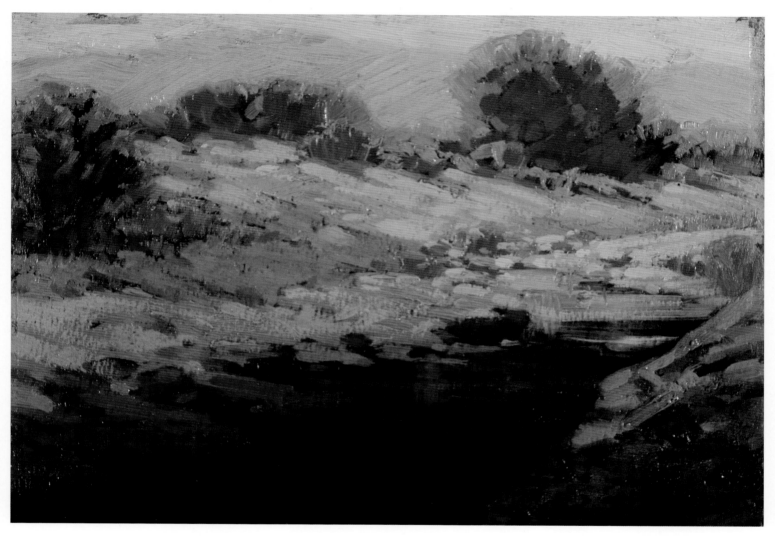

"Eaton Canyon." Oil on board. 10" x 14". *Private collection..*

Detail of brush strokes and impasto (Italian for thick paint) used in "Eaton Canyon."

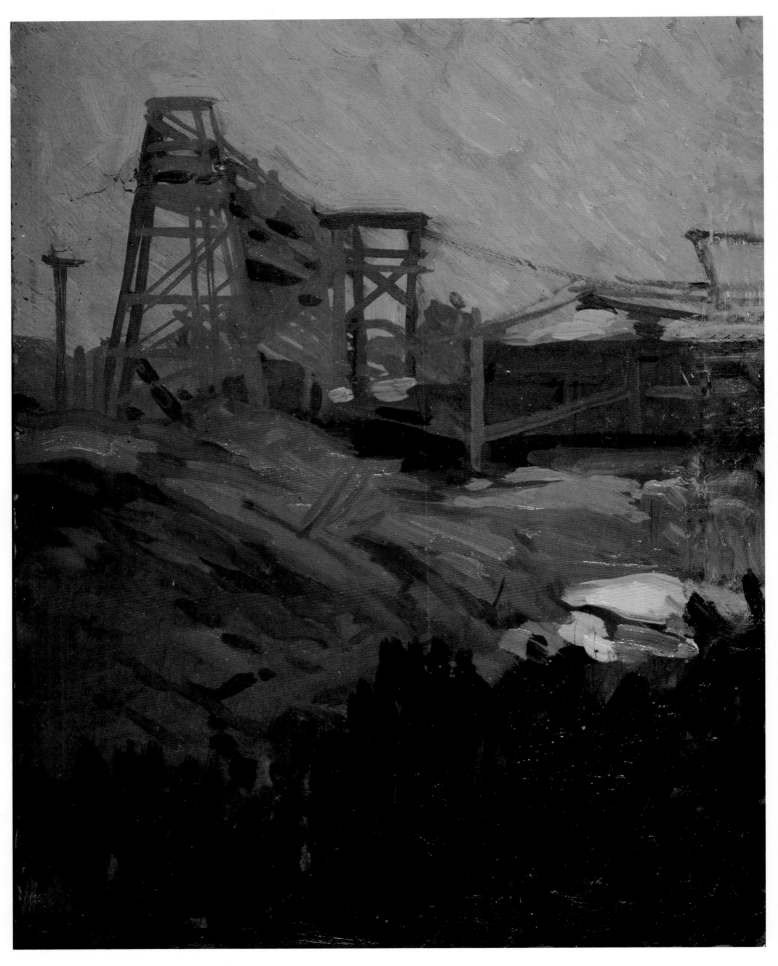

"Oil Well." Oil on board. 10" x 8". C. 1918. *Collection of Harris Estate.*

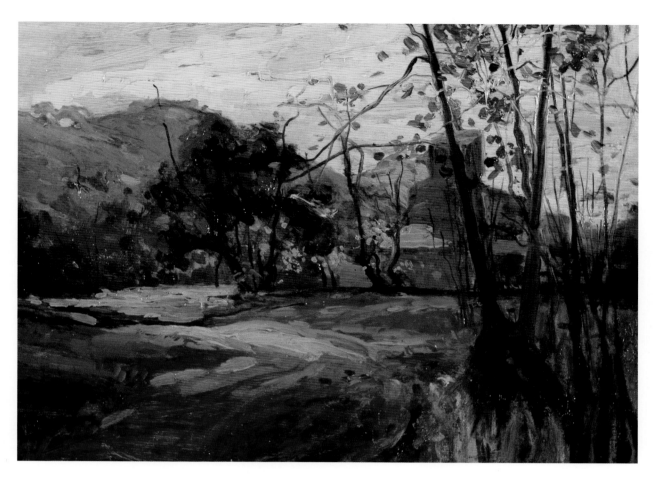

Untitled. Landscape with structure. Oil on board. 10" x 14". C. 1920. *Collection of Elizabeth and Howard Randol.*

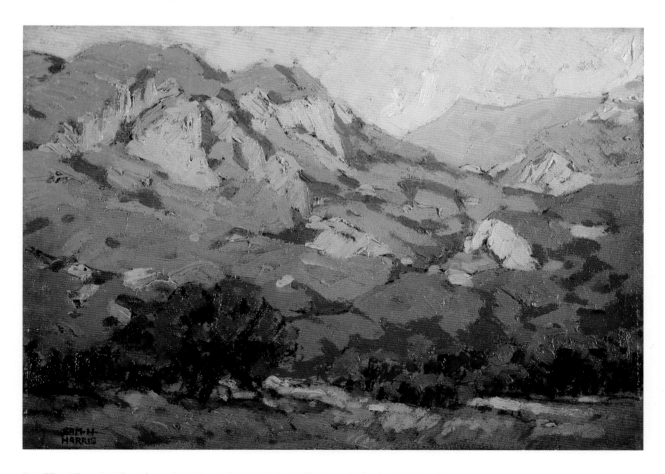

"Malibu Then." Oil on board. 10" x 14". C. 1920s. *Collection of Charles N. Mauch.*

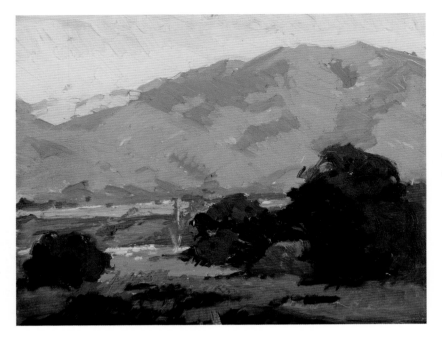

"Arcadia Then." Oil on board. 8" x 10". C. 1922.
Collection of Gary Lang.

"Verdugo Woodlands". Oil on board. 8" x 10". Dated
1921 verso (the back of the painting). *Collection of
Gary Lang.*

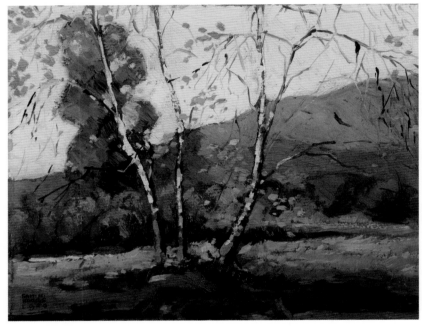

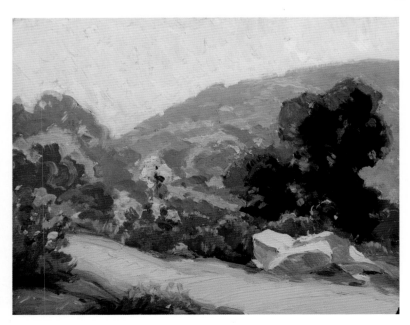

Untitled. Early landscape sketch. Oil on board. 8" x 10". C. 1919.
Collection of Gary Lang.

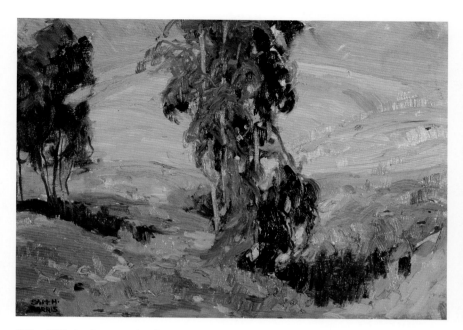

"The Hills in Summer." Oil on board. 10" x 14". C. 1918.
Collection of Charles N. Mauch.

Detail of "The Hills in Summer" showing impasto and brush strokes.

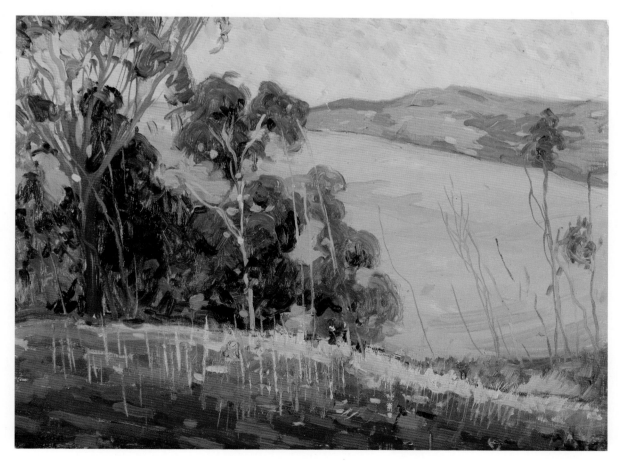

Untitled landscape. Oil on board. 12" x 16". C. 1918. *Collection of Gary Lang.*

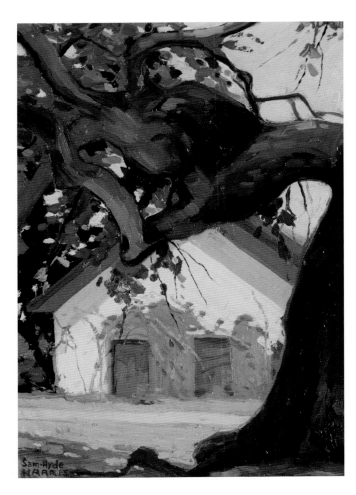

"House with Oak Tree." Oil on cardboard. 16" x 12". C. 1919. *Collection of Peggy and Joel Peña.*

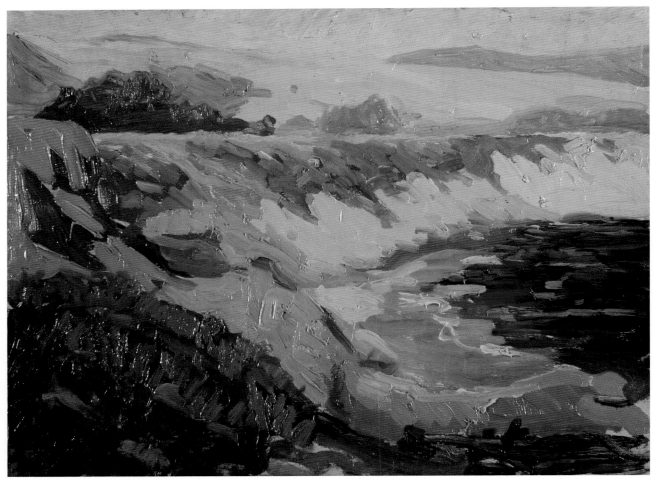

"Laguna." Oil on board. 12" x 12". *Collection of Ellen & Randy Lumm, courtesy Thom Gianetto, Edenhurst Gallery..*

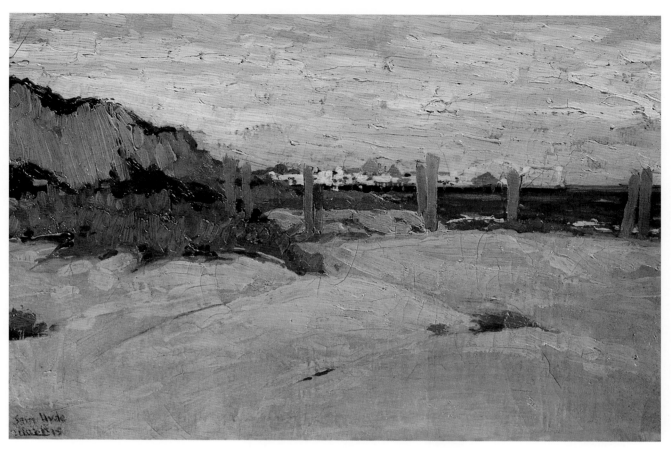

"Sand Dunes, Santa Monica." Detail shows exhibition tag on early canvas. 10" x 14". C. 1919. *Private collection.*

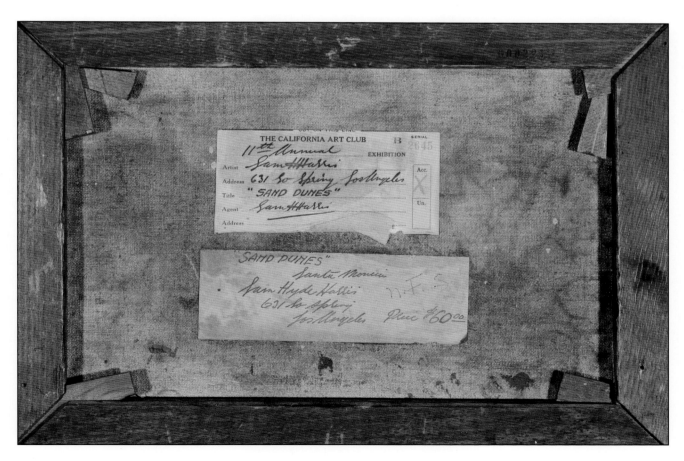

Exhibition tag on the back of the canvas: 11th Annual Exhibition, California Art Club. Los Angeles County Museum. Oct. 7 - Nov. 15, 1920. "Sand Dunes, Santa Monica."

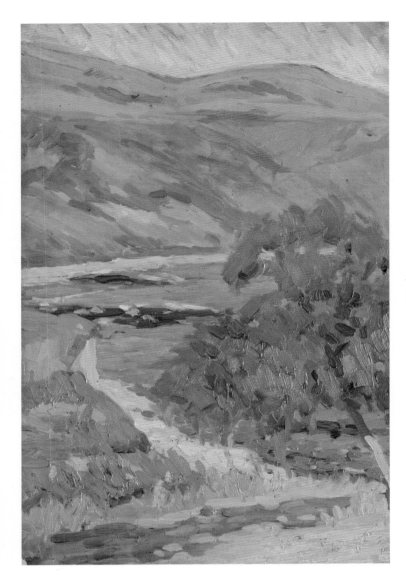

"Along the Beach." Oil on board. 15" x 10". C. 1920. *Collection of Harris Estate.*

"Rugged Coast." Oil on board. 8.5" x 12". C. 1920. *Collection of Gary Lang.*

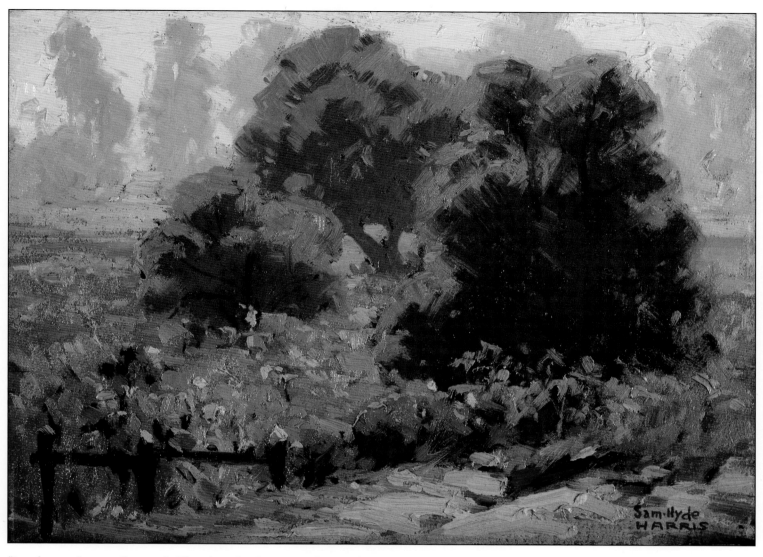

"Landscape, Laguna Canyon." Oil on board. 12" x 16". *Collection of Harris Estate.*

A close-up reveals how two strokes of impasto creates a house far in the distance of "Landscape, Laguna Canyon."

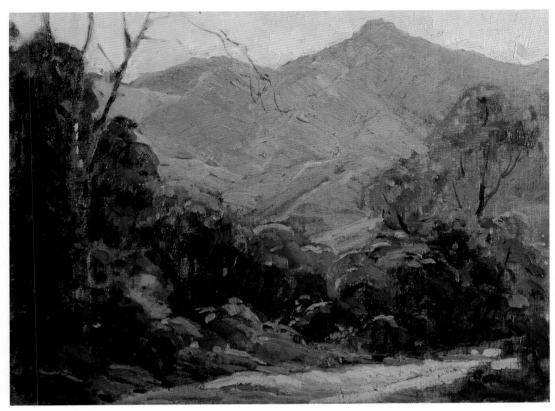

"Altadena." Oil on board. 12" x 16".
Collection of Harris Estate.

The detail shows a complexity of
color, impasto, and under wash of
color in "Altadena."

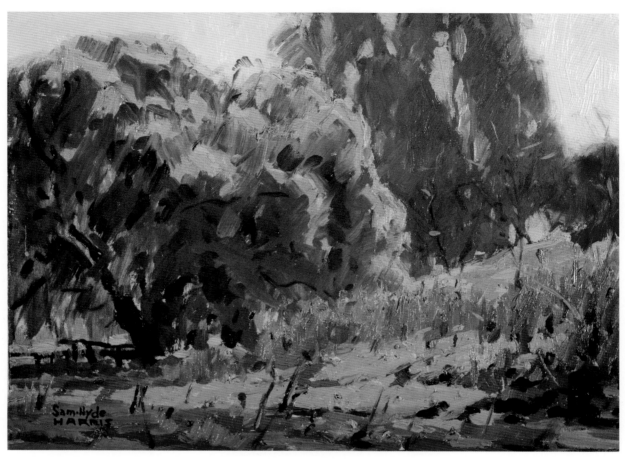

"Spring Splendor." Oil on board. 12" x 16". C. 1920s. *Collection of Harris Estate.*

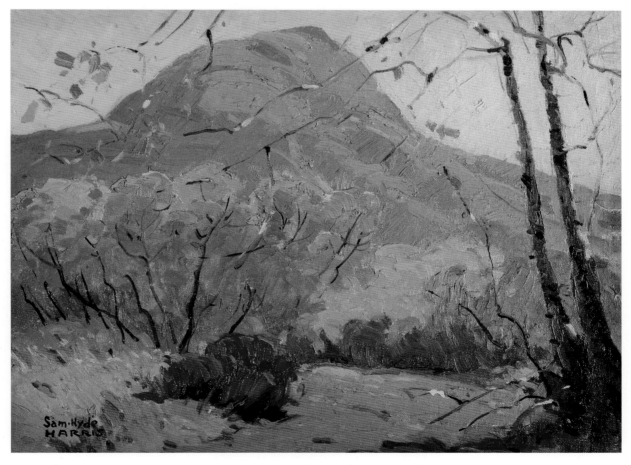

"Rites of Spring." Oil on board. 12" x 16". C. 1920s. *Collection of Charles F. Redinger.*

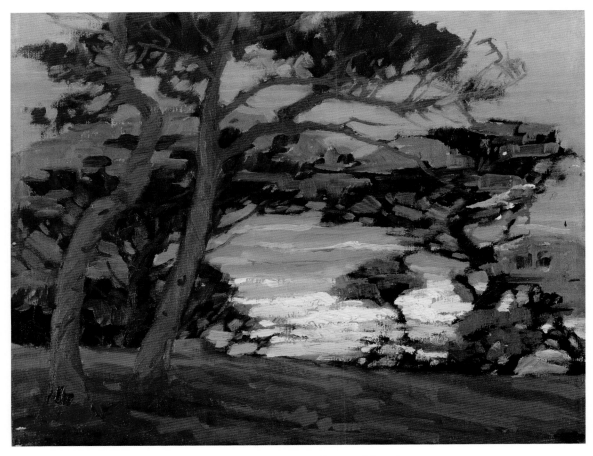

"Monterey Design." Oil on canvas on board. 16" x 20". *Collection of Gary Lang.*

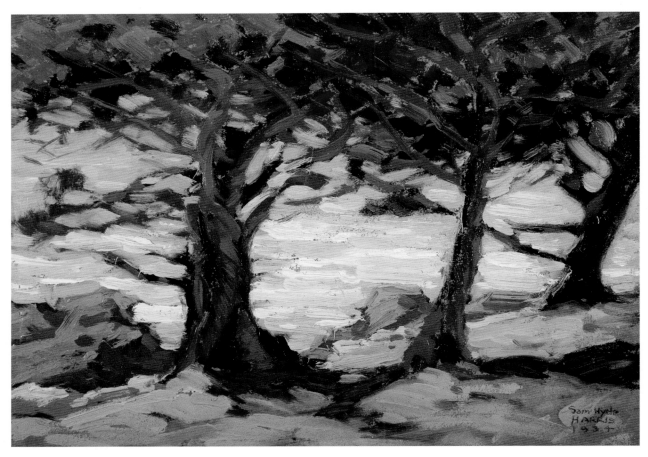

"Carmel Cypress." Oil on artist board. 10" x 14". Dated 1934. *Collection of Gary Lang.*

44

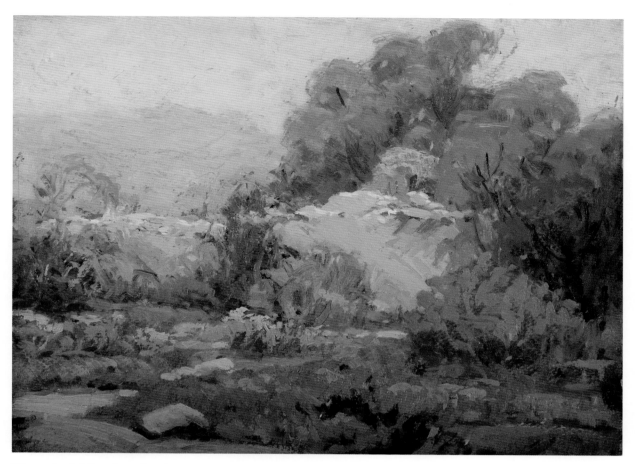

"Yesterday." Oil on board. 12" x 16". C. 1922. *Collection of Gary Lang.*

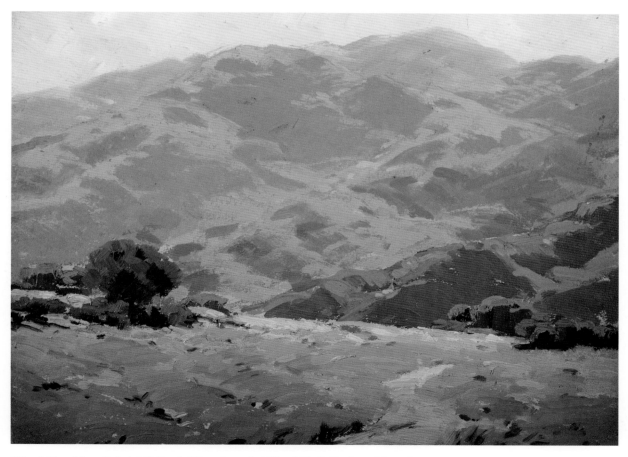

"Foothills of San Gabriel Valley." Oil on board. 12" x 16". *Collection of Gary Lang.*

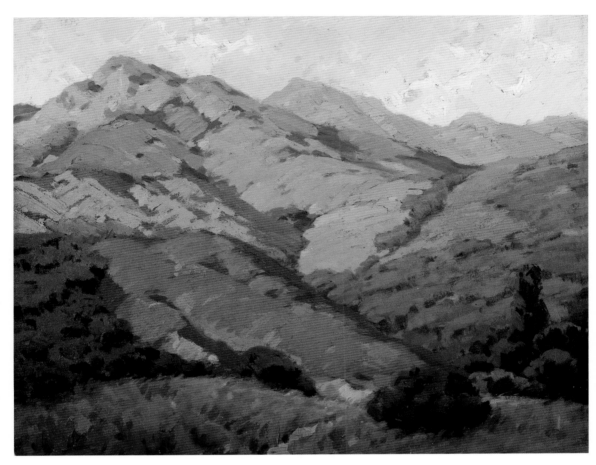

"Colorful Mountain Range." Oil on board. 16" x 20". C. 1922. *Collection of Gary Lang.*

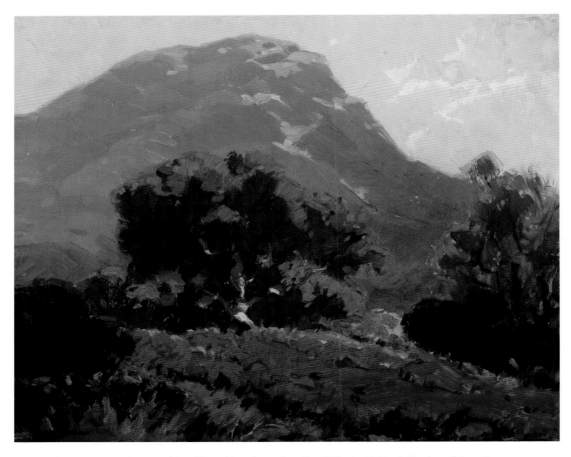

Untitled. Tree in landscape with hills. Oil on board. 16" x 20". C. 1922. *Collection of Gary Lang.*

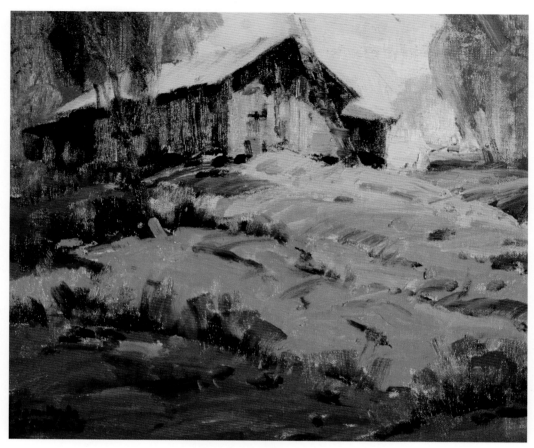

"Shack on Hill." Oil on canvas on board. 10" x 12". C. 1920s.
Collection of Elizabeth and Howard Randol.

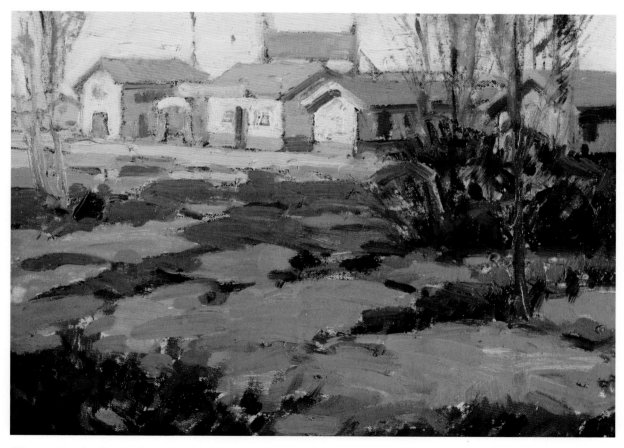

"Sunset Beach - Depression Days." Oil on board. 10" x 14". C. 1925. *Collection of Linda and Kirk Edgar.*

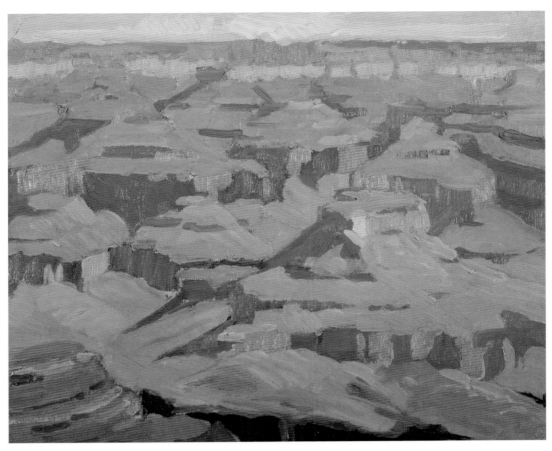

"Grand Canyon Impression." Oil on board. 10" x 12". C. 1920. *Collection of Gary Lang.*

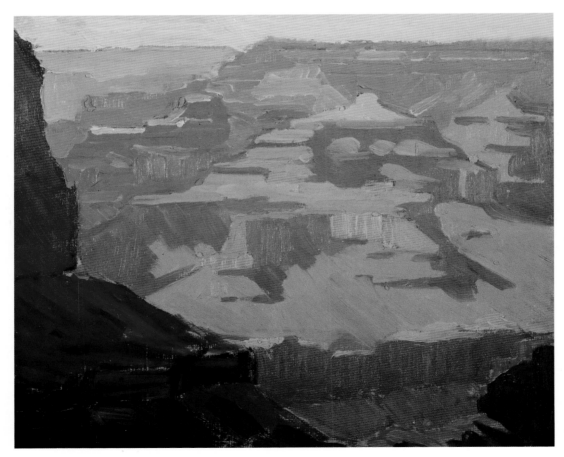

"Grand Canyon Vista." Oil on board. 10" x 12". C. 1920s. *Collection of Gary Lang.*

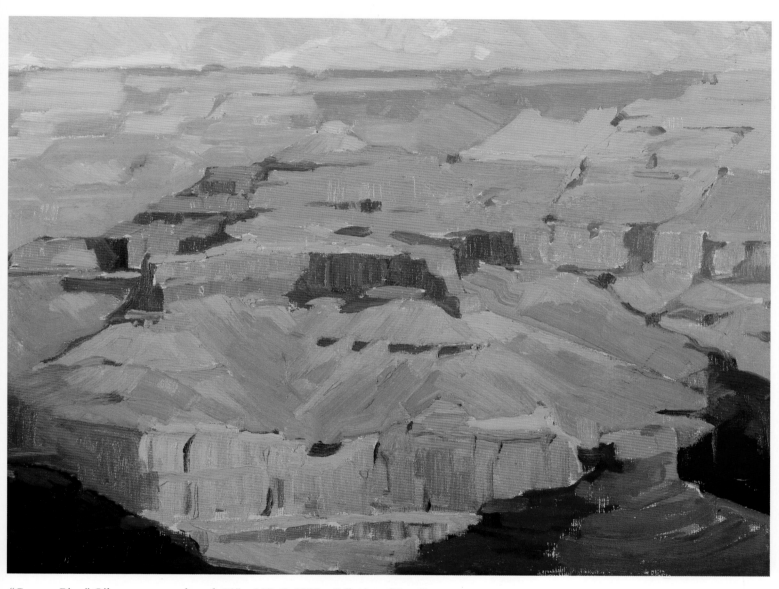

"Canyon Rim." Oil on canvas on board. 12" x 16". C. 1920s. *Collection of Gary Lang.*

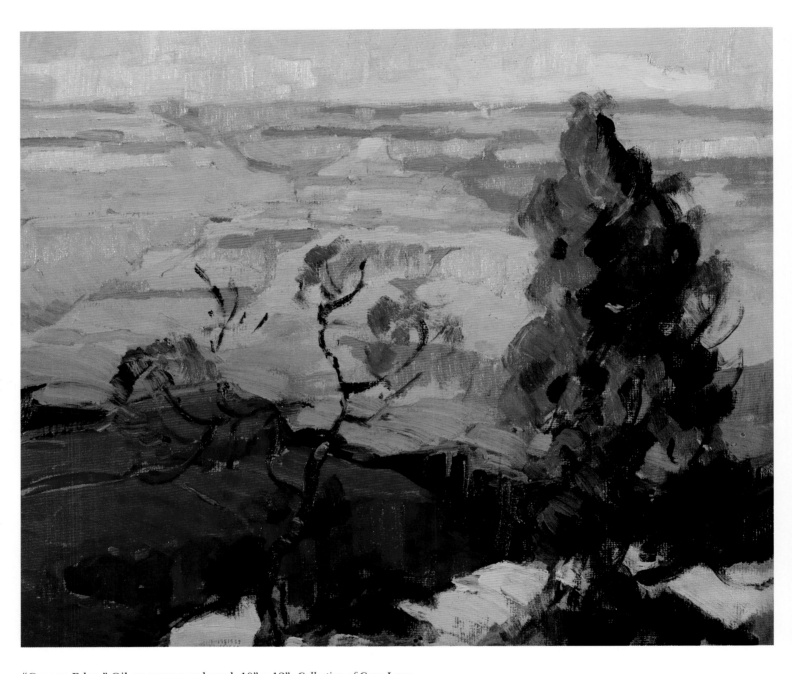

"Canyon Edge." Oil on canvas on board. 10" x 12". *Collection of Gary Lang.*

Section III: Commercial Works, circa 1905 - 1950

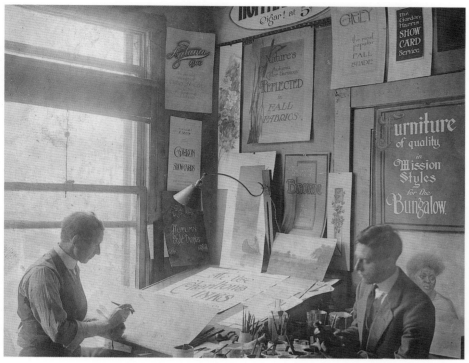

Sam's early advertising studio filled with examples of his lettering skill. Sam is on the lower right. *Collection of Harris Family*

Early advertising business card.
Collection of Harris Family.

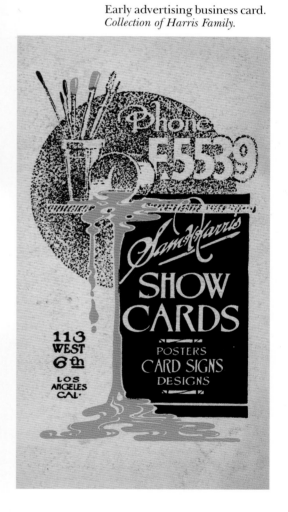

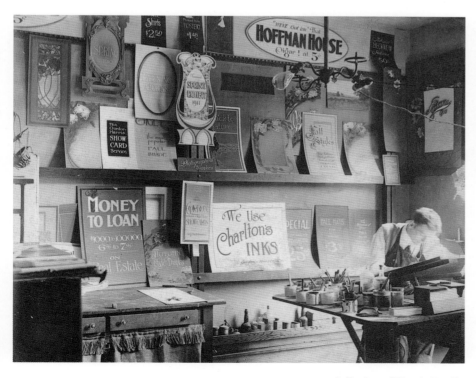

Collection of Harris Family

Drawing for a tablecloth design with Mexican figures. Colored pencil
drawing on paper. C. 1930. *Private collection.*

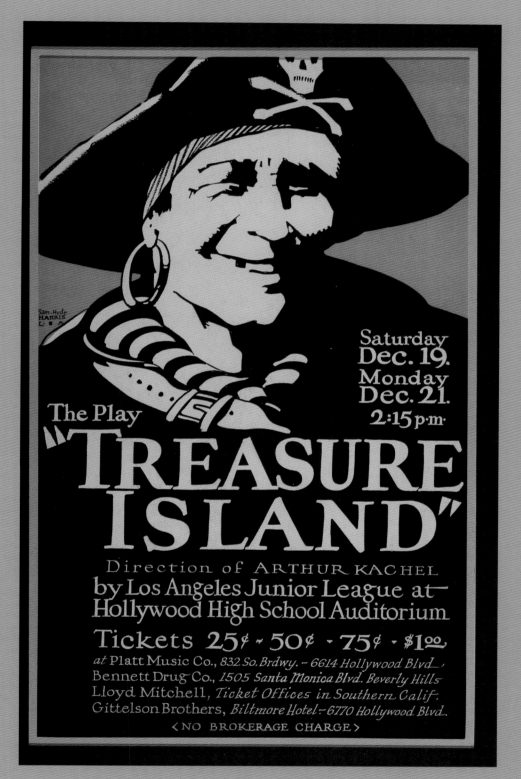

"Treasure Island." Poster printed on poster
board. 20" x 12.5". *Private collection.*

Sam Hyde Harris advertising poster. Multi-media: tempera, photo, ink on board. *Collection of Charles F. Redinger.*

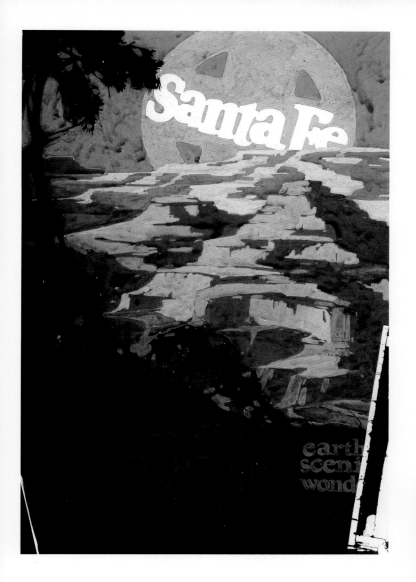

Detail. "Grand Canyon." Tempera on board,

Detail. Sam's lettering.

Sam Hyde Harris was generally engaged in some aspect of the commercial art field from 1905 thru the 1950s. In his commercial art, there is a creative side of Sam which is not so apparent in the easel paintings. Here the challenge is an assignment to create an image, which conveys an idea, memorable is possible, like the Van De Kamp windmill. The idea is translated from a quick sketch to a number of more complex drawings, then, the miniature full color model, called a marquette. It is from the marquette's that the client chooses and suggests changes to be completed in the full scale, tempera, poster. The final step is the silkscreen poster, printed folders and magazine advertisements.

"Posters." Sam Hyde Harris advertising display. *Private collection.*

56

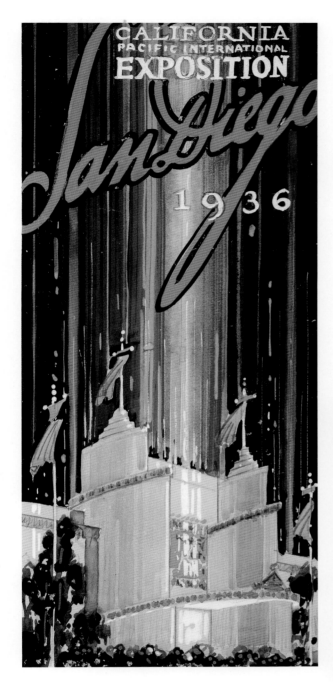

Detail. "California Pacific International Exposition" 1936 San Diego, Marquette. Tempera on board. 9" x 4". *Private collection.*

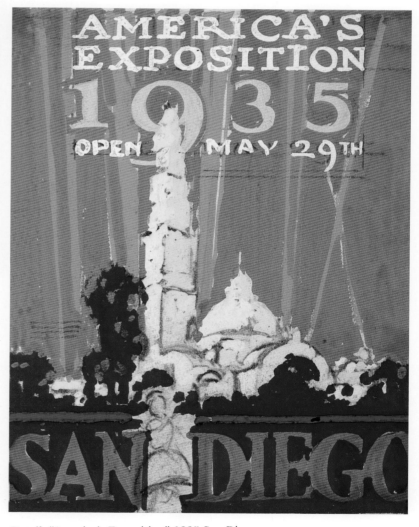

Detail. "America's Exposition" 1935 San Diego, opened May 29th, Marquette. Tempera on board. 4" x 3". *Private collection.*

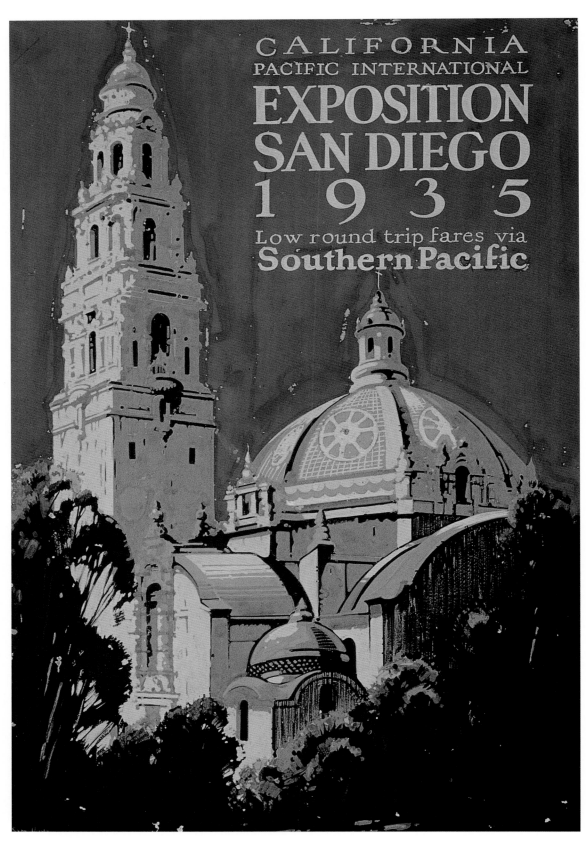

San Diego, California Exposition 1935. Tempera on board. Full
poster, 22" x 15". *Collection of Judith Leavelle-King.*

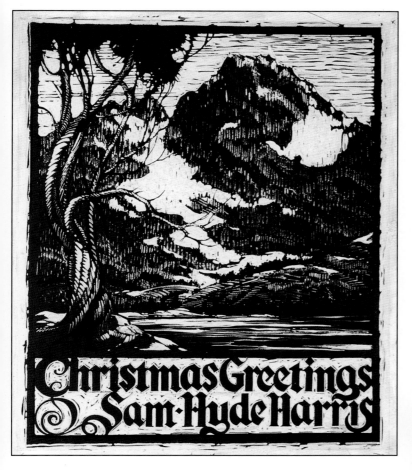

"Christmas Greeting," marquette. Black and white tempera on paper. 15.5" x 12.75". *Collection of Judith Leavelle-King*.

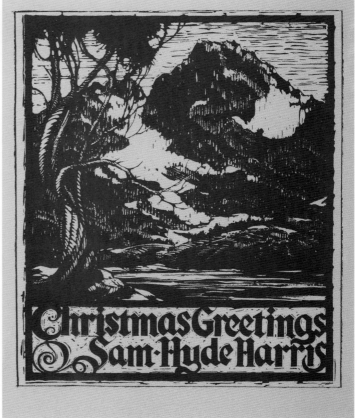

"Christmas Greeting." Printed version. *Collection of Judith Leavelle-King*.

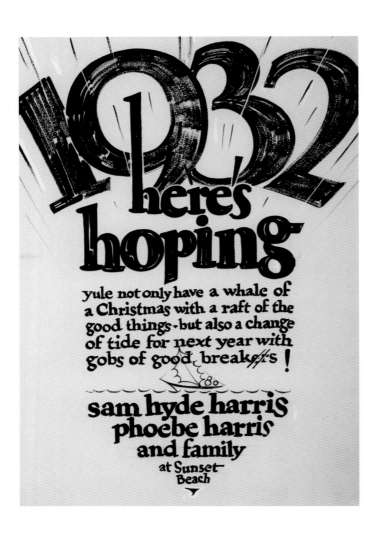

1932 invitation, Sam and Phoebe. Tempera on board. 12.5" x 6". *Collection of Charles N. Mauch.*

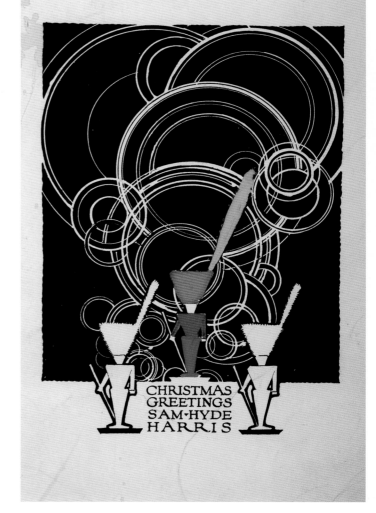

"Christmas." Mixed medium. *Collection of Charles N. Mauch.*

"Christmas" (trees and moon). Woodblock with tempera. *Collection of Charles N. Mauch.*

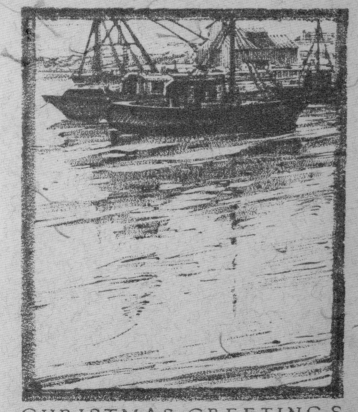

"Christmas" (boats), Phoebe and Sam, print. C. 1930s. *Collection of Charles N. Mauch.*

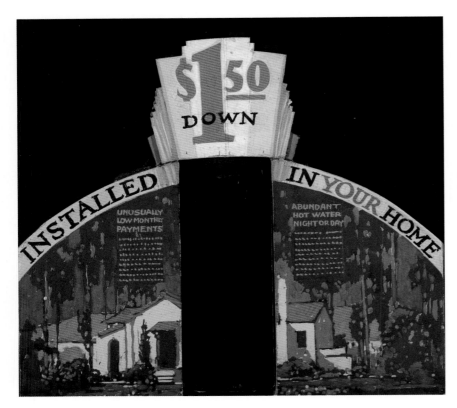

"$1.50 down Installed", marquette. Tempera on board. 9" x 10". C. late 1920s. *Private collection.*

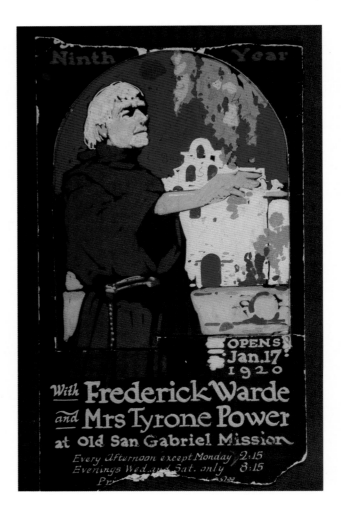

"Old San Gabriel Mission." Tempera on board. 10" x 5.5". Dated 1920. *Collection of Charles N. Mauch.*

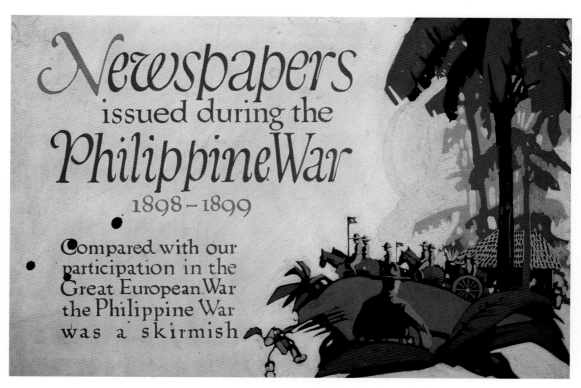

"Newspapers issued during the Philippine War," marquette. Tempera on board. 11" x 13.5". *Collection of Charles N. Mauch.*

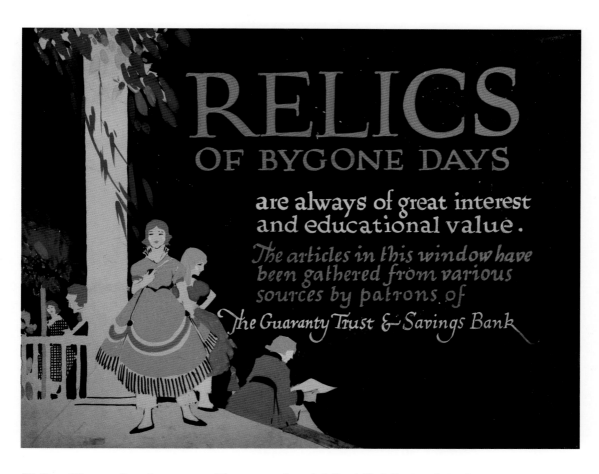

"Relics of Bygone Days," marquette. Tempera on board. 14" x 11". *Collection of Harris Estate.*

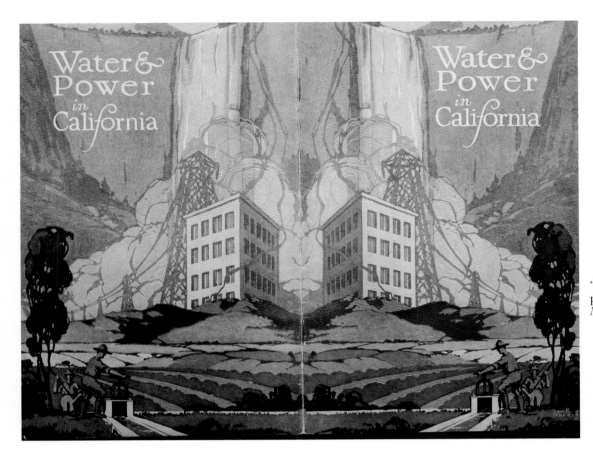

"Water and Power." Printed pamphlet. *Collection of Charles N. Mauch.*

"Death Valley." Printed pamphlet. *Collection of Charles N. Mauch.*

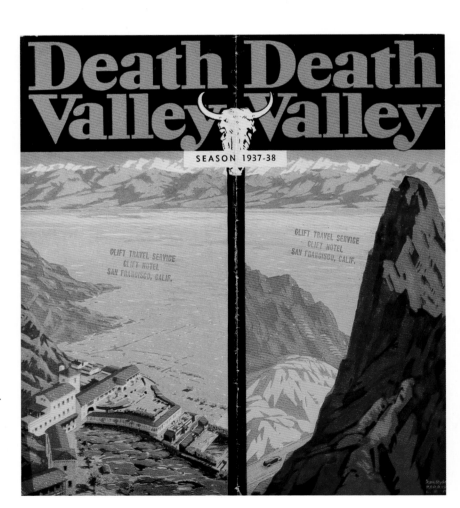

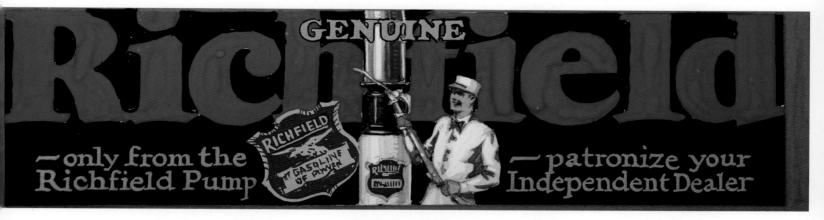

"Richfield," marquette. Tempera on artist board. 3" x 10". *Private collection.*

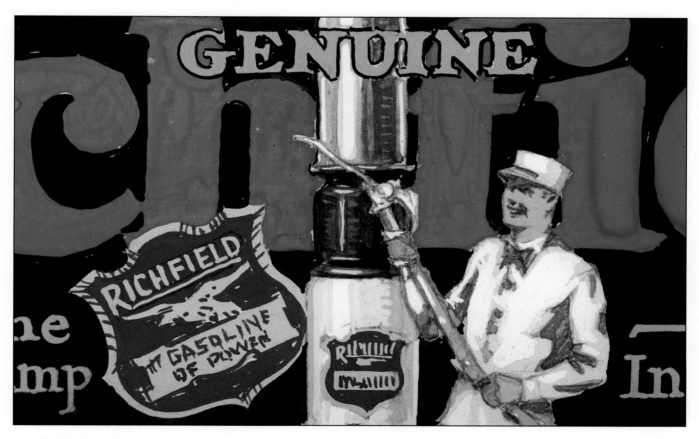

Detail of "Richfield"

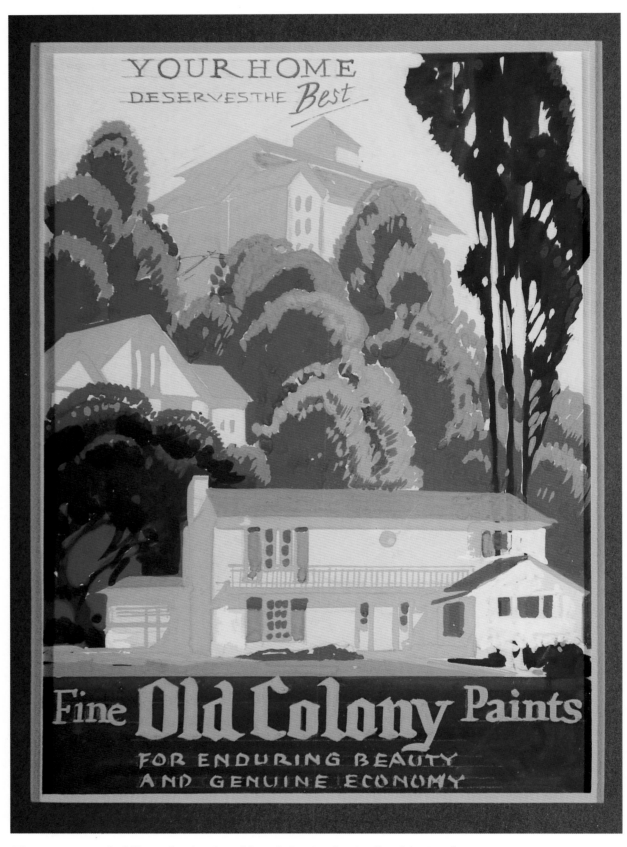

The structure on the hill was the view from his early San Marino Studio of the Pasadena Huntington Hotel (Sheraton).

"Old Colony Paints" with the Huntington (Sheraton) in the background, marquette. Tempera on board. 9" x 6". *Collection of Charles N. Mauch.*

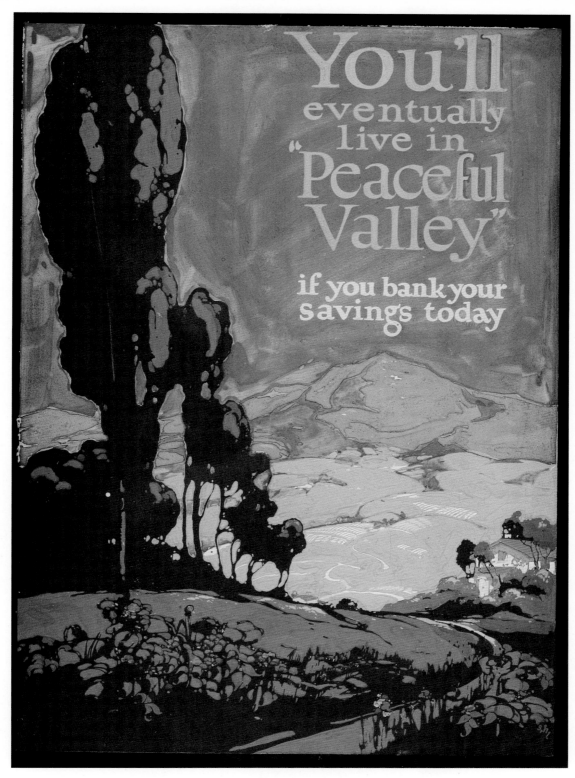

"Peaceful Valley." Poster, full size. Tempera on artist board, 24" x 17.5". C. 1920s.
Collection of Charles N. Mauch.

Unusual signature example, with small "s" and small "h", lower right.

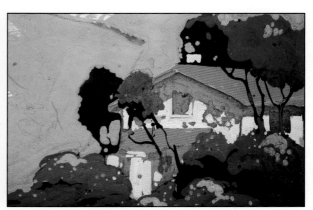

Detail of houses.

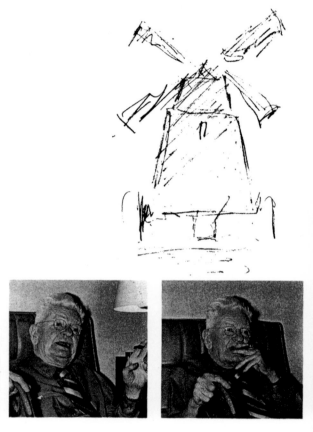

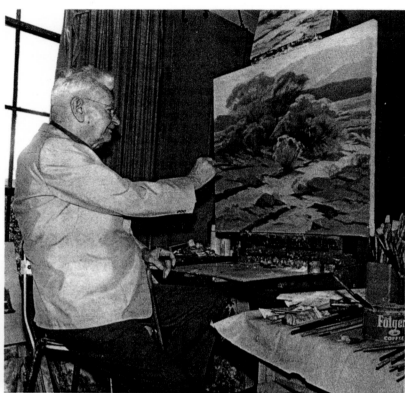

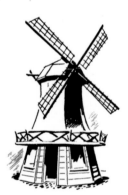

Sam Hyde Harris, 85, at work in his Alhambra studio. Windmill pencil sketch, above left, is rendering of the very first Windmill used in conjunction with the Van de Kamp name.

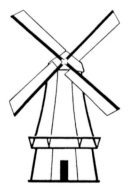

The trademark, 1921 Windmill late 30's Modern 'mill mid-40's Present trademark:

"Van de Kamp's." Reprint. Copy of newspaper articles and reprints of Van de Kamp's "Windmill" Industrial Relations Department Vol. 49, No. 4, May 1974. *Collection of Judith Leavelle-King.*

Evolution of Windmill Trademark

The evolution of the design of Van de Kamp's Windmill trademark reflects the changing pattern of distribution of Van de Kamp's bakery products as well as modernization of its manner of presentation to the public.

Van de Kamp's was six years old when the first Windmill store was opened on Western Avenue near Beverly Boulevard, halfway between downtown Los Angeles and Hollywood, and it was the design of that store which established the Company's first enduring trademark.

Five years prior to that Windmill store, however, the Windmill symbol was introduced to the fledgling Van de Kamp enterprise.

Potato Chips, then known as Saratoga Chips, was Van de Kamp's first product but in the following year, when a potato shortage threatened, a macaroon cookie made its debut. This was followed by salty pretzels and it was than that a commercial artist, Sam Hyde Harris, rendered a window showcard of a Dutch boy saying —

"Ya, I luf dos pretzels!"

In the background of the sign, artist Harris introduced a Windmill, the *first* Van de Kamp Windmill. It was then incorporated into the Company trade name design for use in store signing, stationery, packaging, truck identification and general advertising.

Reprint from the "Windmill."

Sam Hyde Harris Added It to the Company Name — a Windmill

Sam Hyde Harris, 85, introduced Van de Kamp's to the Windmill. Harris, however, needs no introduction to lovers of oil paintings of the Southern California landscape.

The Alhambran is, perhaps, one of the last two of a celebrated group of Southland landscape artists who flourished in the "teens, 20's, 30's and 40's" and whose works may be seen in museums and private art collections.

Harris entered the field of advertising art about the age of 21 and became one of the top men in the business. His downtown Los Angeles shop was near Van de Kamp's first store and Co-founder Lawrence Frank went to him for the Company's early commercial signs.

Harris designed the graceful and sweeping lettering of the first Van de Kamp "logo," which can still be seen high above the entrance of the Fletcher Drive baking kitchens.

When he "lettered" the first Van de Kamp truck he used oils and the copy had the texture of a Rembrandt.

Over 6-feet erect, hale, hearty and cigar chewing, Harris created posters for the railroads: Union Pacific, Santa Fe, Southern Pacific and Pacific Electric, handling SP work as late as the 50's. His posters are collector's items today.

A teacher and critic, Harris is numbered among the Southern California landscape giants William Wendt, Hanson Puthuff, Jack Wilkinson Smith (whose studio on Champion Place, Alhambra, he now owns), Victor Forsythe, Edgar Payne and Orrin White.

He has won well over 100 awards, including several as recently as last year. His desert paintings are legend. Sometimes he will be found painting scenes with Jimmy Swinnerton, 98, the celebrated desert artist.

On a wall of his very comfortable antique living room hangs a Norman Rockwell original "Professor Bumpski". "Rockwell," says Harris "has given more pleasure to more people through his art than any artist that ever lived." Rockwell's studio was right next to Harris'.

Harris may be right about Rockwell's work but if Harris' paintings of the Verdugo Woodlands and Arcadia, in the vicinity of Santa Anita, had had the circulation of the old Saturday Evening Post, his paintings, too, probably would have brought equal pleasure to as many.

We are grateful, *Sam Hyde Harris.*

Los Angeles Times, January 21, 1955.

Collection of Harris Family

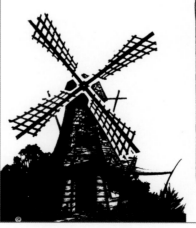

Van de Kamp's Celebrate 40th Anniversary in L. A.

Over 200 civic and business leaders joined "first timers" in celebrating Van de Kamp's 40th anniversary at an open house held at the baking kitchens, 2930 Fletcher Drive, hosted by co-founders Lawrence L. Frank, president and Theodore J. Van de Kamp, executive vice president.

Among the first timers present was the company's first landlord, Remington Olmstead, who rented the little eight foot store at 236½ South Spring street to the brothers-in-law for the first store, opened just forty years ago; Sam Hyde Harris, the first artist, and the craftsman who re-designed the signature style of the company name; C. H. Fricke, who sold the first wrapping paper used in the first Van de Kamp Saratoga Potato Chip store; and many of the first suppliers of flour, equipment and machinery were present to reminisce and tour the plant.

Honored guests were greeted by Frank Van de Kamp, and Edward Mills, vice president and general manager.

Chain store and independent market operators from four Southland counties joined the anniversary celebration.

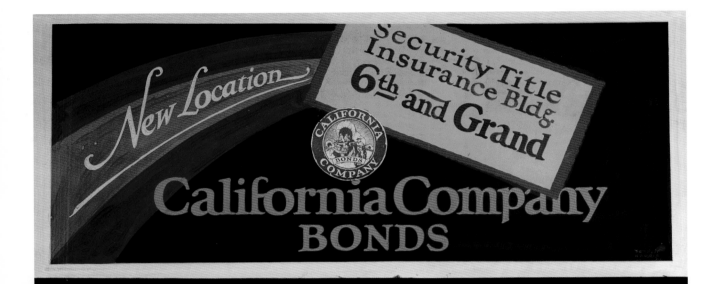

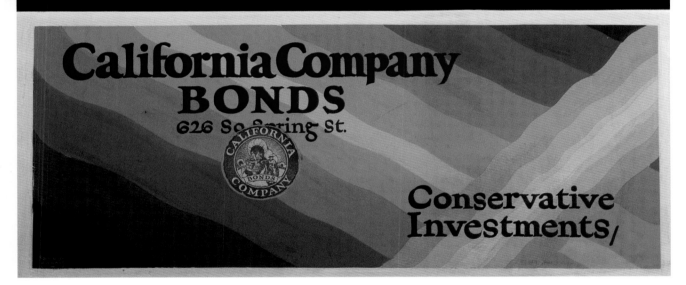

"California Company Bonds," A and B. Tempera on artist board. *Collection of Harris Estate.*

Detail of exhibition tag "California Company Bonds."

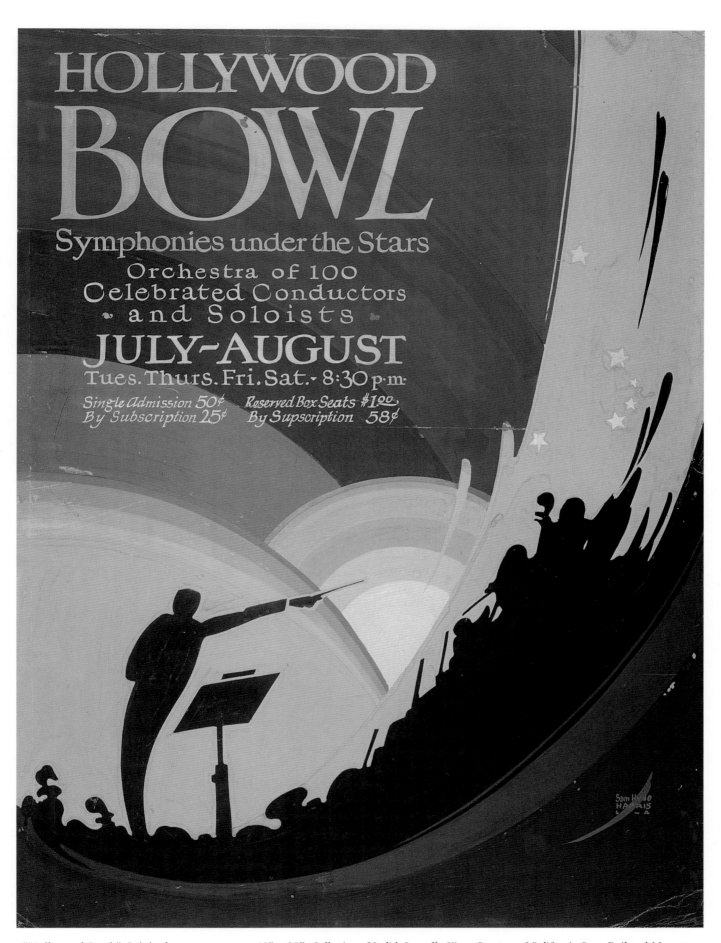

"Hollywood Bowl." Original tempera poster. 40" x 30". *Collection of Judith Leavelle-King. Courtesy of California State Railroad Museum.*

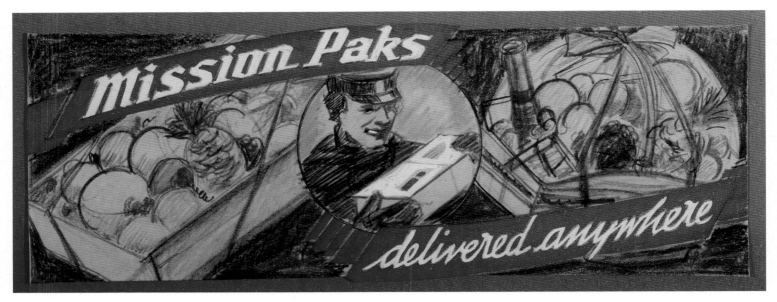

"Mission Paks," marquette. 4" x 12". Mixed medium: crayon, tempera and pencil on artist board. *Collection of Charles N. Mauch.*

"Sparkeeta Rootbeer," marquette. Colored pencil on board. 4" x 8". *Collection of Charles N. Mauch.*

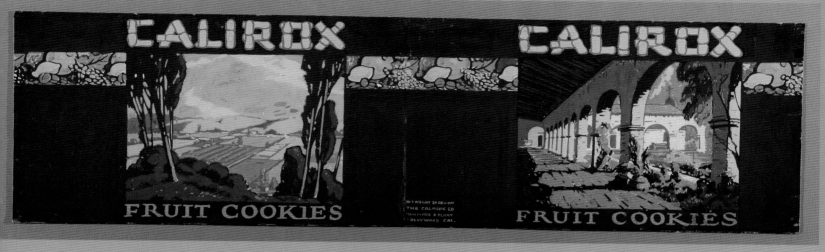

"Calirox," marquette. 6" x 24". Tempera on board. *Collection of Maurine St. Gaudens.*

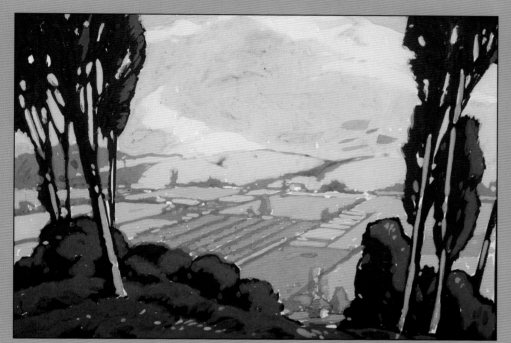

Detail of "Calirox."

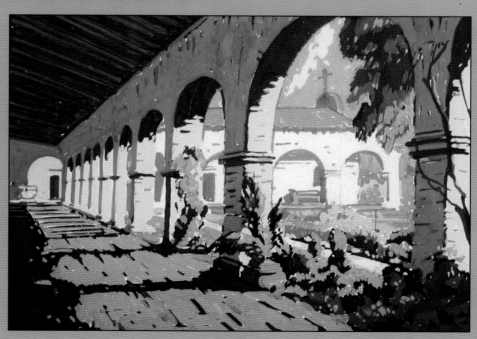

Detail of "Calirox."

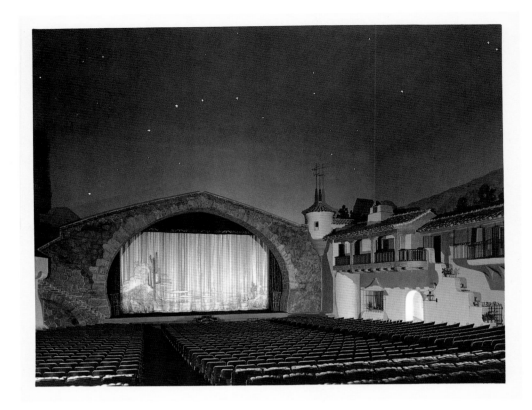

Photograph of the stage of the Ramona Theater, Hemet, California.
Private collection.

"Ramona." Printed poster. 18" x 12".
Collection of Charles N. Mauch.

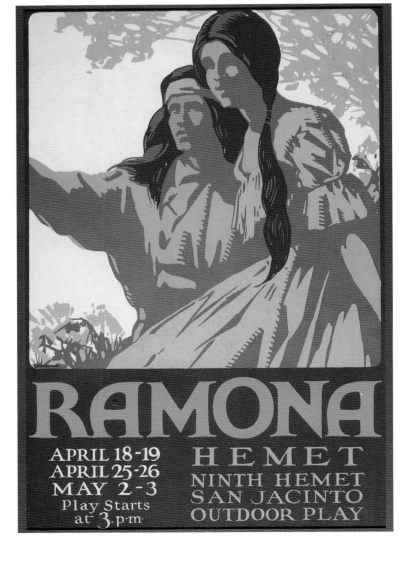

The Tournament of Roses

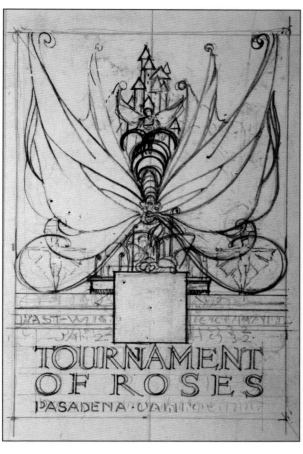

1932 sketch of Tournament of Roses float design.
Pencil on poster board. 7" x 5". *Private collection.*

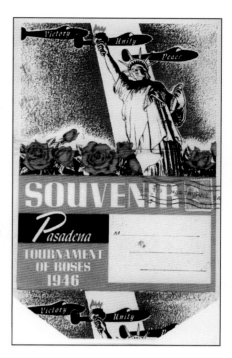

"Souvenir, Pasadena Tournament of Roses 1949." Theme: "Victory, Unity, Peace." Printed material. *Private collector.*

Newspaper clipping. Source unknown, c. 1946. *Collection of Harris Family.*

DOVE OF PEACE PICKED AS BEST FLOAT DESIGN

A white dove leading the world today was selected by the chamber of commerce float committee as Alhambra's entry in the Pasadena Tournament of Roses. The prize-winning design, submitted by Sam Hyde Harris, president of the San Gabriel Artists Guild, and his brother, Donald Hyde Harris, was modified in certain details by the committee because of construction difficulties.

The winning entry was one of more than 45 designs and float models submitted to the committee following the theme, "United in Peace." Some 30 models and 10 design drawings were entered by Alhambra and Mark Keppel High Schools.

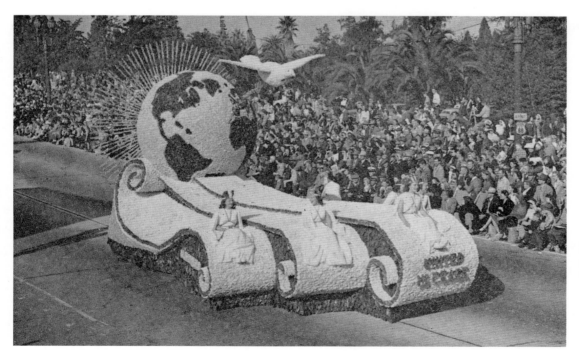

Photo of prize-winning float designed by Sam Hyde Harris. *Collection of Harris Family.*

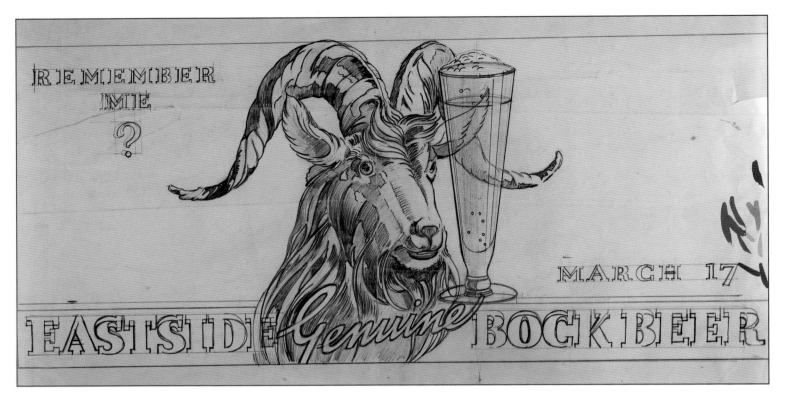

"Eastside Beer." Pencil drawing for poster. 11" x 24". *Collection of Charles F. Redinger.*

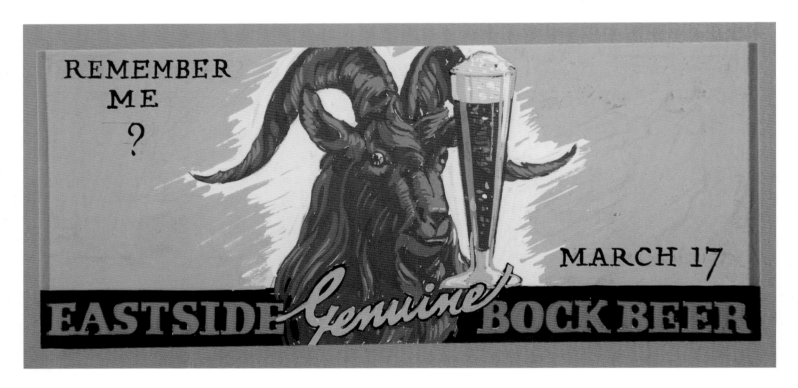

"Eastside Beer," marquette. Tempera on board. 3.5" x 8". *Collection of Charles N. Mauch.*

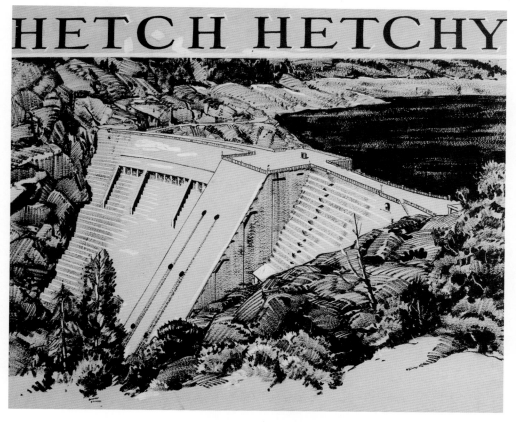

"HETCH HETCHY," marquette. Mixed medium: tempera
and ink. 16" x 18". *Collection of Charles F. Redinger.*

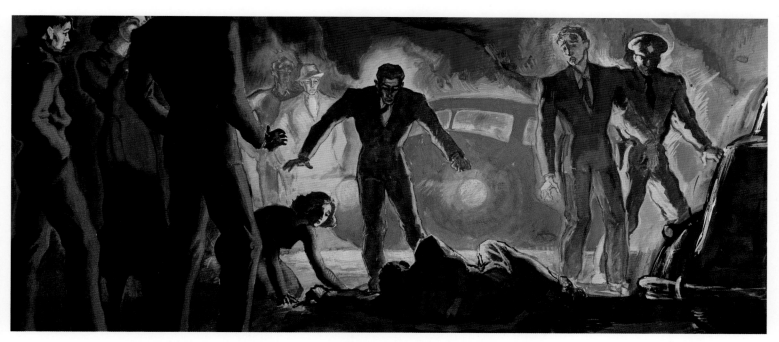

"Accident Scene." Mixed medium: watercolor and tempera. 12" x 27". *Collection of Harris Estate.*

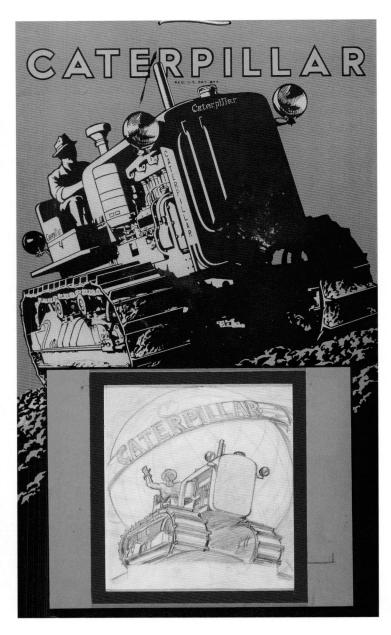

"Caterpillar." Printed calendar, presented with original pencil sketch. Calendar board. 25" x 14.5". *Collection of Charles N. Mauch.*

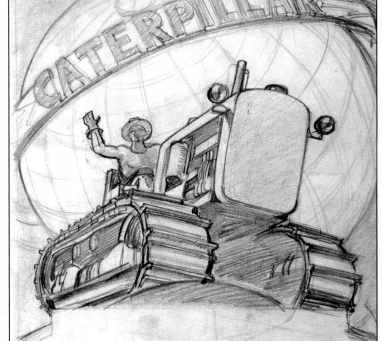

Detail of pencil sketch on paper for "Caterpillar." 8" x 11.

Railroad Posters

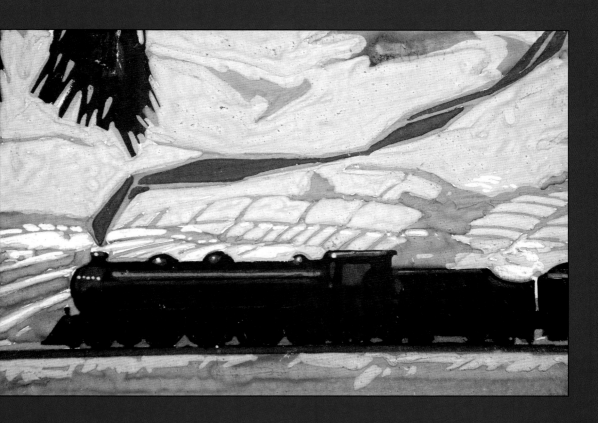

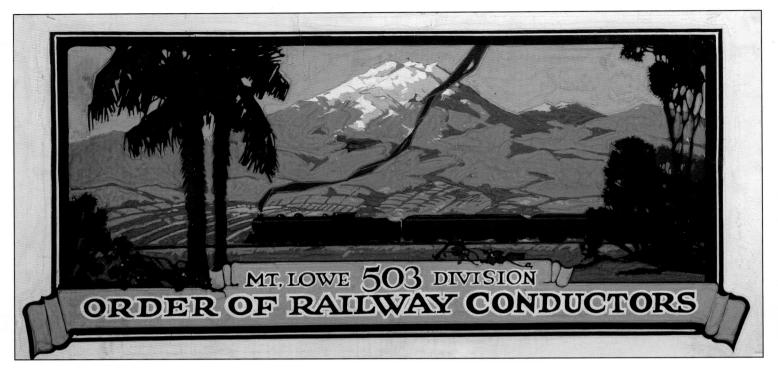

"Mt. Lowe 503 Order of Railroad Conductors," marquette. Tempera on black poster board, deep blacks are raw black poster board. 8" x 17". *Collection of Charles N. Mauch.*

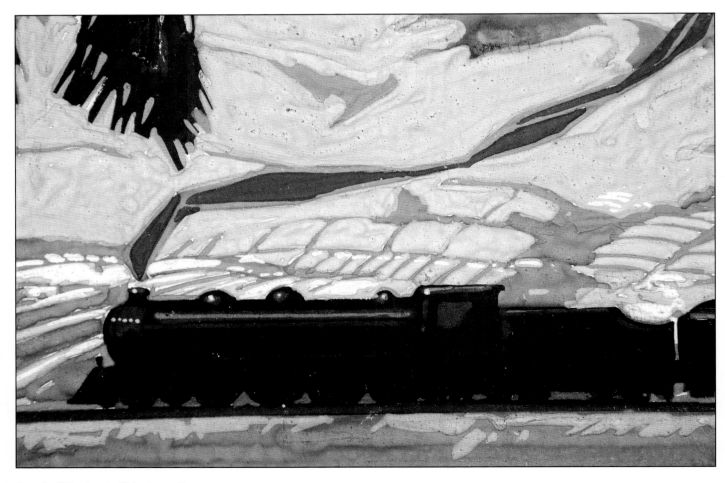

Detail of Engine in "Mt. Lowe."

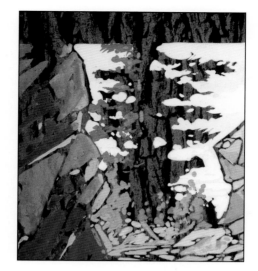

Sam's interpretation of Mt. Lowe's "Granite Gate." Here Sam applies color, in a mosaic fashion, to a piece of wallpaper with a tree bark design. The tree bark pattern is used to form the dark areas as seen in the details.

Detail of the bark designed wallpaper used as dark areas.

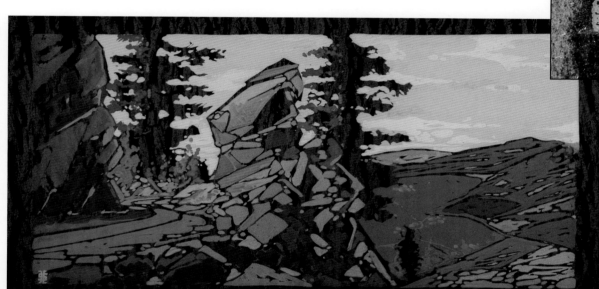

Detail of the wallpaper tempera, showing an unusual signature example.

Tempera on wood bark design wallpaper, which is used as negative space and to create the tree trunk. 6" x 15". *Private collection.*

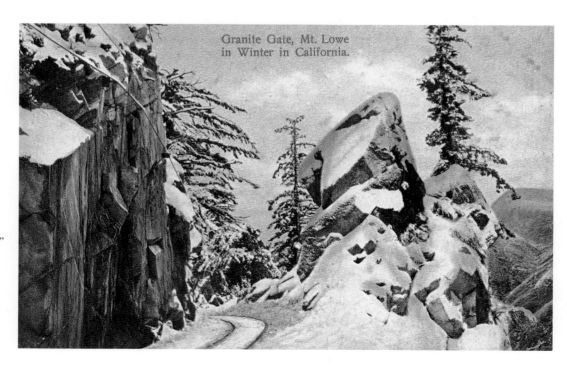

Granite Gate, Mt. Lowe in Winter in California.

Postcard of "Granite Gate." *Private collection.*

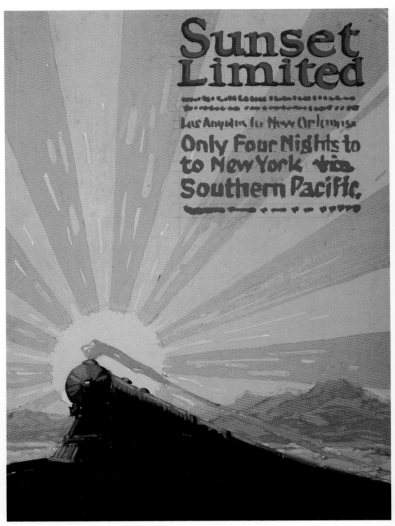

"Sunset Limited" (sun burst), marquette. Tempera on artist board. 8" x 6". *Collection of Charles N. Mauch.*

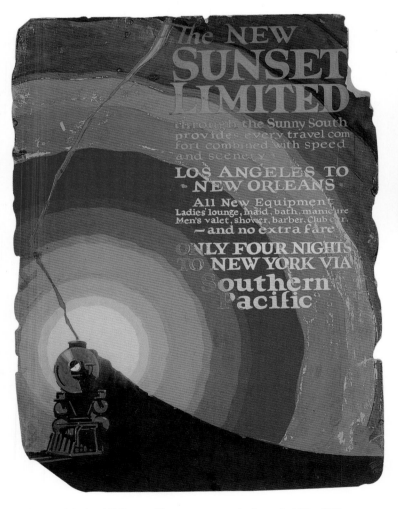

"Sunset Limited." Poster. Tempera on artist board. 40" x 30". *Collection of Judith Leavelle-King. Courtesy of California State Railroad Museum.*

"Travel Posters"
Sam Hyde Harris

A six-minute talk given by Sam Hyde Harris
over Radio Station KMTR under the auspices
of the Pacific Railway Advertising Co.,
and the Tripolay Club.

On Spring Street one forenoon, a Poster Artist, a member of the Tripolay Club, met an old friend, an architect, whom he had not seen for several years. After the usual greetings were exchanged, the architect said:

"Well, I finally married, and my wife and I are making a trip to New York, we are going by rail and steamer, and I think you'll be interested to know just how that happened. I was glancing through an Art Magazine and came across a reproduction of an old poster of yours advertising: "ONE HUNDRED GOLDEN HOURS AT SEA" – New Orleans to New York. You remember that poster? It naturally made quite an impression upon my wife and I, and we decided, after some discussion, to take the trip. I've already purchased the tickets and we're leaving this week."

Just one of those very rare incidents, of course, but an interesting example of a Poster – years after its original purpose had been served, still bringing returns to the advertiser.

From an historical standpoint the poster is probably the oldest form of advertising. The pictorial symbol was used for hundreds of years, and understood, by those unable to read.

In use today, as a complete unit itself, or as an integral part of a campaign, embracing other advertising media, the chief qualification of the Poster, is to speak quickly, deliver its idea, its message, in a brilliant, forceful fashion; establish itself in an indelible manner in the mind of the observer.

For this reason, a single idea, conceived in a bold, simple fashion; few masses, well designed, well placed, color in harmony or contrast with subjects, coupled with a minimum of copy, is essential. So designed that in this day and age of speed, literally speaking, "Even he who runs may read and understand."

Probably in no other field has the Poster played such an important part as in the field of travel – transportation.

Particularly well known are the European Railway Poster. Half sheets and one sheets, displayed on the runways of the various stations, suggesting the allure of the countryside and seaside resorts, its cathedrals, points of historical interest, and so forth.

Best exemplified perhaps, is the London Underground, which has capitalized valuable space previously wasted, by employing artists of ability and reputation, such men as Frank Brangwyn, Arnesby Brown, and Maurice Grieffenhagen, to design posters for display thereon. These men were given free reign, without any restriction, to express themselves in their own medium and fashion, which has produced over the years, a variety of posters of exceptional art quality and exceedingly high advertising value and has greatly augmented travel in rural England. Many of these Posters are eagerly sought after, and art lovers, both, have made collections of them here and abroad.

Styles change in Poster Art, as in everything else. However, the fundamentals, or principles, of a good poster remain the same: Good composition or design, good color, right lettering, well placed – good taste.

Modern Posters have been successfully used by steamship lines, with an extreme simplicity of line and color, in a flash suggest – size – speed – and smartness.

In recent years, here in the west, a group of poster men developed a distinct style of travel poster – well designed, sparkling in color, with lettering an integral part of the design – not something just added on. Chief among this group was the late Louis Treviso, whose western layout and lettering, at the time influenced the trend throughout the entire country. Grand Canyon, Apache Trail, Yosemite, High Sierras, Death Valley, the Desert, our National Parks and other subjects, treated in a manner that was new, startling, different – suggesting the color, romance, bigness of space –typical of the West, in a few words – selling California! Selling the West! In poster collections today are many examples of what later became well known as "Western Posters."

Trees, actual giants themselves, but tiny in comparison, giving tremendous height to a sheer mass of granite, magnificent in form, beautiful in color, its grandeur reflected in Nature's mirror, the quiet waters of the foreground – Half Dome, Yosemite.

In the distance a faint suggestion of Diamond Head, the delicate tracery of the silhouette palm against the sky dominated by the bronzed figure astride the fleeting surfboard shimmering in the sunlight, almost makes superfluous, the one word of the poster – Hawaii.

Blue, gold, orange, a suggestion of emerald green, mellowed with age, a mosaic dome surmounts a noble structure of old world beauty rich in ornamentation; red tiled roofs of the quaint, picturesque adobe nestling in the tree covered hills, in a flash suggests the color, romance and glamour of Old Mexico now being rediscovered right at our doors!

In this fashion, the Poster Artist, by elimination of detail, of the nonessential, in a broad sweep, sometimes in a subtle manner arrests our attention, fires our imagination, stimulates the wanderlust.

Let's travel – Go places – Perhaps do things!

—Collection of Harris Family

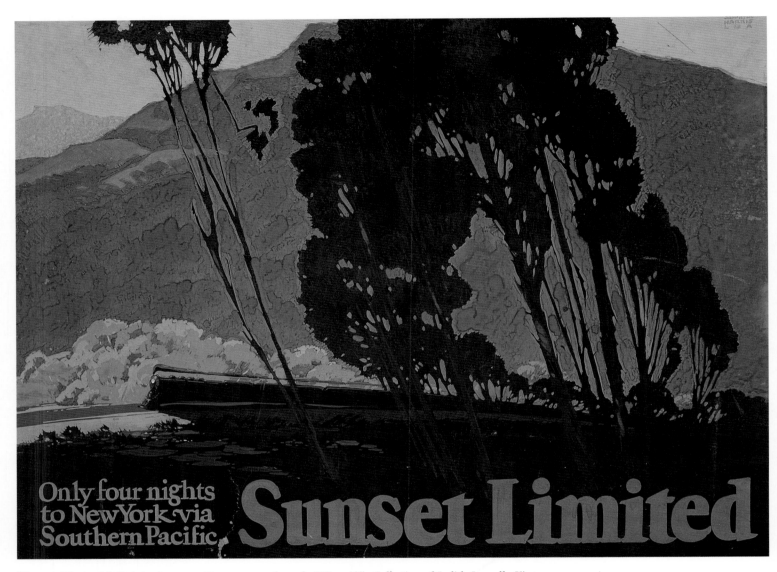

"Sunset Limited." Original poster. Tempera on board. 30" x 40". *Collection of Judith Leavelle-King.*
Courtesy of California State Railroad Museum.

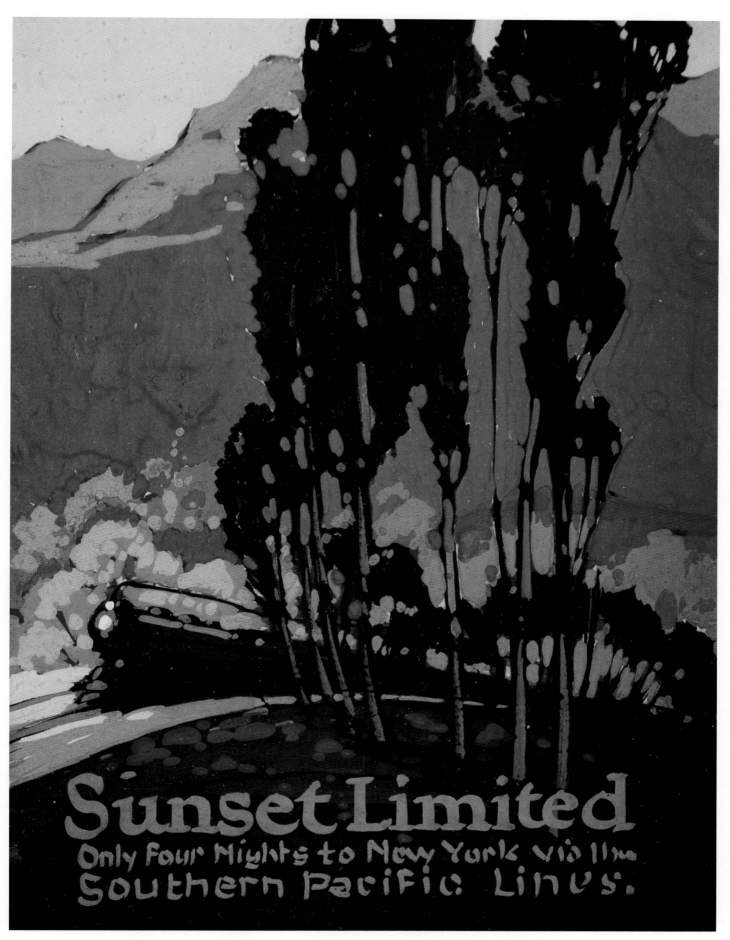

"Sunset Limited," marquette. Tempera on artist board, 8" x 6". *Collection of Charles N. Mauch.*

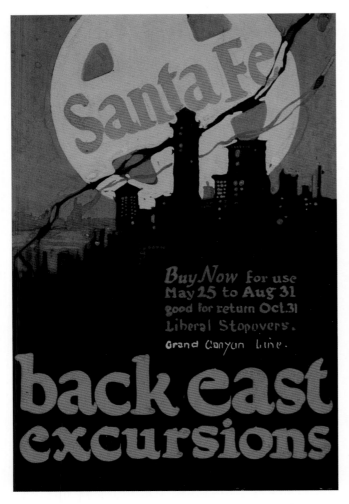

"Back East Excursions," marquette. Tempera on artist board. 11" x 7". *Collection of Maurine St. Gaudens.*

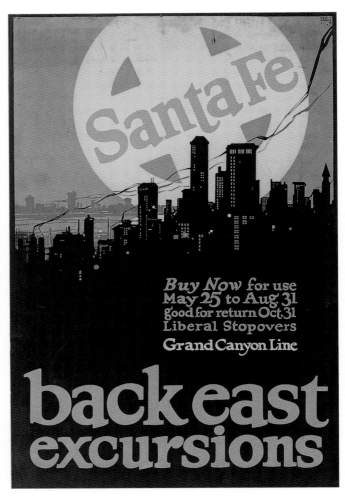

"Back East Excursions." Original poster, full size. Tempera on board. 30" x 20". *Collection of Judith Leavelle-King. Courtesy of California State Railroad Museum.*

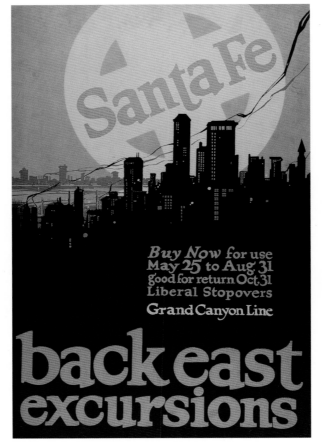

Printed poster. Silkscreen on board. 30" x 20". *Collection of Maurine St. Gaudens.*

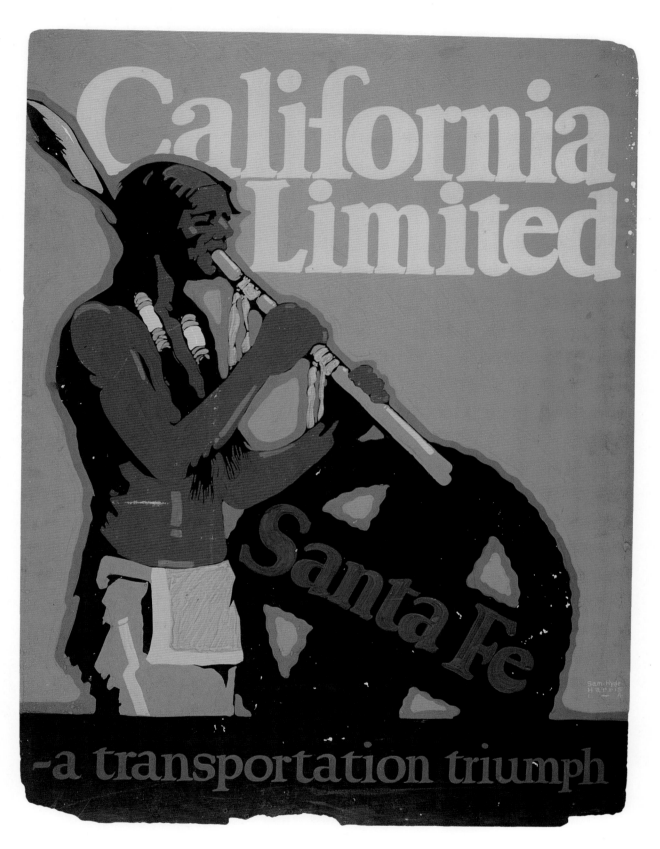

"California Limited." Poster, full size. Tempera on board, 40" x 30". *Collection of Judith Leavelle-King. Courtesy of California State Railroad Museum.*

While many commercial artists used colored artist board to work on, giving them an instant background, Sam was a master at using the colored board (mostly black) as negative space. He created images by applying color in almost stencil like form to all the light areas. By infusing the surrounding areas in color and leaving all the dark areas without any pigment the dark areas take the shape of trees and foreground details as seen in "Peaceful Valley" (*see page 67*) and "Huntington Lake" (*see page 99*), in addition to parts of figures; "California Limited" (*see page 87*), the porters in "63 Hours"(*see pages 106 & 107*) and the whole train in "Mt. Lowe Conductors" (*see page 80*), "Sunset Limited" (*see pages 84 & 85*), and "San Francisco" (*see page 100*) just to mention a few. A very interesting and accomplished technique.

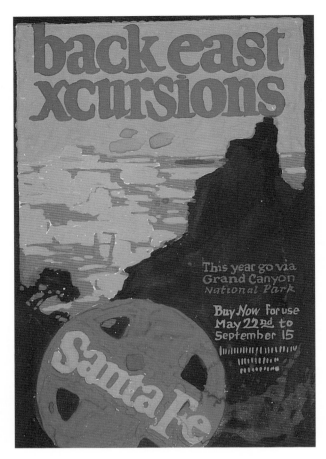

"Back East Excursions" ("Grand Canyon"). Original poster marquette. Tempera on board. 7.5" x 5". *Collection of Judith Leavelle-King. Courtesy of California State Railroad Museum.*

"Back East Excursions" ("Grand Canyon"). Small Marquette in progress for Santa FeÆ. Tempera on board. 6" x 4.5". *Collection of Charles N. Mauch.*

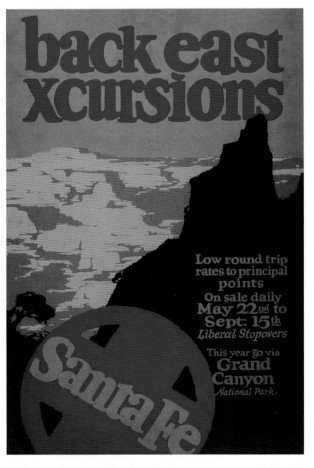

"Grand Canyon." Printed silkscreen poster. 30" x 20". *Collection of Charles N. Mauch.*

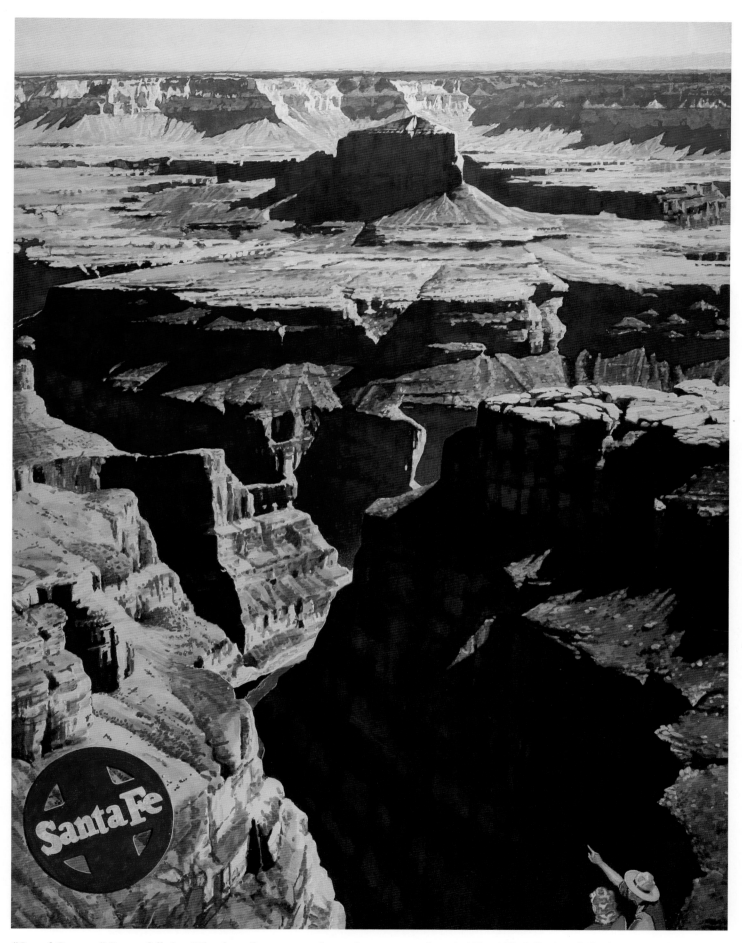

"Grand Canyon." Poster, full size. Mixed medium: watercolor and tempera on board, 40" x 30". *Collection of Charles N. Mauch.*

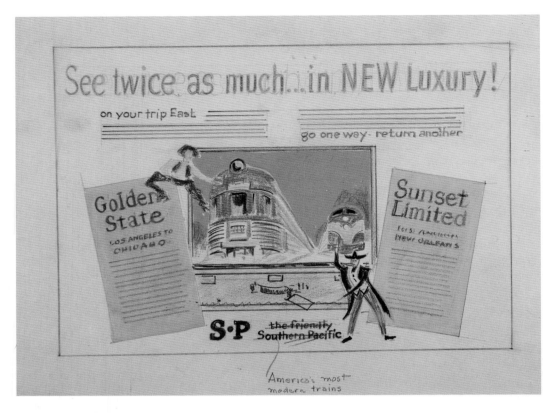

"New Luxury." Work-up sketch for an advertisement. Mixed medium on board.
7" x 10". *Collection of Charles N. Mauch.*

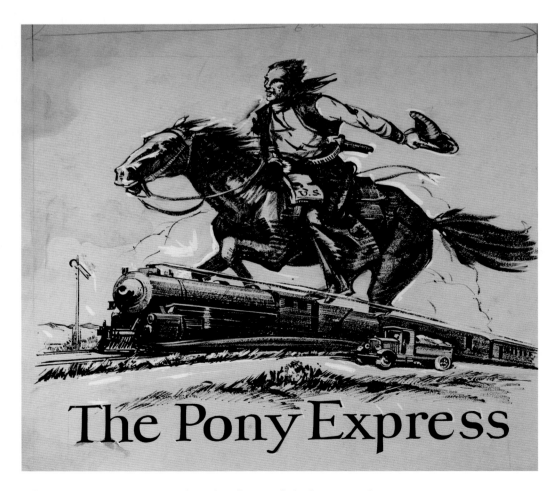

"Pony Express." Tempera on board. *Collection of Charles N. Mauch.*

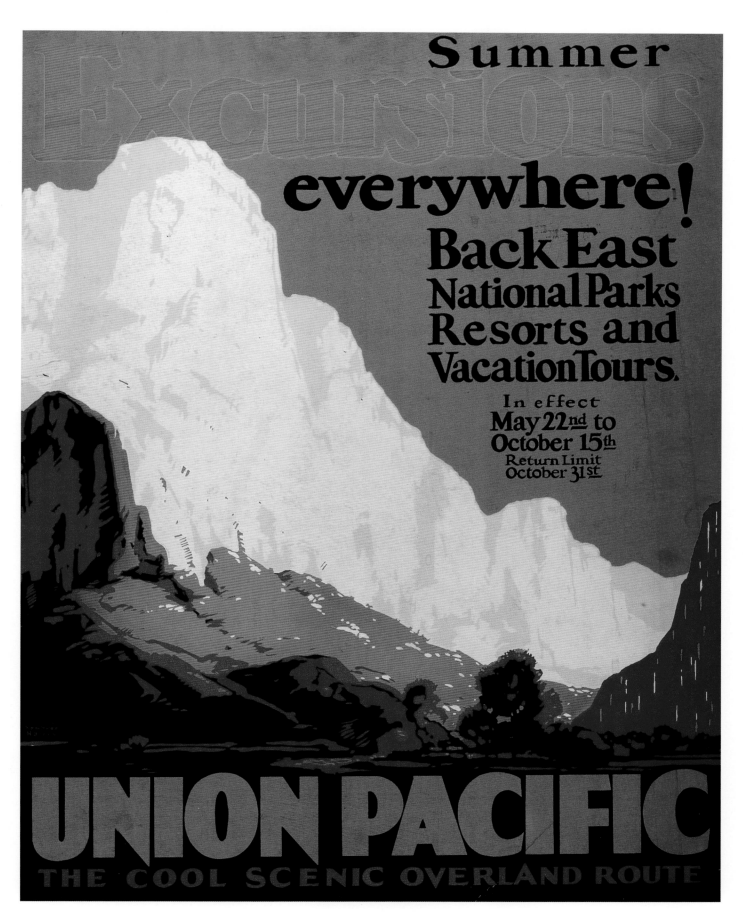

"Excursions, Union Pacific." Silkscreen poster. 28" x 22". *Collection of Charles N. Mauch.*

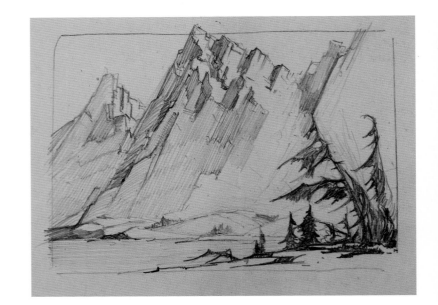

Small pencil sketch for the "High Sierra" poster. *Private collection.*

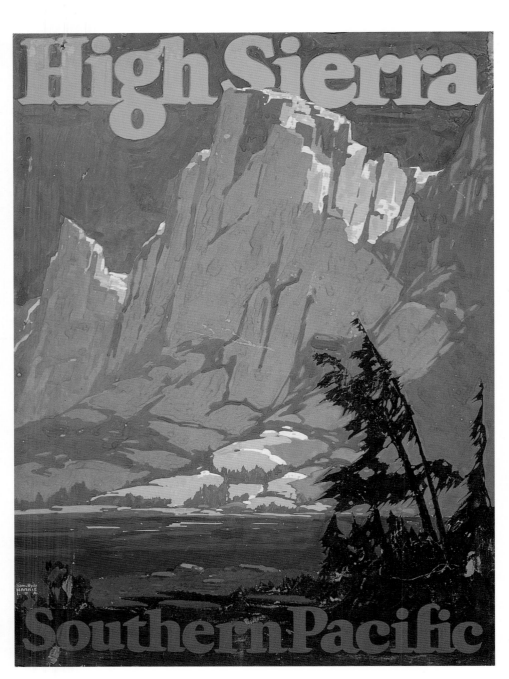

"High Sierra, Southern Pacific." Poster, full size. Tempera on board. *Collection of Judith Leavelle-King. Courtesy of California State Railroad Museum.*

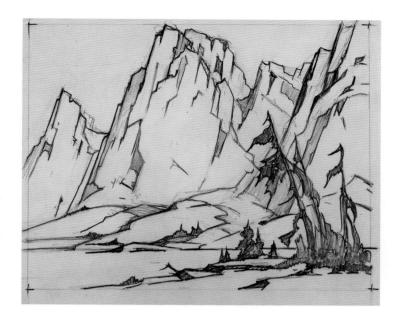

Sketch for "Southern Pacific, High Sierra." Pencil on paper. *Private collection.*

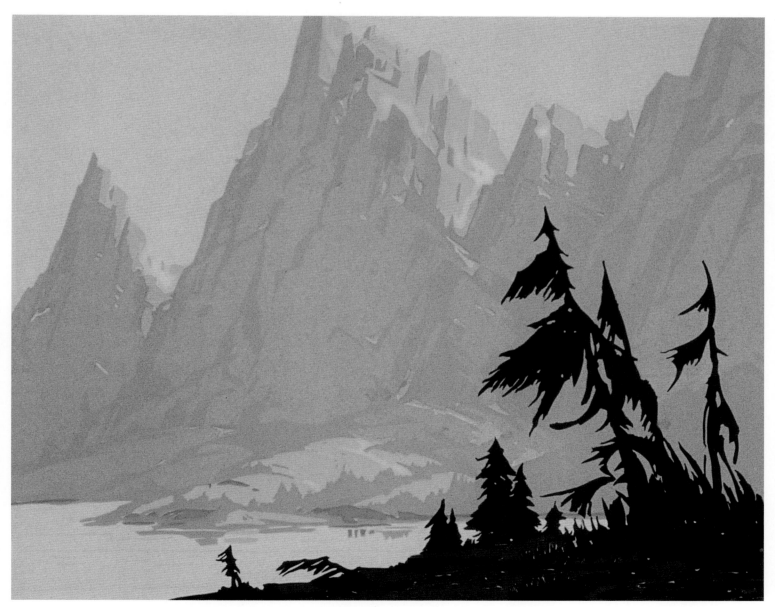

Woodblock for "High Sierra." Woodblock on paper. *Collection of Harris Family.*

When an idea (marquette) was successful, it was used in numerous ways even for matchbook covers and playing cards. Here the addition of people and cotton to the landscape with enlarged structures complete the final image.

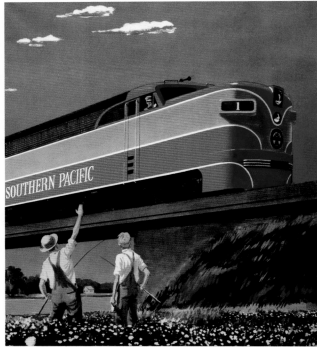

Magazine advertisement. *Collection of Charles N. Mauch.*

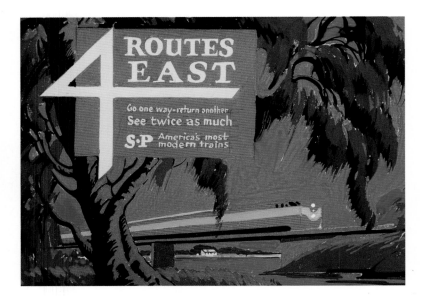

"4 Routes East" (Los Angeles to New Orleans). Marquette. Tempera on board. *Collection of Charles N. Mauch.*

"Sunset Limited" (Southern Pacific – Los Angeles to New Orleans). Printed poster. 22.5" x 15.5". *Collection of Charles N. Mauch.*

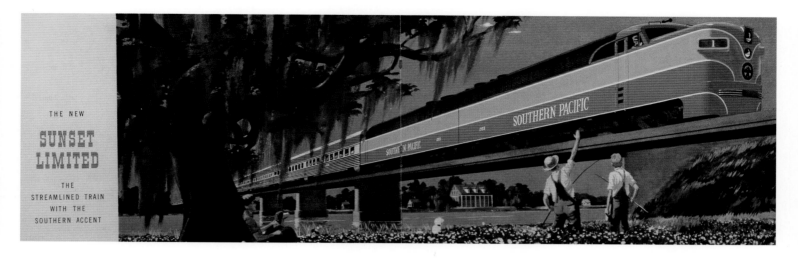

Brochure for Southern Pacific. Printed material. 5.5" x 17.75". *Collection of Charles N. Mauch.*

Deck of cards. *Collection of Charles N. Mauch.*

"Coast-to-Coast Pullman Service." Marquette. Tempera on board. 12" x 14". *Collection of Charles N. Mauch.*

"Southern Pacific." Small watercolor. *Collection of Charles N. Mauch.*

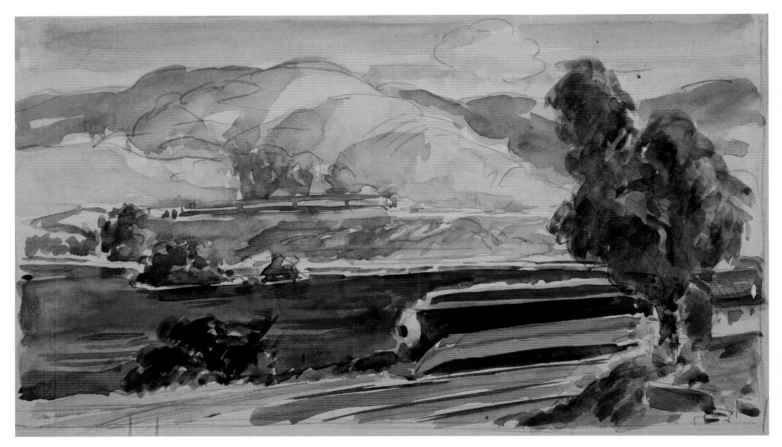

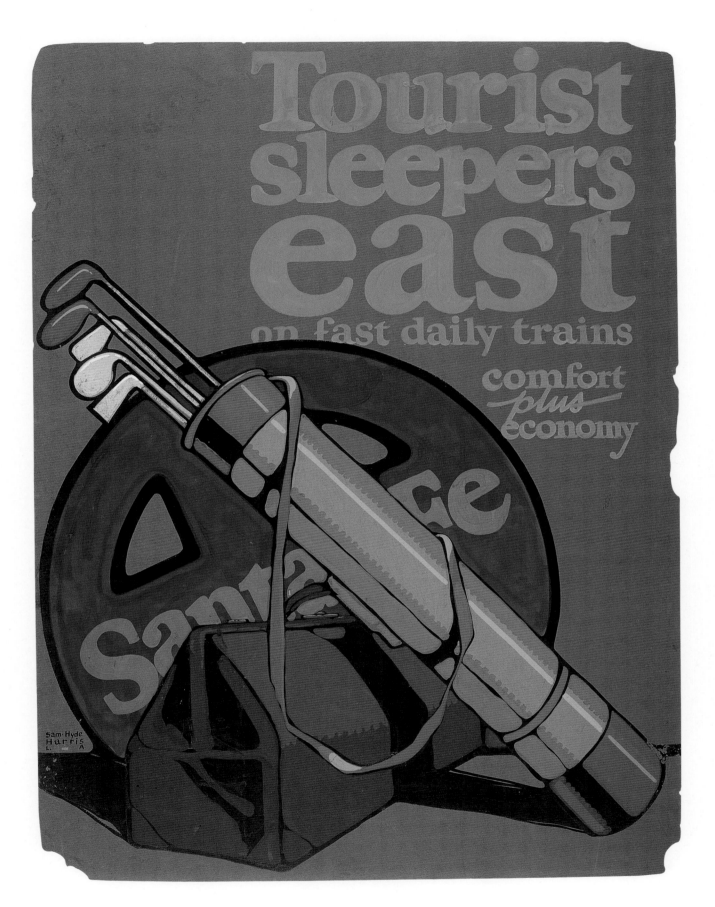

"Tourist Sleeper East." Poster, full size. Tempera on board. *Collection of Judith Leavelle-King.*
Courtesy of California State Railroad Museum.

"Huntington Lake was man-made starting in 1913, named for Henry Huntington, who financed the Big Creek, San Joaquin Hydroelectric Project to bring electricity to Southern California.

"Lakeshore resort was built in 1922 and is one of the last wooden structures of its kind to remain in California. Southern Pacific was owned by Collin P. Huntington."[27]

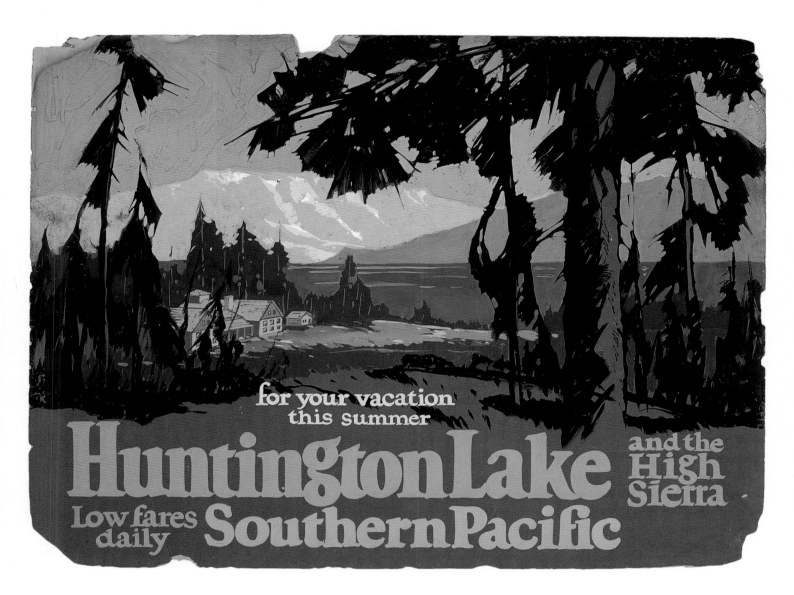

"Huntington Lake." Original poster, tempera. *Collection of Judith Leavelle-King. Courtesy of California State Railroad Museum.*

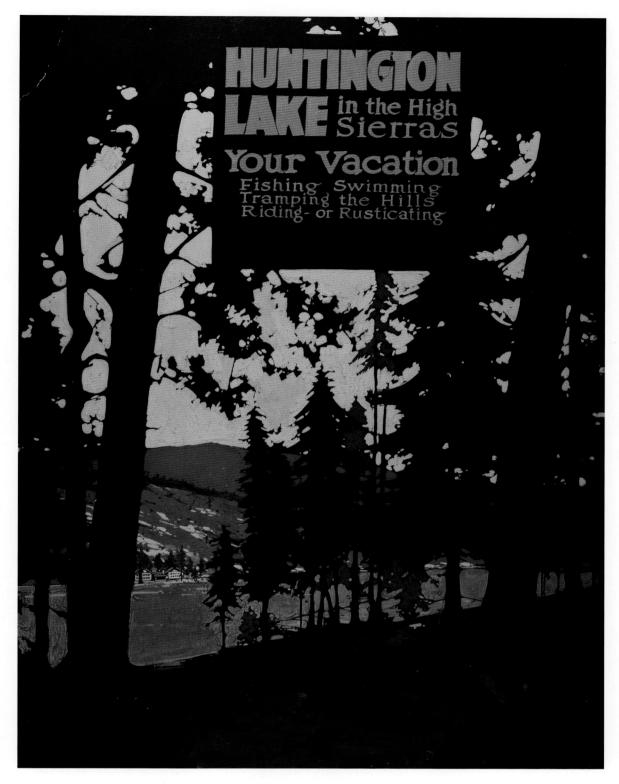

This poster clearly shows the use of the raw black board to form the trees and dark areas almost like a stencil. Note the use of the word "Rusticating".

"Huntington Lake." Original poster. Tempera on board. 40" x 30". C. 1920s. *Collection of Charles N. Mauch.*

Detail of "Huntington Lake."

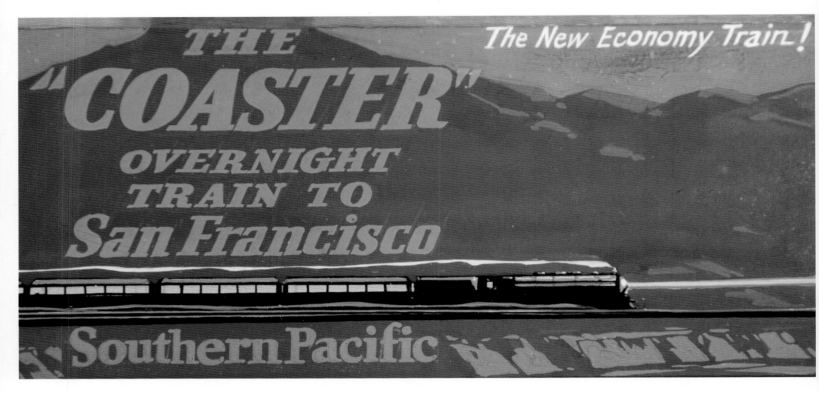

"The Coaster," marquette. Tempera on board. 5" x 10". *Collection of Charles N. Mauch.*

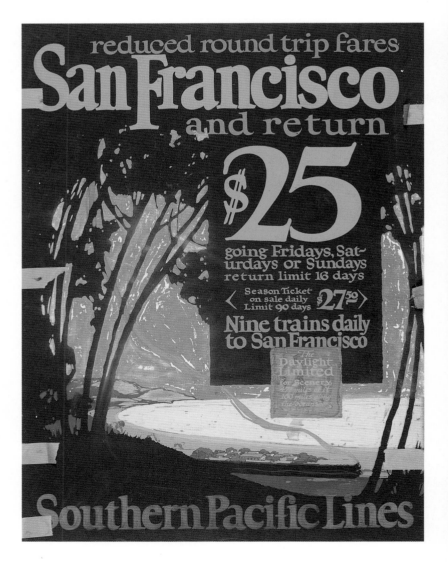

"San Francisco, $25.00." Tempera on board. 40" x 30". *Collection of Judith Leavelle-King. Courtesy of California State Railroad Museum.*

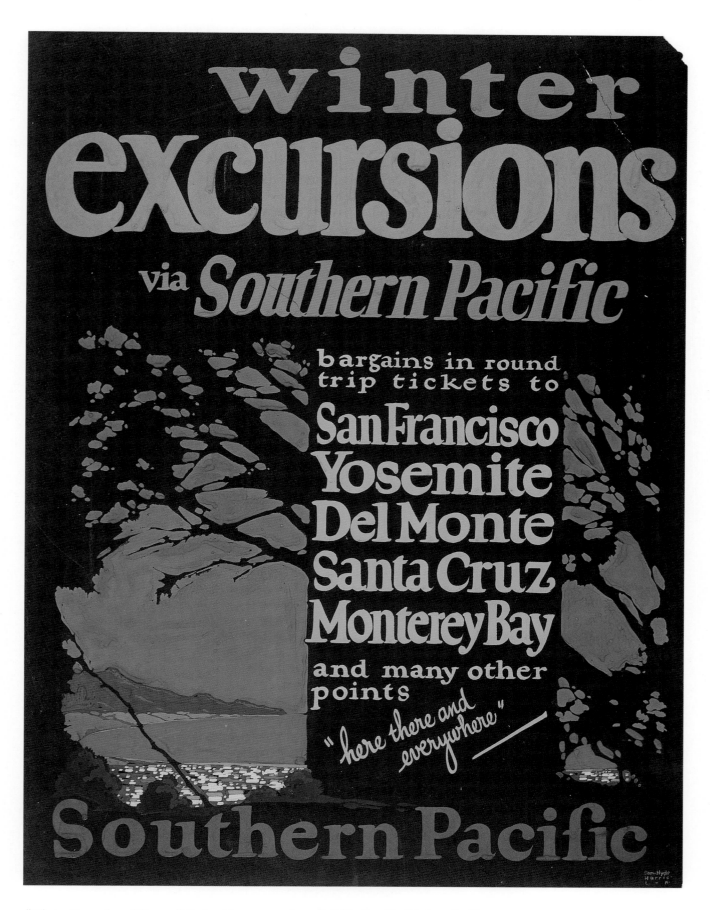

"Winter Excursions." Poster, full size. Tempera on board. *Collection of Judith Leavelle-King.*
Courtesy of California State Railroad Museum.

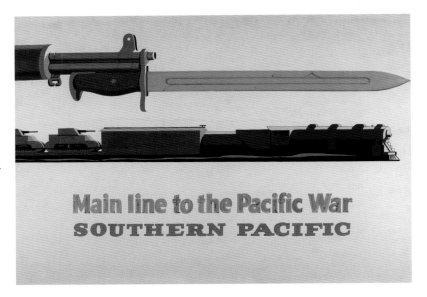

"Main Line to the Pacific War – Southern Pacific." Poster, full size. Tempera on board. 27" x 39.5". *Collection of Charles N. Mauch.*

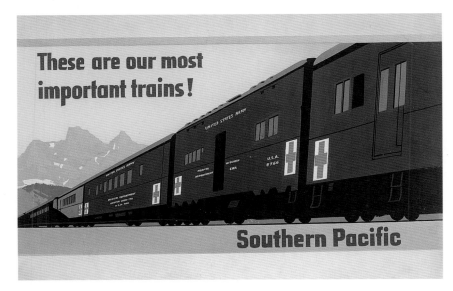

"Red Cross Train." Poster, full size. 29" x 49". *Collection of Judith Leavelle-King. Courtesy of California State Railroad Museum.*

"Think," marquette. Tempera on board. 7" x 10". *Collection of Charles N. Mauch.*

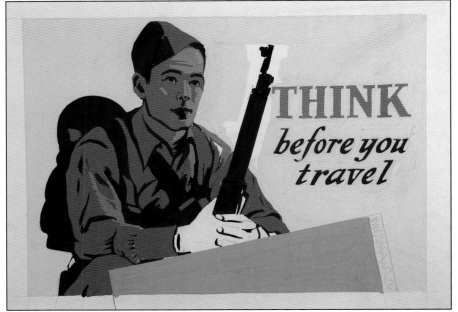

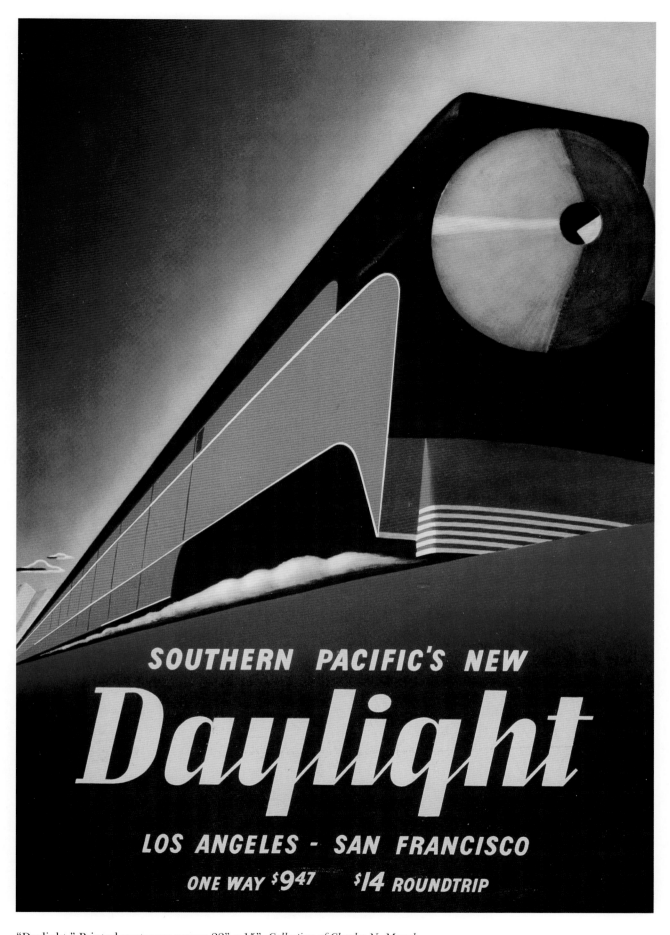

"Daylight." Printed poster on paper. 22" x 15". *Collection of Charles N. Mauch.*

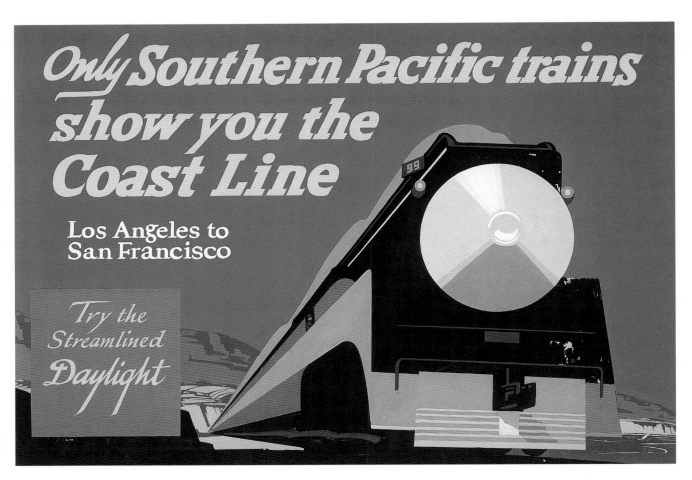

"Coast Line." Poster, full size. Tempera on board. *Collection of Judith Leavelle-King.*
Courtesy of California State Railroad Museum.

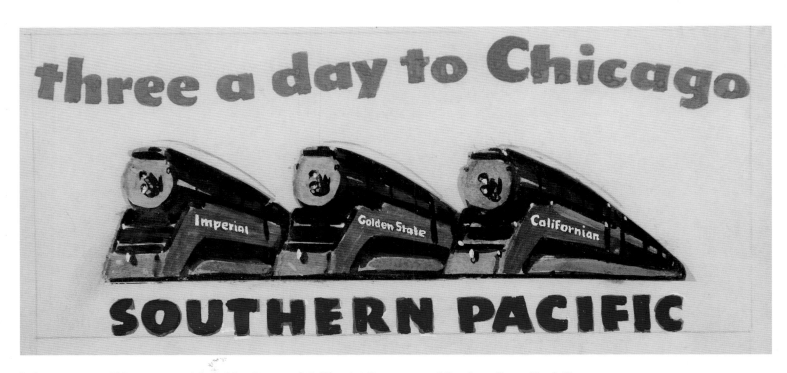

"Three a Day to Chicago: Imperial, Golden State and Californian," marquette. Mixed medium. 4" x 8.5".
Collection of Charles N. Mauch.

"Steam Engine." Pencil drawing. 5" x 7.5". *Collection of Charles N. Mauch.*

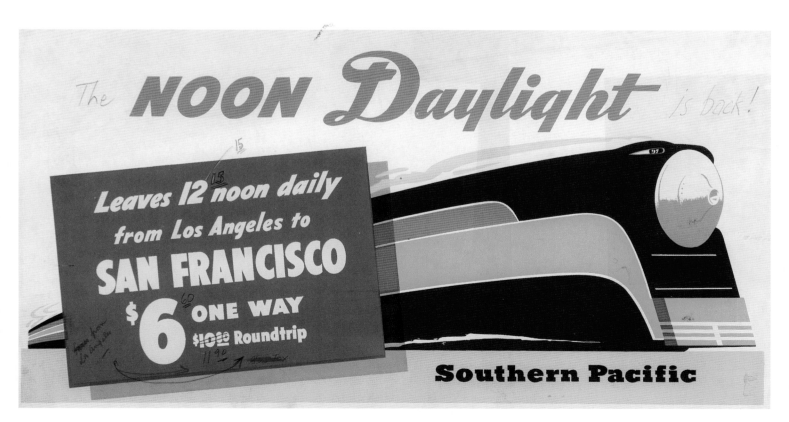

"Noon Daylight." Silkscreen with correction. 10.5" x 20.5". *Collection of Charles N. Mauch.*

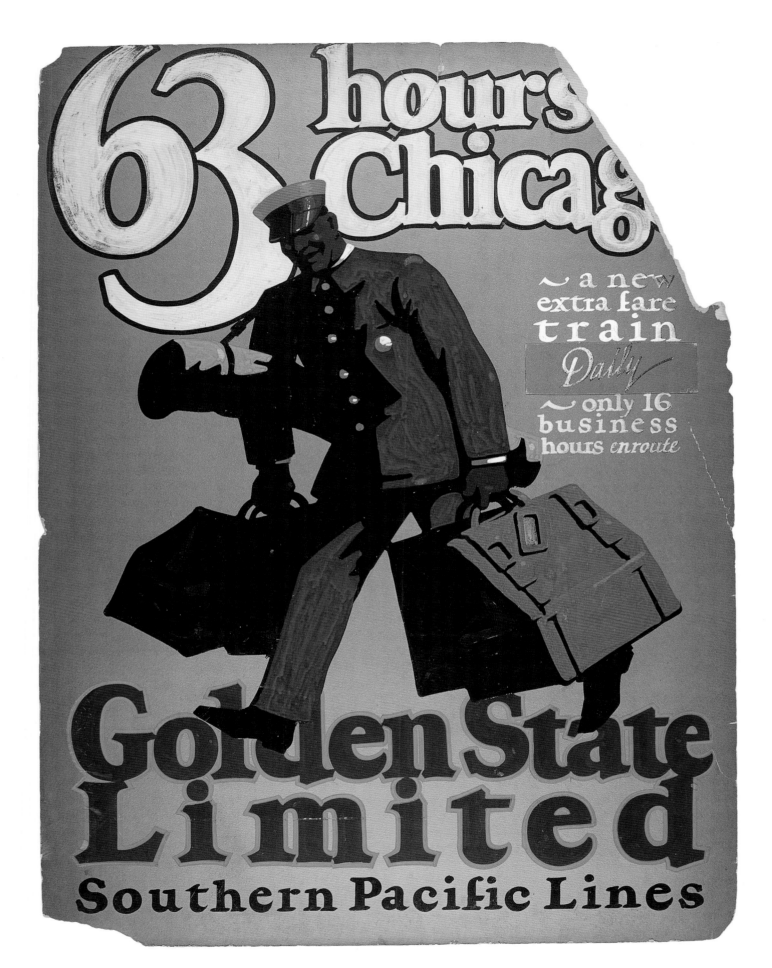

"63 Hours" (vertical version). Tempera on board. 40" x 30". *Collection of Judith Leavelle-King. Courtesy of California State Railroad Museum.*

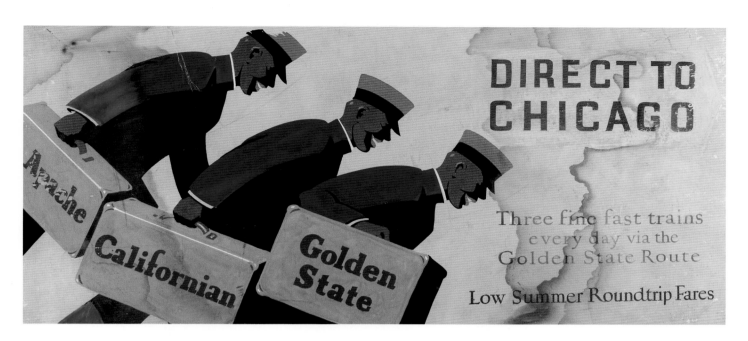

"Direct to Chicago." Poster. 17" x 39". *Collection of Charles N. Mauch.*

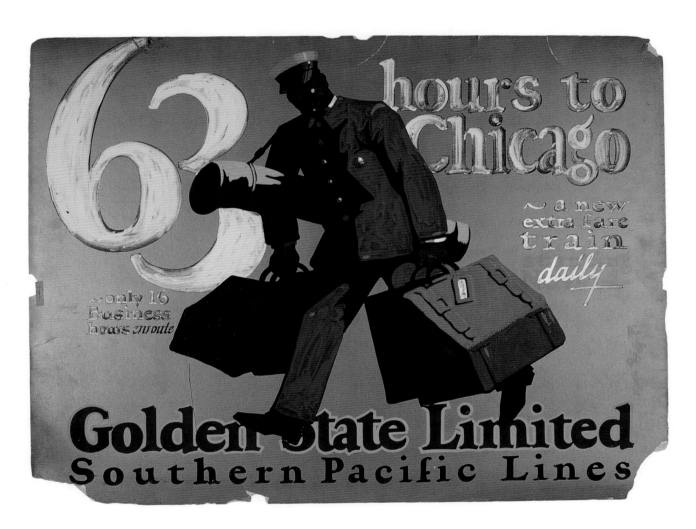

"63 Hours" (porter). Tempera poster. 17" x 39". *Collection of Judith Leavelle-King.*
Courtesy of California State Railroad Museum.

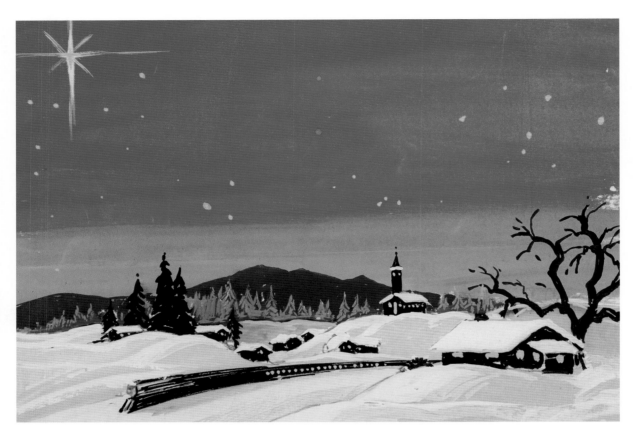

Marquette no. 1 for "Holiday Greetings." Tempera on board. 6.5" x 9.75". *Collection of Charles N. Mauch.*

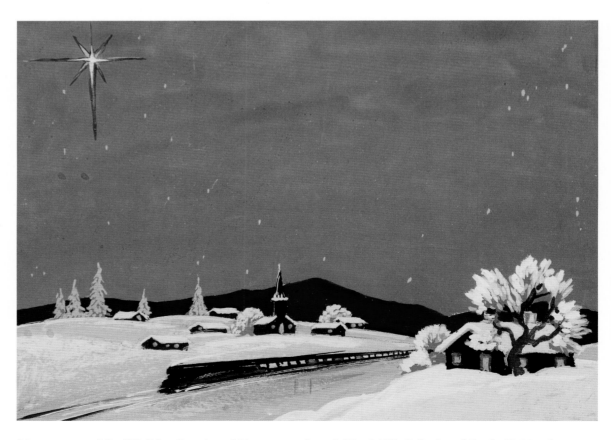

Marquette no. 2 for "Holiday Greetings." Tempera on board. 7" x 9.75". *Collection of Charles N. Mauch.*

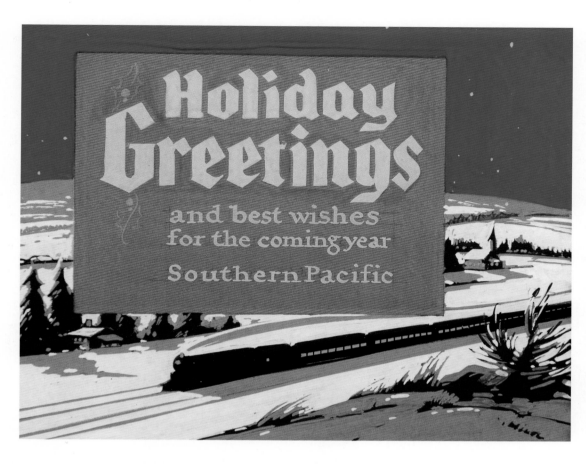

Marquette no. 3 for "Holiday Greetings" (final). Tempera on board. 7" x 9". *Collection of Charles N. Mauch.*

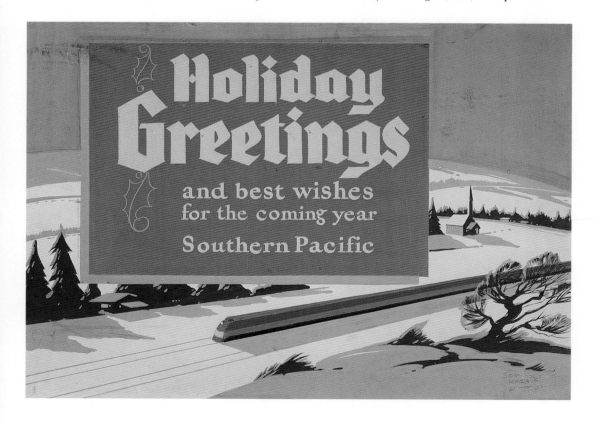

"Holiday Greetings." Large poster. Tempera on board. 30" x 40". *Collection of Judith Leavelle-King.*
Courtesy of California State Railroad Museum.

Marquette work up for "Christmas." Tempera on board. *Collection of Charles N. Mauch.*

Marquette for "Christmas." Tempera on board. 7" x 9". *Collection of Charles N. Mauch.*

"1940 Christmas." Marquette. Tempera on board. 5" x 8". *Collection of Charles N. Mauch.*

"Winter Scene." Poster, full size. Tempera. 40" x 30". *Collection of Harris Estate.*

Detail of "Winter Scene."

Taxco Mission, Mexico

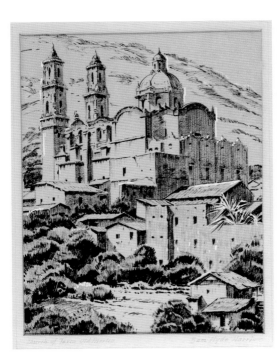

"Taxco Mission, Mexico." Tempera and pencil drawing. 10.5 x 8". *Collection of Charles N. Mauch.*

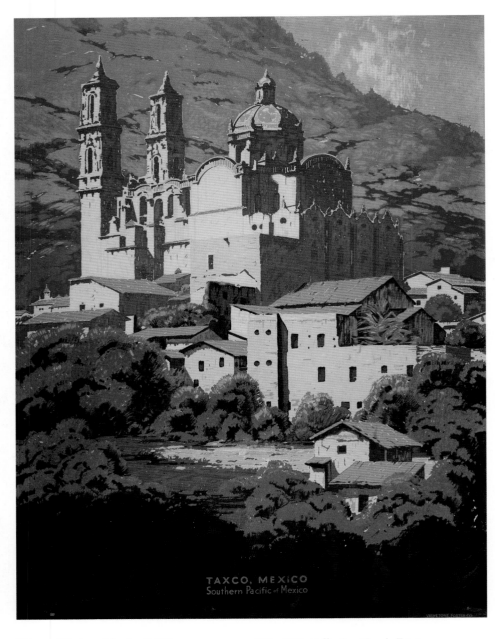

"Taxco Mission, Mexico." Silkscreen poster. 40" x 30". *Collection Harris Estate.*

112

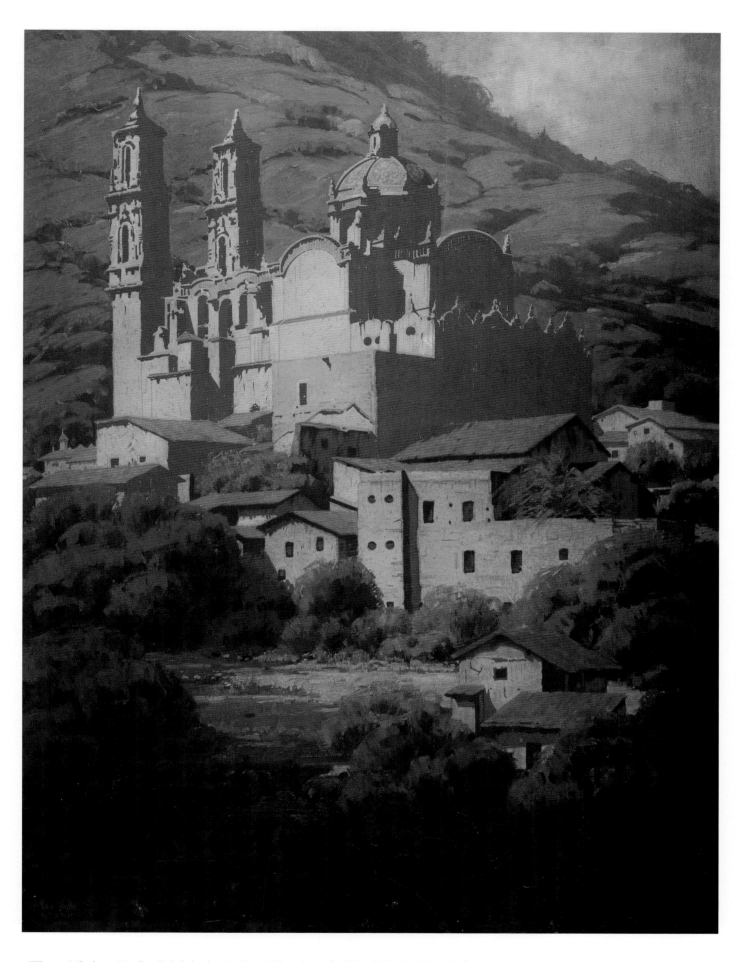

"Taxco Mission, Mexico." Original painting. Oil on board. 40" x 30". C. 1930s. *Collection of Harris Estate*.

Woodblocks

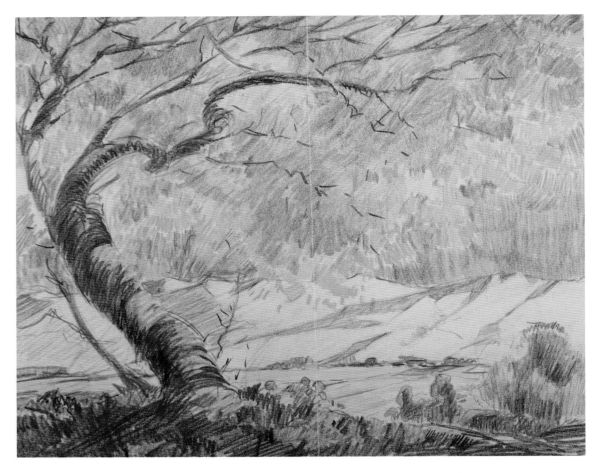

Colored pencil drawing on paper. The image is seen reversed in the woodblock below. *Collection of Maurine St. Gaudens.*

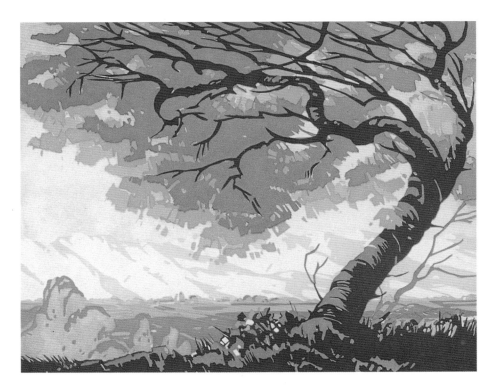

Woodblock of drawing above, with the image reversed. C. 1930s - 1940s. *Collection of Jean Parsons Harris.*

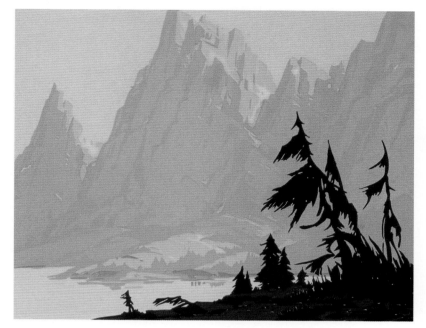

Woodblock (*see also "High Sierra" poster on page 92*). *Collection of Jean Parsons Harris.*

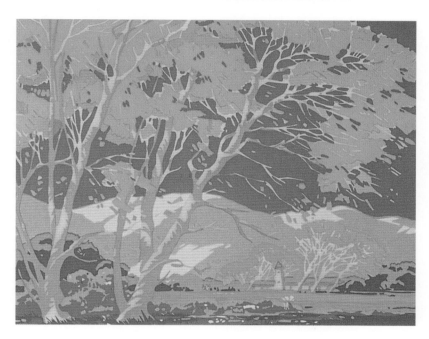

Woodblock. C. 1930s - 1940s. *Collection of Jean Parsons Harris.*

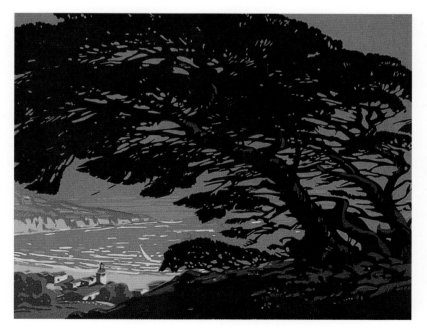

Woodblock. C. 1930s - 1940s. *Collection of Jean Parsons Harris.*

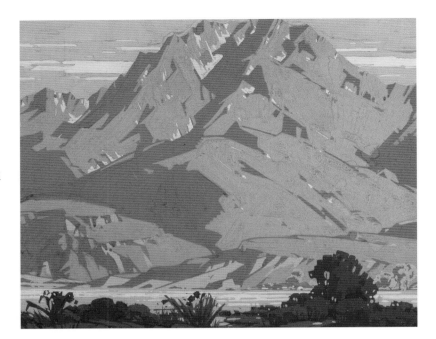

"Mt. San Jacinto." Tempera work up for wood block. Tempera on board. *Private collection.*

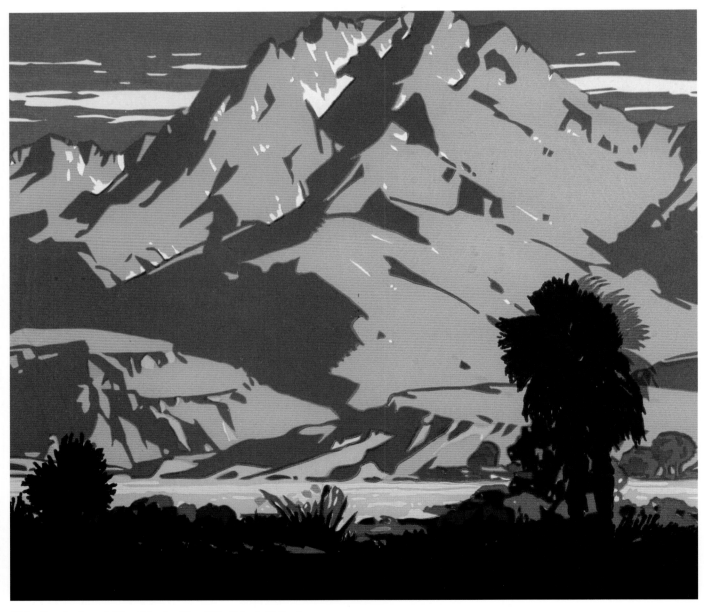

"Mt. San Jacinto." Woodblock. 8" x 10". *Private Collection.*

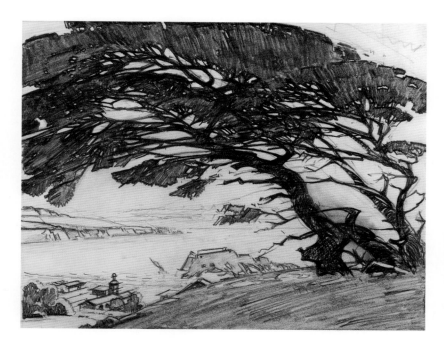

"Monterey." Pencil on paper. 8" x 10".
Collection of Charles F. Redinger.

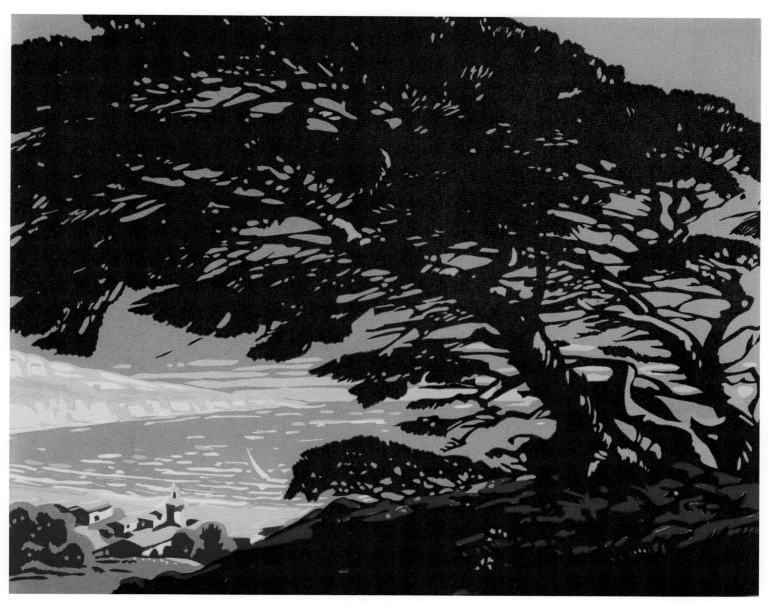

"Monterey." Woodblock. 8" x 10". *Collection of Charles F. Redinger.*

Four compositional studies. Pencil drawings on paper. 3" x 4", each. *Private collection.*

Four compositional studies. The top two are examples of foliage size and mountain size in proportion to each other. The bottom two experiment with high and low horizon line. Pencil drawings on paper 4" x 3", each. *Private collection.*

Section IV: The Soft Style and More, circa 1917 - 1945

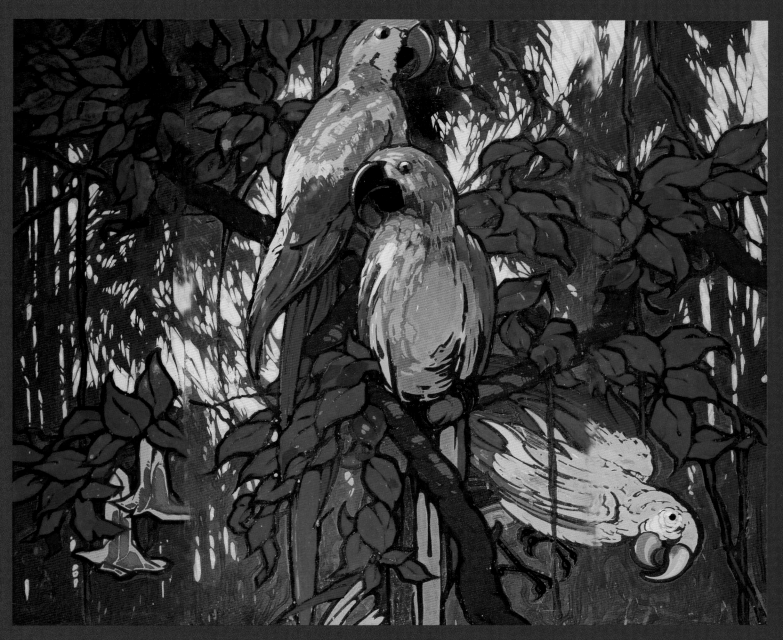

The "Parrot" screen, a major element of Marion Harris's living room décor. Tempera on heavy Epson board. 59" x 47", 3 pieces. C. 1930. *Collection of Harris Estate.*

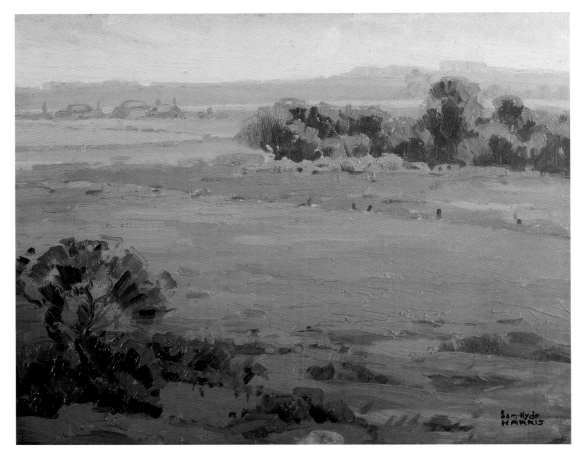

"Green Acres." Oil on canvas on board. 16" x 20". *Collection of Richard and Christina Doren.*

Detail of "Green Acres." The complete farm complex is created with quick dashes and dabs of color.

"Landscape in Oil"
Sam Hyde Harris

Generally speaking the elements of a successful landscape come under the following headings:

1. Composition
2. Drawing
3. Values
4. Color
5. Feeling

While there are many lesser factors involved, these are the five most vital, and, strange as it may seem, this is the order of their consideration and of their importance.

First Point: Composition

Let us first consider COMPOSITON, call it what you may – Layout, Pattern, Design, or the smart term of today Organization. It is our first consideration in any landscape, and in my humble opinion the most important member of the five points, sometimes referred to as "The Backbone of Art". Webster defines it as "The art or practice of so combining the parts of a work as to produce a harmonious whole." Lawrence Murphy, one of the truly great teachers of composition, expressed it in a manner that will speak volumes – "The intelligent breaking up of space." While Bill Hite, one of our members, humorously commented, "I never had any trouble with composition until Sam came around."

Take Verdugo Woodlands location, for example, Sky, Distant Mountains, Big Close-up Hills, Oaks, Sycamores, Eucalyptus, and interesting brush in the weedy foreground. Our problem immediately becomes one of selection, not "How Much", but "How Little" and at all times in the back of our heads the warning - "Keep it very simple."

If we are intrigued by a certain tree, or group of trees, we will make it a tree picture, with the sky, hills, foreground, etc., a secondary consideration, not to detract, but to accentuate the importance of the tree material.

If a rich colorful foothill captures our attention and our fancy, let us give the preponderance of space to the hills, with a limited area of sky and foreground, with small trees, thereby we will make the hills impressive.

Let some one of the various areas or elements dominate the canvas, so that it is definitely – A Sky Picture – A Tree Picture – A Foreground Picture – or a Mountain Project. One speaker of the evening, if you please, not five women talking at once and no one heard.

Take your little view finder, with an aperture 1.5 x 2 inches start looking through it at arms length (you take in less) raise it up or down, maybe a trifle right or left. Walk around a bit, sometimes a little closer or farther away from the subject helps. After a while the little bird will tell you "This is the spot" take time off to make a thumb nail sketch or two in pencil or in charcoal.

Second Point: Drawing

Having established a reasonably sound composition, the question arises, how much drawing, how far to go with charcoal, or whether to make one drawing with color or wash – very few hard and fast rules can be laid down.

Painting is an art, not a science. The artist is, or should be, a natural born experimenter; try anything once, or again and again. Listen carefully to suggestion or criticism from every source, weigh or analyze it, digest it... finally one has to sink or swim on their own decision.

Generally speaking for the young artist, charcoal is a flexible medium, easily changed, quickly fixed with a light spray of fixative.

It is a great temptation to make a few passes with the charcoal, and get right into splashing around with paint, but today for my money a fairly carefully drawn sketch pays dividends in the final analysis. Particularly when such elements as boats, barns, or other buildings are concerned, the construction of them is highly important. Certainly a degree of simplicity is needed for we are not competing with a camera for a photographic rendition... Sometimes exaggeration or distortion is advisable; we are shooting for the spirit or essence of the particular subject. Charlie Owens once said: "You know Sam, boats have to be *drawn*, they are, both, in the water and on the water."

After all, the light and shadow of one object changes all too fast, at times it is advisable to definitely establish the shapes of one shadow area, the objects necessary, as rapidly as possible. The shadow forms of one mountain are well defined say at 9:00 a.m. – by noon they are practically gone – by 4:00 p.m. we have an entirely new set of shadows and shadow areas to deal with.

Shadow shapes in the foreground, cast by trees, barns or other objects should be carefully established, they should denote the character of the object casting the shows, also the lay or slant and even the texture of the earth it is cast upon.

Finally, keep in mind when one drawing is fixed, and the charcoal is laid aside for the brush, we are still drawing, but we are simply using another tool; every brush stroke put down is drawing.

Dean Cornwell once remarked: "I can draw all right, but I have trouble *shading*…"

Third Point: Values

No two people seem to agree on the definition of the term "values" as applied to a painting, and it is quite often confused with hue or tone. The most simple definition would seem to be, "The light and dark relation, regardless of color."

Some of the great minds claim that the true test for a painting, is not the picture itself, but a photograph of it. In other words, if it holds up in black and white, without the benefit of color, it relies entirely on composition, drawing and value alone. That is the real criterion.

On the other hand, a picture that depends on, perhaps, brilliant, clever or pleasing color alone, without the support of composition, drawing, and values: when reduced

to black and white can be a miserable failure.

The Claude Lorraine glass was invented by the great French landscape painter of that name for just that purpose, to see values alone, regardless of color.

One outstanding painter and teacher in Southern California remarked, "If I had my own way with a landscape class, I would make them paint outdoors for six months in nothing but black and white. It would be the best thing in the world for them, but the only trouble is I would have no class by the end of two weeks – it would not be exciting enough for them but I still think that it would be a good idea."

Many times the young painter working outdoors gets into deep water, thinking he is having color trouble, when he is really having and fighting value troubles. Look for the value, the correct value of the spot or area, adjacent to the one next to it, look at your subject through a glass or piece of film, or a strong pair of sun glasses, (the principle of the Claude Lorraine glass) the color will be reduced and your values seen more clearly. If your tendency is to paint too dark or in too low a key, hold a piece of charcoal (which is grey, not black) against the darkest value you can find in your subject, and notice how much darker the charcoal seems to appear. Here again the advantage of the umbrella is apparent, working without an umbrella your sketch may appear to have clean brilliant color and sound values, but when shown in the normal subdued light of the indoors, it is many degrees lower in tone and the values will appear low, heavy and at times muddy.

Compare the value of the roof of the barn right against the sky, is it lighter, or a whisper of a shade darker than the rest of the roof? Then the relation of the side of the barn, not overlooking the shadow under the eaves of the roof, pretty dark, but not as dark or rich as the inside of the barn seen through the open door or seen of the cracks in the side of the barn. Compare both the color and value of the golden hay or stuff at the right hand side of the barn. A thing is light or dark, rich or poor, according to what it is next to; it is all relative. Some part of the middle distance may appear very strong against the sky, but compared to value of the barn, it is many degrees lighter.

Of course, as a general rule, the sky and the distance are the lightest part of one canvas, getting stronger as we advance through the middle distance to the foreground, which gives to one sketch the term "Aerial Perspective" not as noticeable on a bright clear day, but especially so when the very famous California Smog is in evidence.

Fourth Point: Color

While color is listed fourth in this little series of articles, don't under-rate its importance; composition, first; drawing, second; values, third; color, fourth.

Color and its use in the present day scheme of living plays a most important part, scientists have discovered that a certain delicate shade of green is more beneficial to the patients in hospitals, than white, which has been in use for so many years.

A recognized fact, a plethora of red in a living room, for example, will in time have the most congenial couple in the wide world, at each other's throats.

A few years past, most bathrooms were white, stoves and Fords were black, but color is finally coming into its own. But let us not drift, we are concerned with color as it is applied to landscape painting.

Basically, there are three colors, at least three primaries, Red, Blue, and Yellow. If it were possible to obtain a perfect pigment with the addition of white that's all we would need.

However, here is a palette, simplicity itself, which will take care of practically all one needs in painting the great out-of-doors…White, Cadmium, Lemon or Pale, Colbalt Blue, Alizarin Crimson, Viridian, Yellow Ochre.

Many painters use a more complicated palette using siennas, umbras, black, several shades of blues and greens, and four or five cadmiums. That is all right too, but when the young painter (14 to 70 years of age) asks me to suggest a palette, these are the five colors and white that I will strongly recommend.

Later, when he is thoroughly familiar with the wide range of variations of color obtainable with this limited palette, he can graduate to a more complex array of colors.

After all there is something in favor of the very simple. If you can't get what you want with five colors, you are less apt to get it with fifty. Webster did not do too badly with the dictionary with only twenty-six letters.

The above palette is considered to be permanent, while there is not space to go into the chemical action of various colors and their color combinations (and none of the authorities seem to agree). One point is many times brought up by artists, and color manufacturers, that is the use of Alizarin Crimson and Viridian together, some claim the combination will darken with age. I personally have done this combination and examination of work done twenty-five years or more ago does not seem to bear out this contention.

Constable, the great English landscape painter, was one of the first to take his easel outdoors, and to endeavor to portray the effect of air and sunlight on grass, trees, sky, and so forth.

Monet and other men of the French Impressionistic school followed in what was a protest against the stylized, formal, indoor landscape production of the "School of Brown Sauce."

Impressionism, the use of broken color, to give an illusion, the sparkle of sunlight, the feeling of air, was quite revolutionary at that time, and its effects and its influence has been far reaching right up to the present day landscape painting.

Unfortunately over the past many years, demonstration paintings were sold as works of art. Here Sam explain why these exist, "A demonstration is neither a sketch nor a finished painting. It's something done for the sole purpose of aiding you in your work." He even explains that he "works very broadly in a demonstration so the fellows in the back rows may see as clearly as those in choice nearby spots."[23]

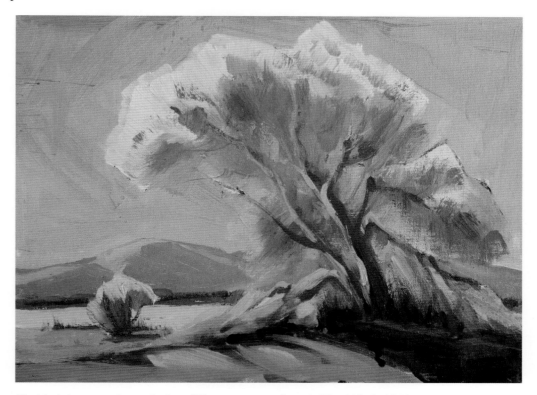

Untitled demostration painting. Oil on canvas on board. 9" x 12". C. 1950.
Collection of Harris Estate.

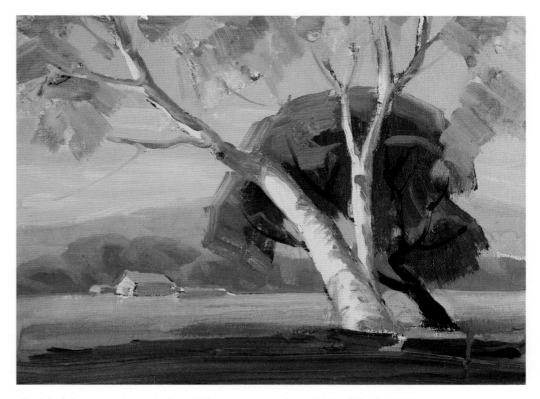

Untitled demostration painting. Oil on canvas on board. 9" x 12". C. 1950.
Collection of Harris Estate.

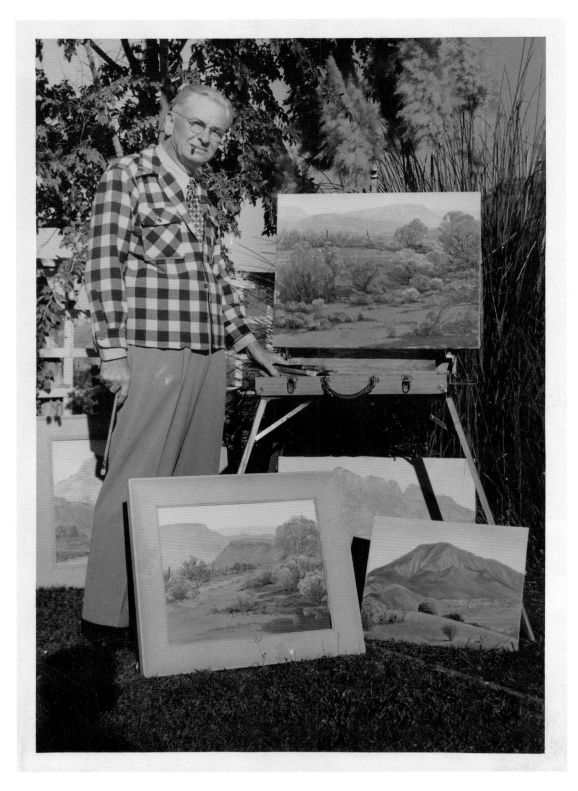

Large photograph of Sam with four paintings of Utah. Late 1940s. *Collection of Harris Family.*

The Soft and More

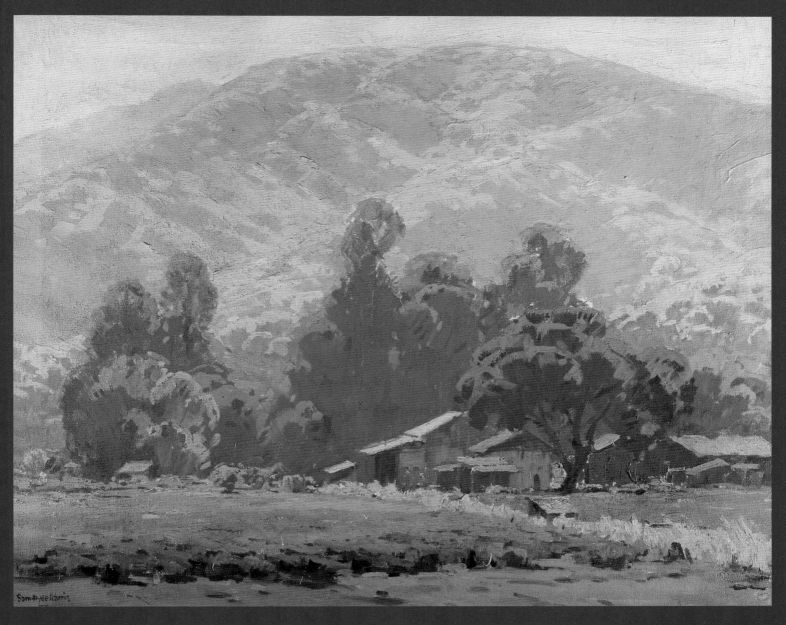

"Arcadia." Oil on canvas. 25" x 30". C. 1925. *Collection of Harris Estate. Provenance: Personal collection of Marion Harris.*

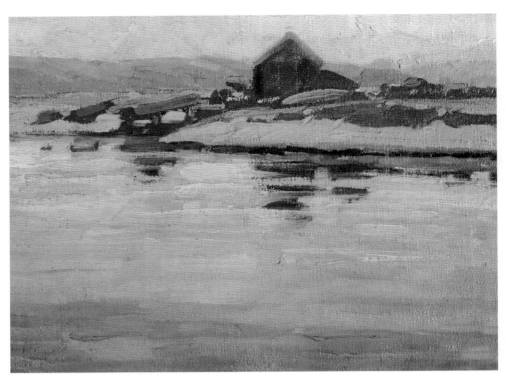

Untitled. Structures by water. Oil on board. 12" x 16". C. 1918. *Collection of Harris Estate.*

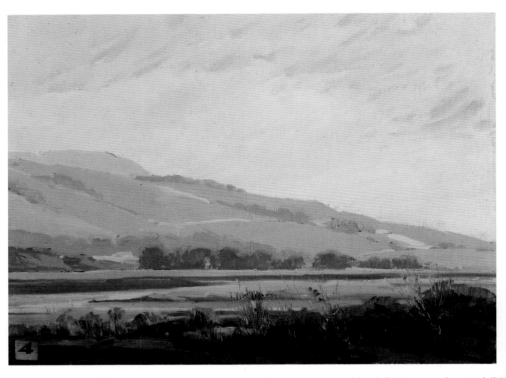

"Receding Mist." The no. 4 paper label in the left corner is an old exhibition number. Exhibition information, front or back (verso) of a painting should not be removed; they represent the history or provenance of the work of art. Oil on board. 12" x 16". *Collection of Harris Estate.*

One of Sam's most recognizable styles are the misty paintings. Sam plays with light and softens the edges of forms to create an atmospheric effect, coupled with his ability to tone down or mute the colors; he gives the feeling of seeing through a soft layer of fog or haze. Paintings of this type are as early as 1918 and as late as 1950.

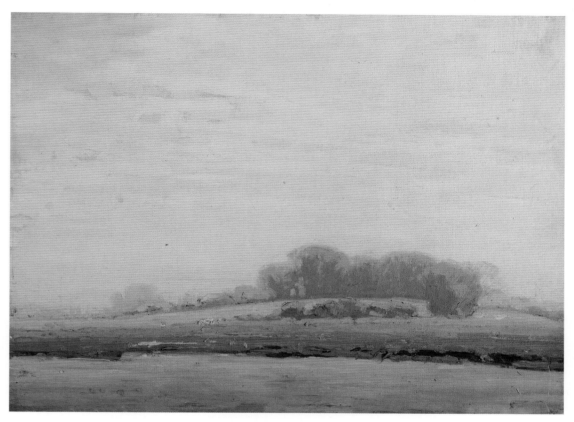

"Fog." Oil on board. 12" x 16". C. 1922. *Collection of Harris Estate.*

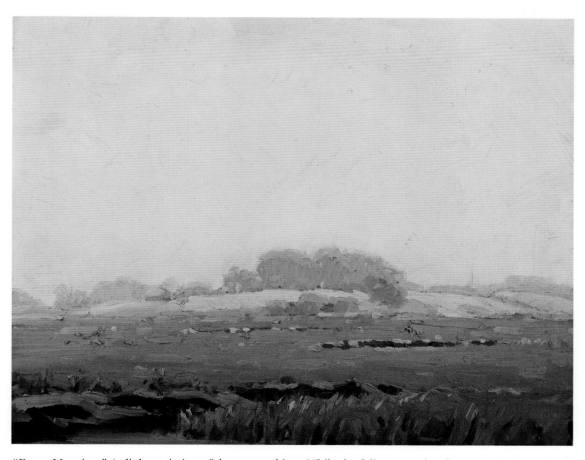

"Foggy Morning." A slight variation of the same subject. While the foliage remains the same size the reduction of water makes the foliage appear larger and closer. Oil on board. 16" x 20". C. 1922. *Collection of Gary Lang.*

Photographs below show five stages of an idea from a pencil sketch to the oil painting, and on to the print process.

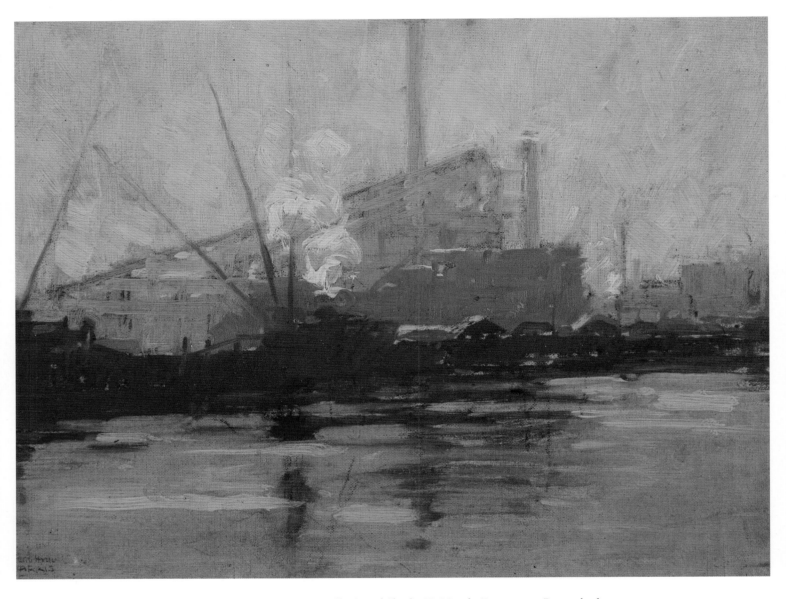

"Industrial Romance." Oil on board. 12" x 16". C. 1920. *Collection of Charles N. Mauch. Provenance: Personal collection of Marion Dodge Harris. Exhibited: 1935 – 6th Monthly Exhibit of San Gabriel Artist Guild, August. No. 35. 1936 Exhibition of Paintings by Sam Hyde Harris, San Gabriel Artists Guild Art Gallery March 29-May3, No. 21.*

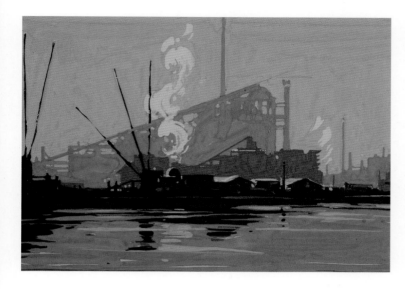

"Industrial Romance." Tempera on paper. 5" x 7.5". C. 1920. *Collection of Charles N. Mauch.*

"Industrial Romance." Pencil on paper. 5" x 9". *Collection of Charles N. Mauch.*

"Industrial Romance." Pencil stencil for print on paper. 5" x 7". C. 1920. *Collection of Charles N. Mauch.*

"Industrial Romance." Print on paper. 5" x 7". C. 1920. *Collection of Charles N. Mauch.*

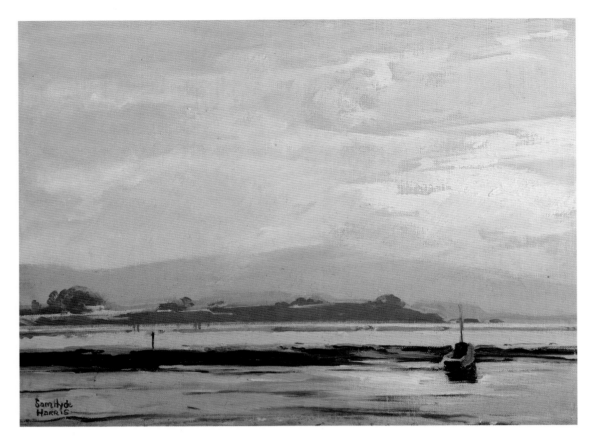

"Morro Romance." Oil on canvas board. 12" x 16". C. 1930 *Collection of Charles F. Redinger. Provenance: Personal collection of Marion Harris.*

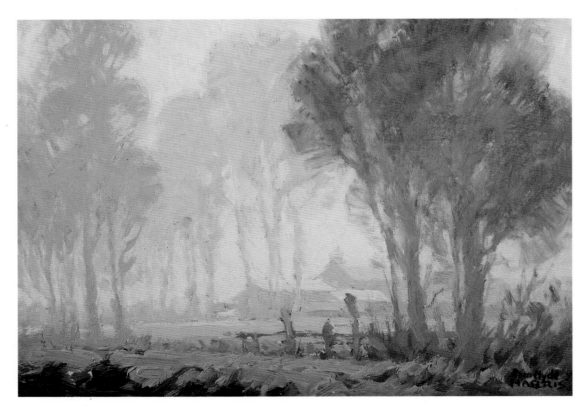

"Farm in Mist." Oil on canvas on board. 12" x 16". C. 1925. *Collection of Oltman Retirement Plan.*

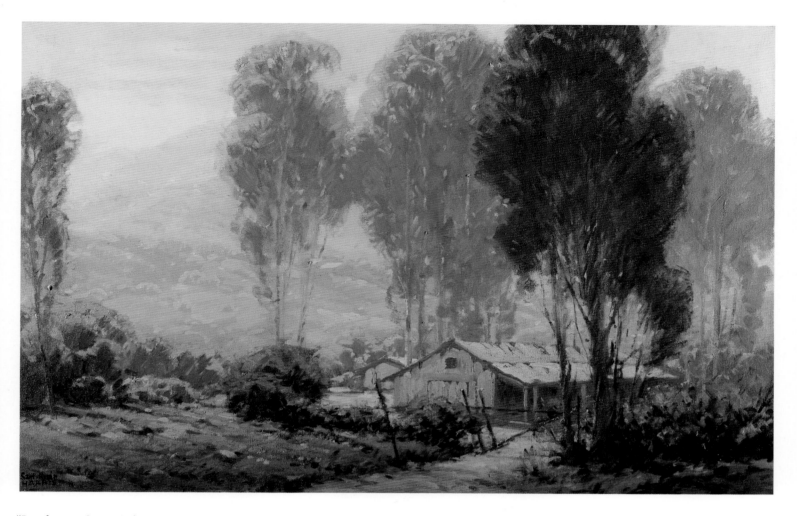

"Landscape, Santa Anita Canyon," Lucky Baldwin Ranch. Oil on canvas. 22" x 35.5". C. 1935. *Private collection, courtesy of Gary Lang.*

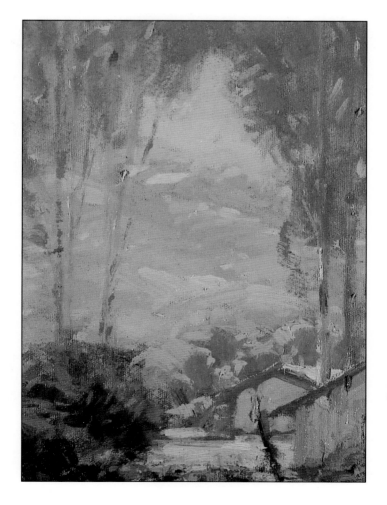

Detail of "Landscape,
Santa Anita Canyon."

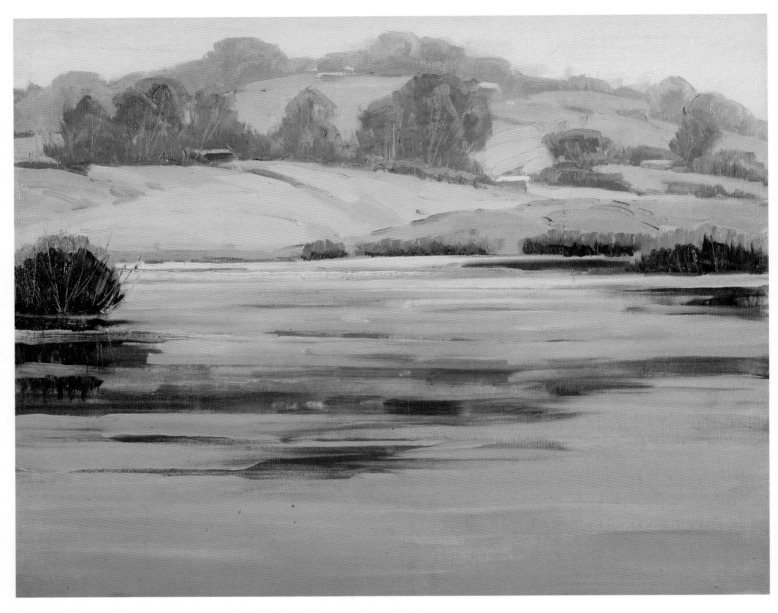

"Carlsbad Noon." Oil on canvas board. 16" x 20". C. 1940s. *Collection of Harris Estate.*

"Chartreuse" Los Angeles River area wetlands. Oil on board. 16" x 20". *Collection of Harris Estate.*

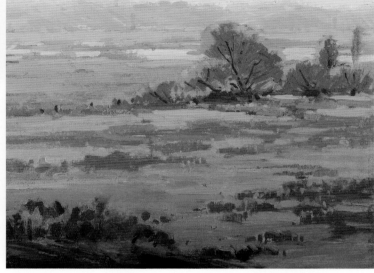

Untitled. Early Los Angeles River area wetlands. This again is a variation on the same theme – early Los Angeles River with oil rigs in the foggy distance. Detail shows the city skyline. Oil on board. 16" x 20". *Collection of Gary Lang.*

Detail, showing the outline of the Los Angeles buildings in the distance.

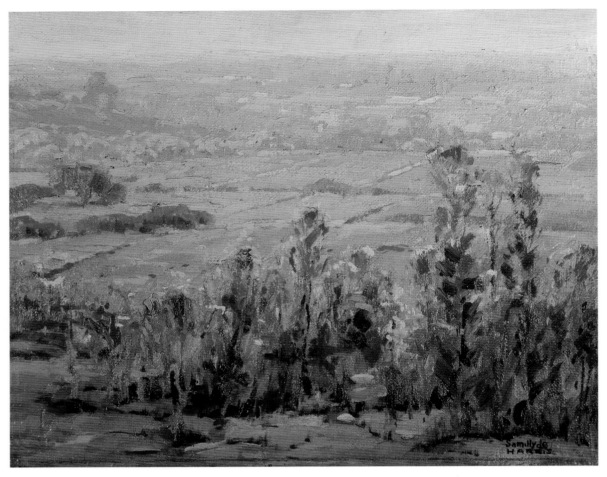

"The Valley" (San Gabriel). Oil on masonite. 16" x 20". C. 1925. *Private collection. Exhibition of Paintings of Sam Hyde Harris, San Gabriel Artists Guild Art Gallery, November 1- December 1, No. 4.*

Detail of "The Valley" (San Gabriel), showing brush strokes and quick application of paint.

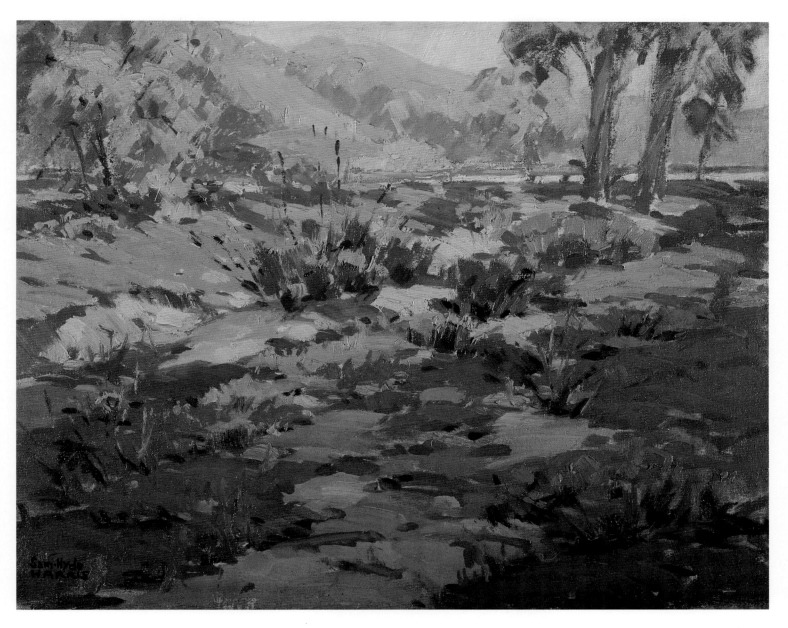

"California Spring" (Arboretum Santa Anita, Arcadia). Oil on board. 16" x 20". C. 1930. *Collection of Ed & Kelli Mace, courtesy of Jim Konoske.*

Photograph of Sam and friends in the San Gabriel Valley, California. *Collection of Harris Family.*

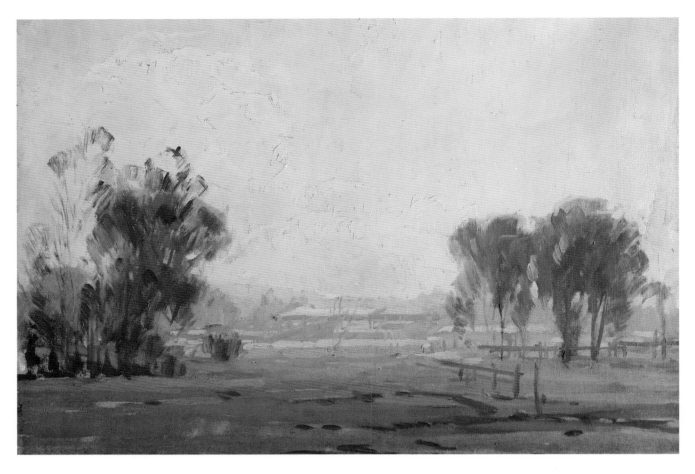

"Big Sky" (Santa Anita, Arcadia). Oil on canvas. 20" x 24". C. 1940. *Collection of Harris Estate.*

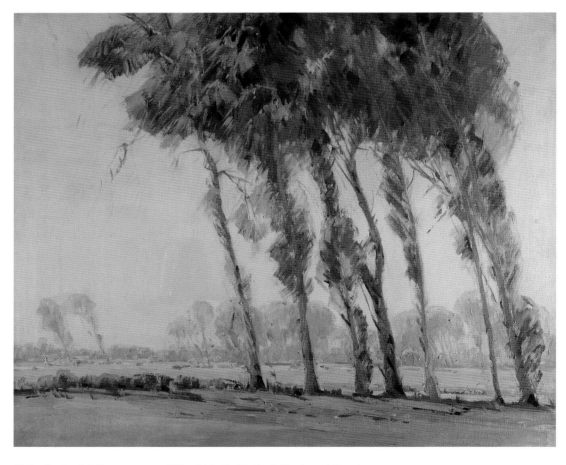

"March On." Oil on canvas. 25" x 30". C. 1940. *Collection of Harris Estate..*

Four pencil sketches. Pencil on paper. 3" x 4", each. C. 1935. *Private collection.*

Paintings from the twenties through the forties combine his atmospheric style with bolder dashes and dabs of colors and strong brush strokes creating great depth.

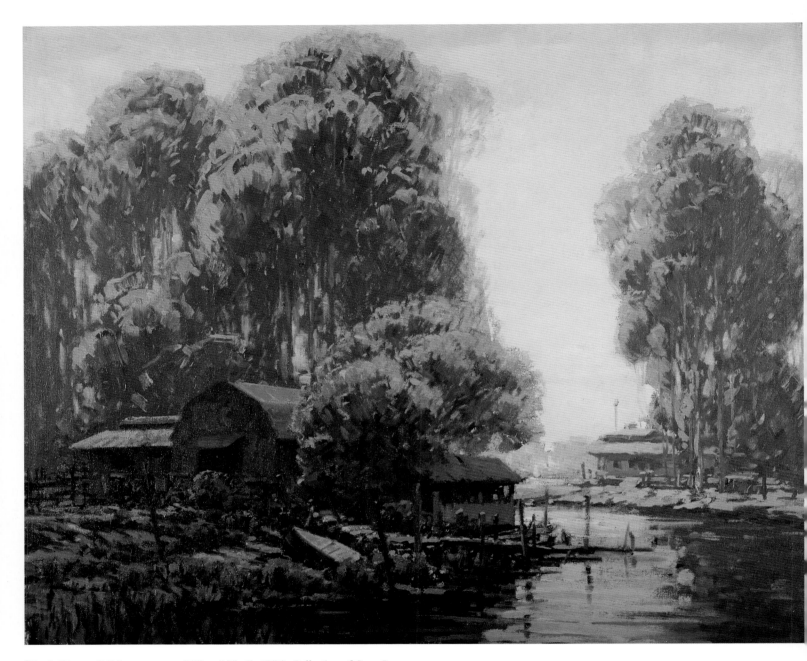

"Back Waters." Oil on canvas. 25" x 30". C. 1928. *Collection of Gary Lang.*

Detail of "Back Waters."

Detail of "Back Waters."

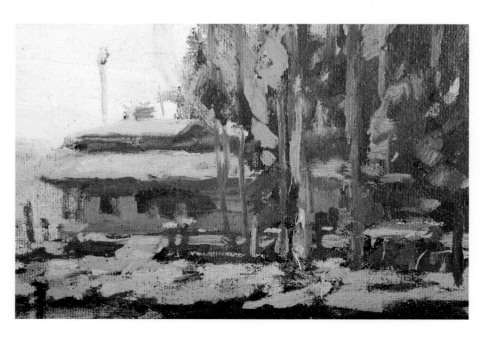

Detail of "Back Waters."

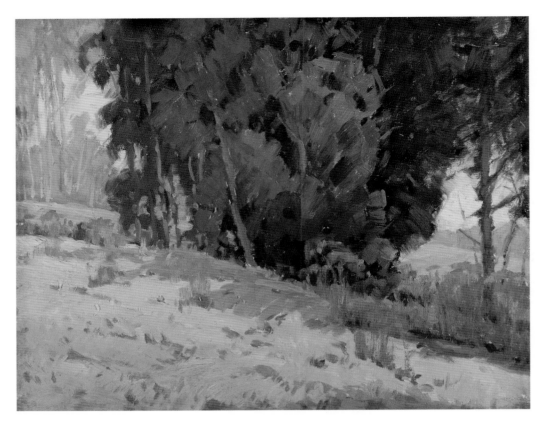

"Between Seasons." Oil on canvas on board. 16" x 20". C. 1925. *Collection of Harris Estate.*

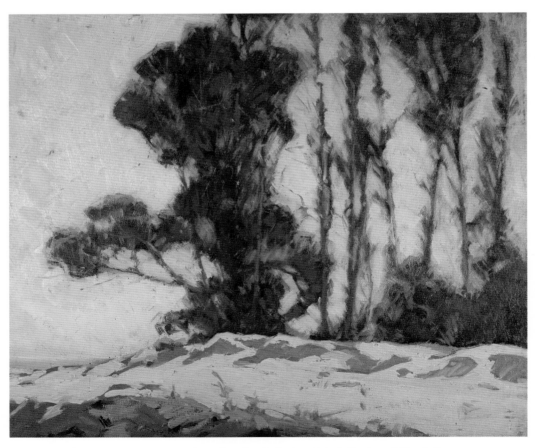

"Sandpit Edge." Oil on canvas on board. 20" x 24". C. 1928. *Collection of Harris Estate.*

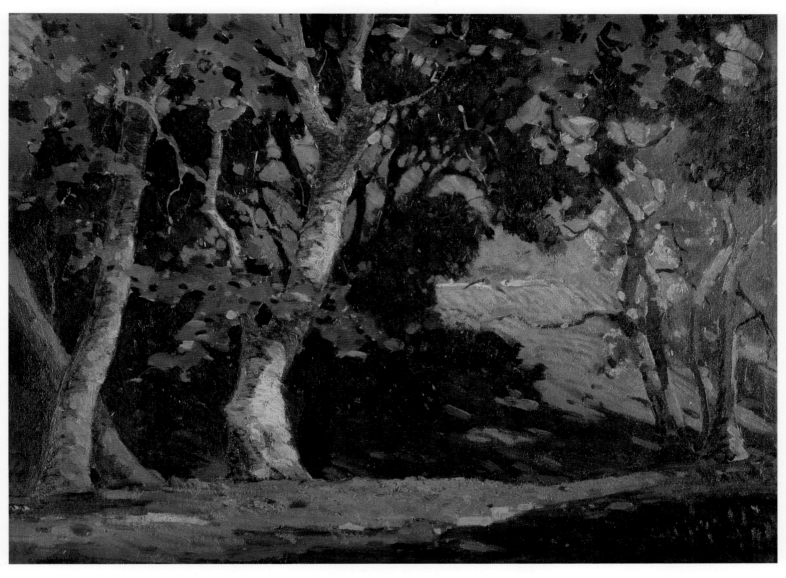

"Shady Hollow" (Arroyo Seco). Oil on canvas. 18" x 24". *Collection of Harris Estate. Provenance: Personal collection of Marion Harris. Exhibited: 14th Annual Exhibition, California Art Club, Los Angeles County Museum 1923.*

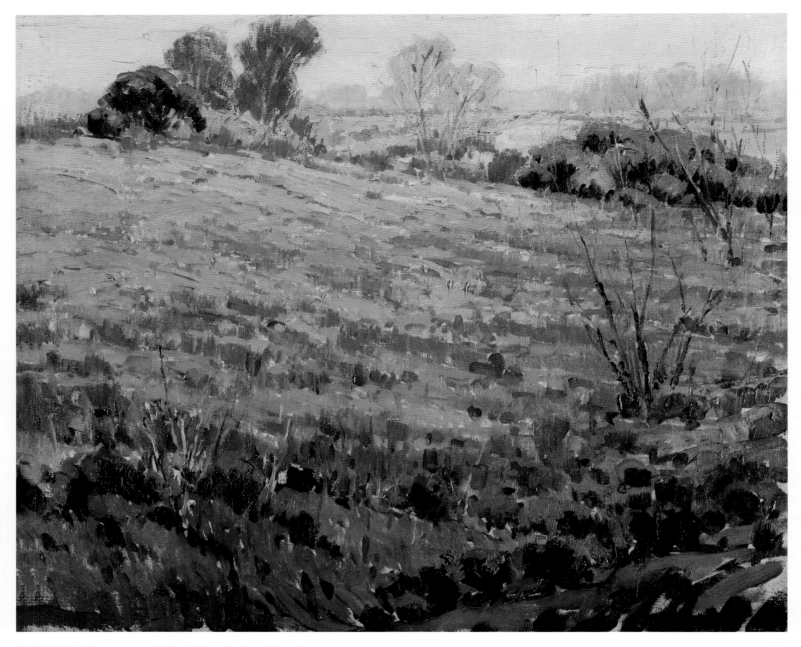

"Hillside." Oil on canvas. 20" x 24". *Collection of Harris Estate.*

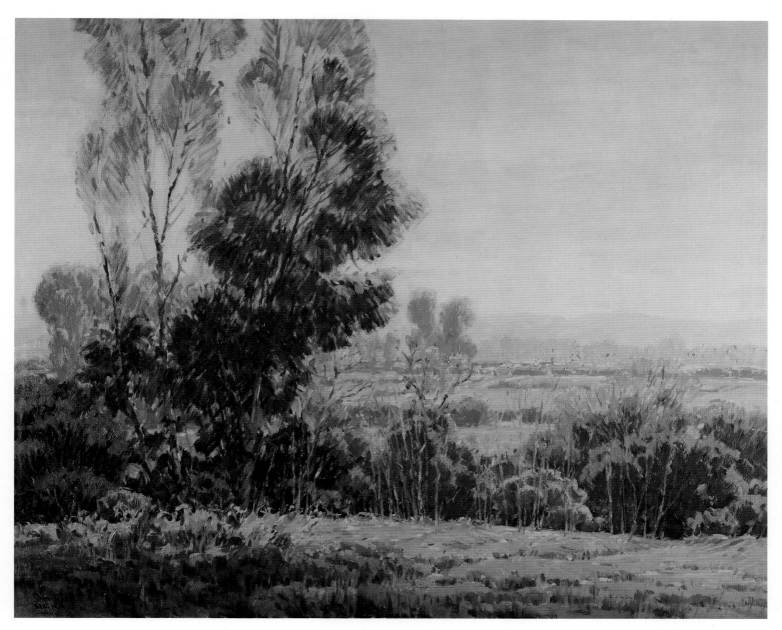

Untitled. Arcadia or San Gabriel. Oil on canvas. 24" x 30". C. 1935. *Private collection.*

Photograph of Sam and his friend working in San Gabriel. *Collection of Harris Family.*

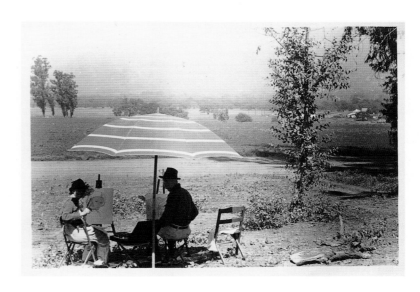

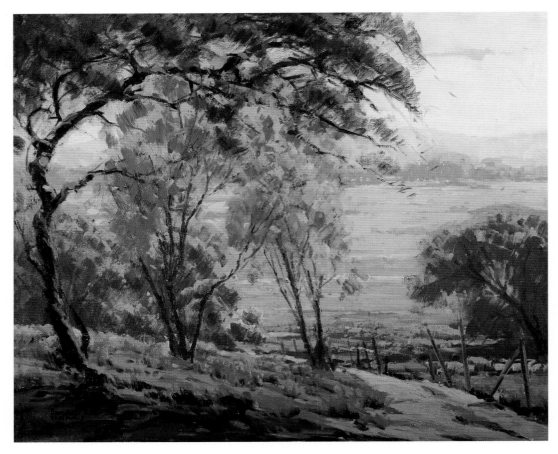

"Tree Near a Country Road." Oil on canvas. 20" x 24". C. 1930s. *Collection of Gary Lang.*

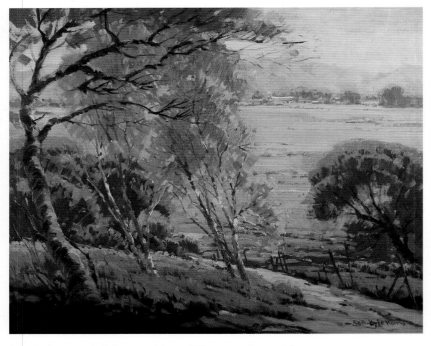

"La Quinta Wash." Same subject, different palette. Oil on canvas 25" x 29". C. 1935. *Collection of Gary Lang.*

Detail of structures in the distance in "La Quinta Wash."

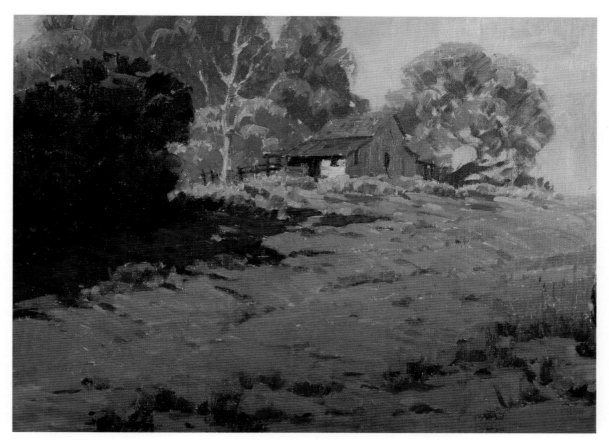

"Hillside No. 2." Oil on canvas on board. 18" x 24". C. 1938. *Collection of Harris Estate.*

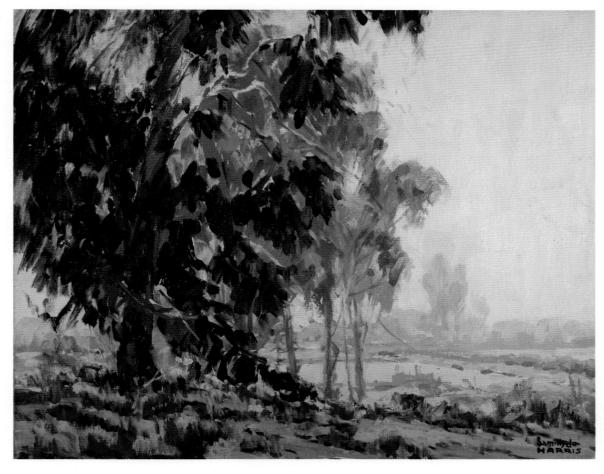

"As It Was." Oil on canvas on board. 16" x 20". *Collection of Harris Estate.*

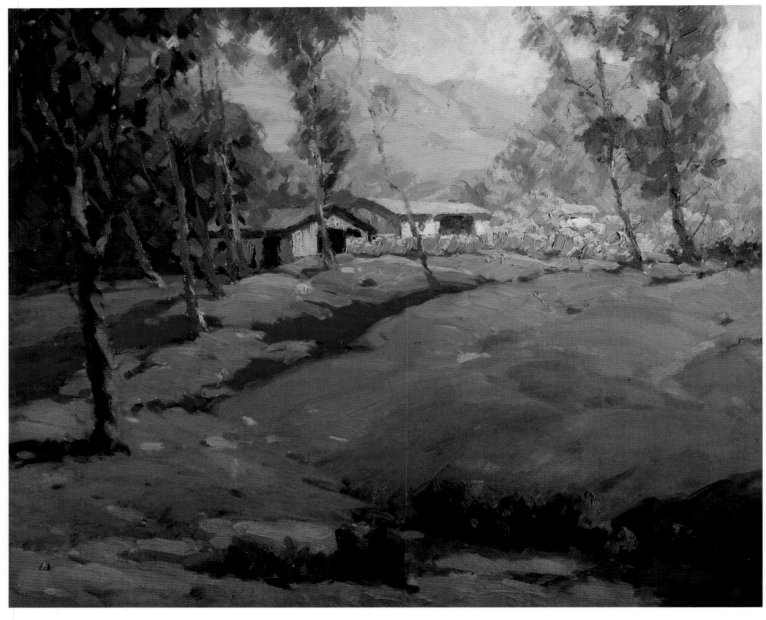

"Green Hillside." Oil on board. 20" x 24". C. 1929. *Collection of Harris Estate. Provenance: Exhibited in 1930.*
21st Annual Exhibition, California Art Club, Los Angeles County Museum, November 7 – December 31.

Back of board showing exhibition tags.

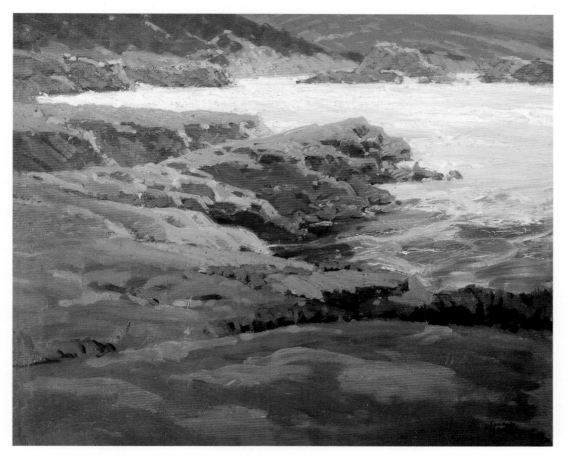

"Coastal." Oil on canvas. 25" x 30". C. 1935. *Collection of David Adams. Courtesy of Jim Konoske.*

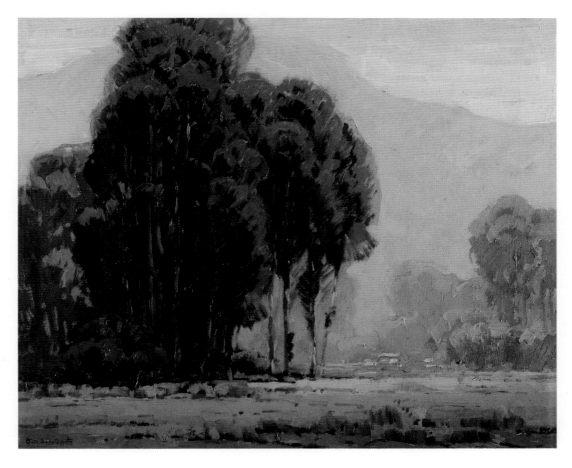

"California Landscape." Oil on canvas. 20" x 24". C. 1935. *Collection of Mr. & Mrs. Thomas A Giovine, courtesy of Thom Gianetto, Edenhurst Gallery.*

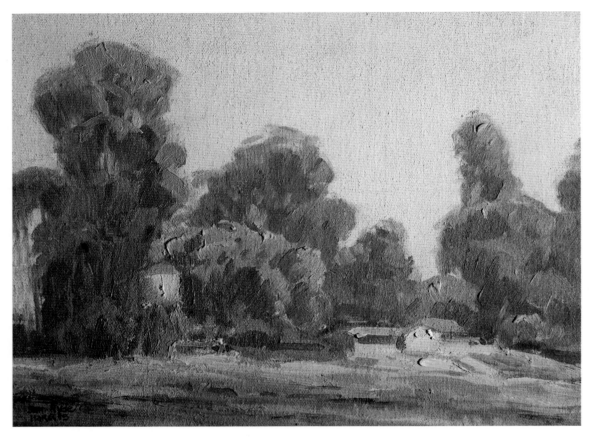

Untitled. Farm sketch. Oil on canvas on board. 9" x 12". C. 1935. *Private collection.*

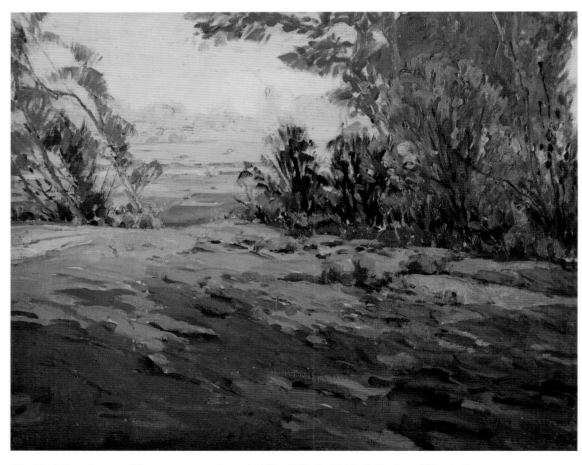

Untitled. Landscape. Oil on canvas on board. 16" x 20". C. 1940. *Collection of Harris Estate.*

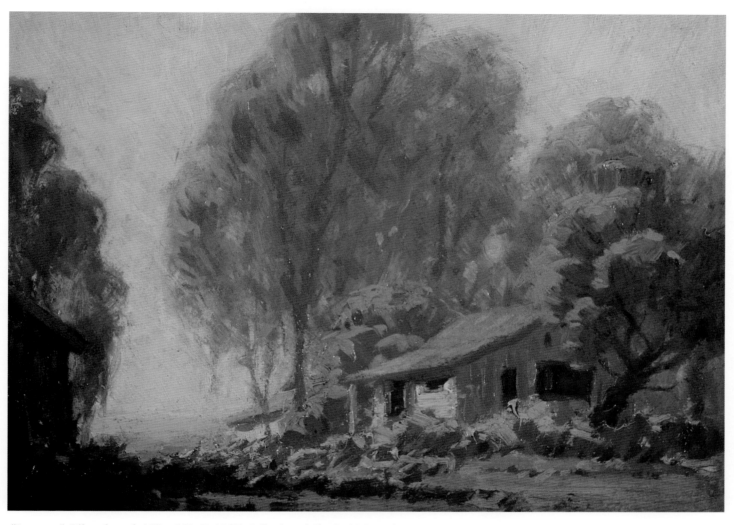

"Laguna." Oil on board. 12" x 16". C. 1935. *Collection of Charles N. Mauch.*

Detail showing quick strokes, complex colors, and thick paint (impasto).

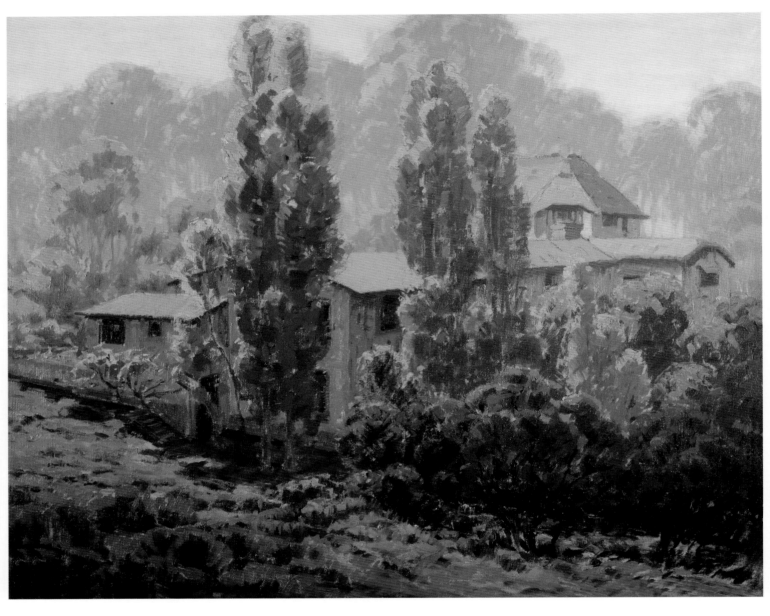

Untitled. House and trees. Oil on canvas. 24" x 30". C. 1925. *Collection of Gary Lang.*

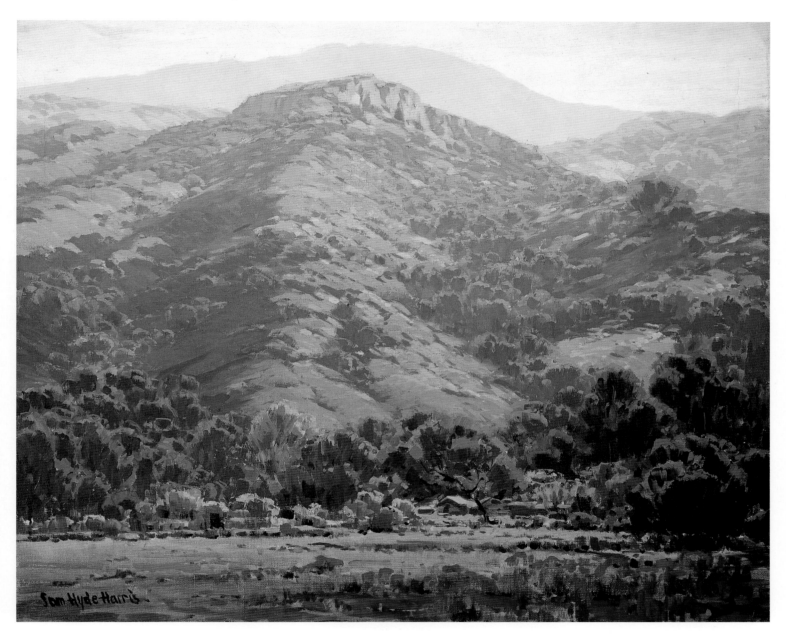

By placing a small structure at the base of oversize mountains or a very tall group of trees he produces the feeling of the grandeur of nature with humans as a subordinate entity.

"Hills in Spring." Oil on canvas. 30" x 36". *Private collection, Manhattan Beach. Courtesy of Gary Lang. Provenance: This painting is pictured in Jean Stern's "Sam Hyde Harris" catalog on page 26. Petersen Publishing Co., 1980.*

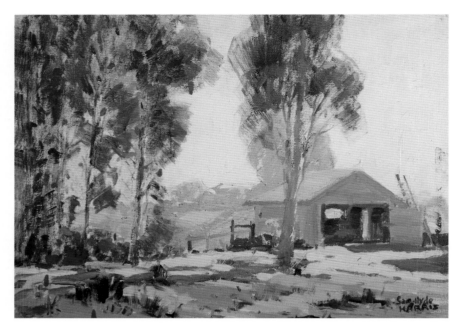

"Ranch Yard." 12" x 16". Oil on canvas. *Collection of Gary Lang.*

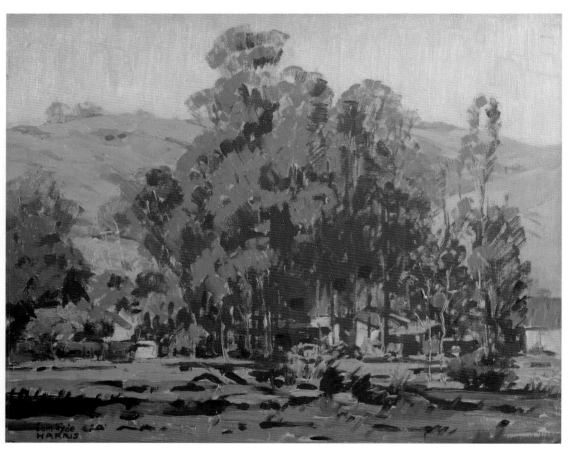

"Time Past." Oil on canvas on board. 16" x 20".
Collection of Richard and Christina Doren.

Verso or back of "Time Past." Shows sketches,
numbers, etc., all information. Harris estate
inventory number appears upper right corner.

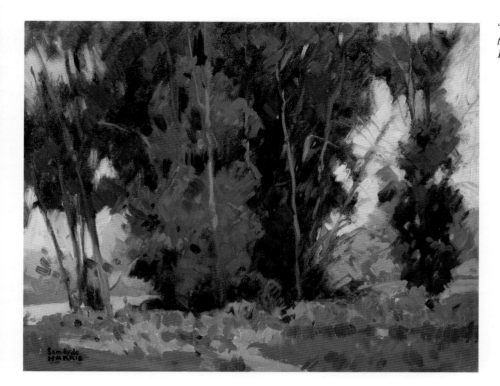

"Forest Edge". 16" x 20". C. 1935. *Collection of Vic and Carol Buccola. Courtesy of Jim Konoske.*

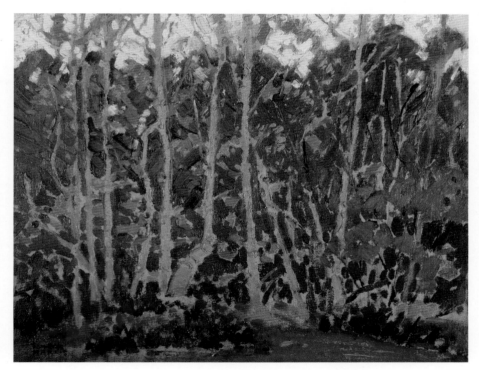

"Trees." Oil on board. 16" x 20". C. 1935. *Collection of Harris Estate.*

Same time period different styles, soft edges, muted tones, and bright dabs and dashes.

Detail of foliage and sky brush strokes in "Trees."

153

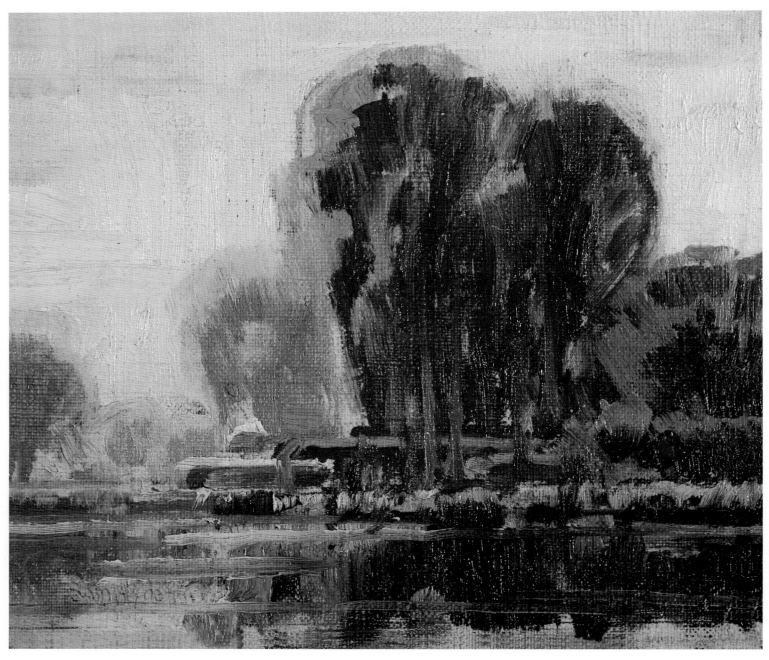

"House by Lagoon." Oil on canvas. 7" x 8". *Collection of Roger Renick.*

Verso of "House by Lagoon," showing signature example.

154

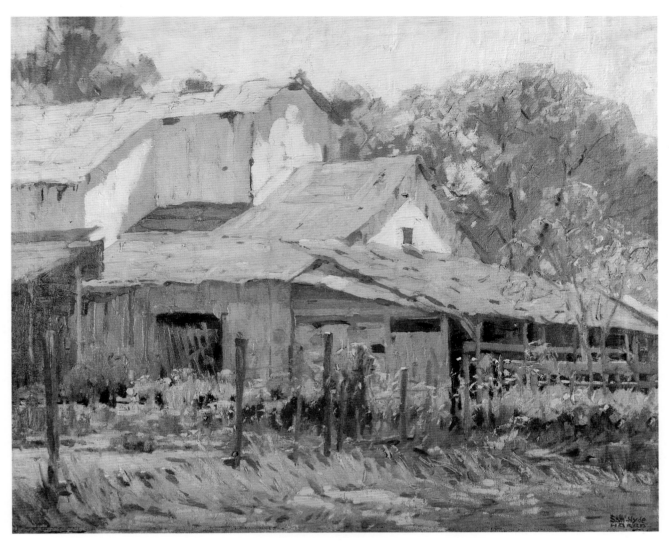

"The Barn." Oil on canvas. 20" x 24". C. 1935. *Private collection.*

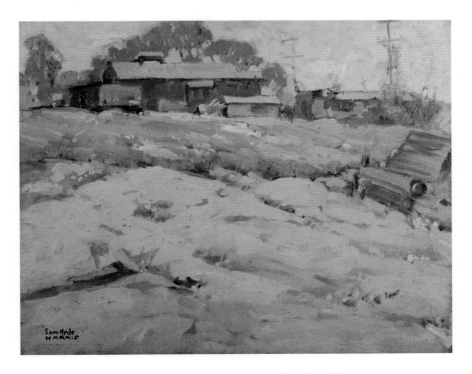

Untitled. Building on hill. Oil on canvas on board. 16" x 20".
C. 1940. *Collection of Harris Estate.*

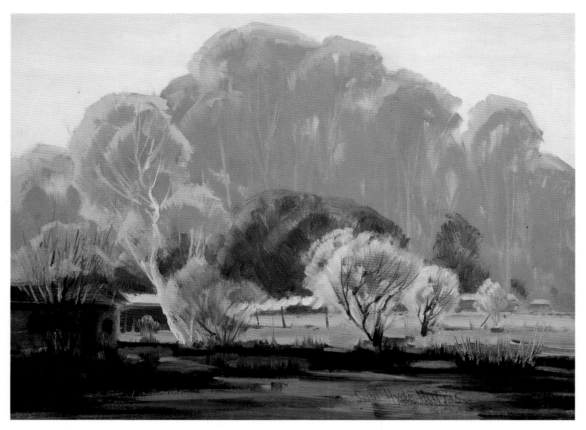

"Spring Memory." Oil on canvas on board. 12" x 16". C. 1948. *Collection of Gary Lang.*

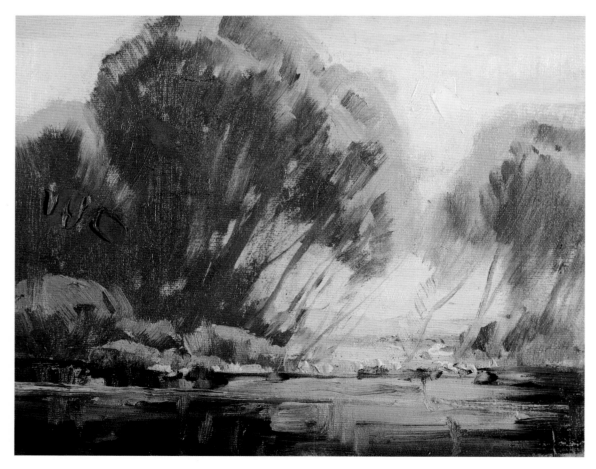

"Lagoon on the Baldwin Estate, now the Los Angeles County Arboretum, Arcadia, California. Oil on canvas. 8" x 10". C. 1938. *Collection of Charles N. Mauch.*

Section V: Harbors

Malibu, San Pedro, Sunset Beach, Newport, the majority of Sam's harbor and boat scenes are of working vessels in rural or developing coastal areas, many with interesting architecture, some with structures near dilapidation. A close look at the hazy backgrounds often reveals ghostly forms of an industrial complex or oil rigs.

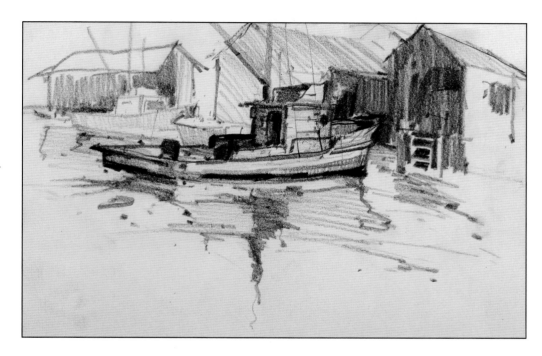

Untitled. Fishing boat with building. Pencil drawing on paper. 8" X 11". C. 1930. *Private collection.*

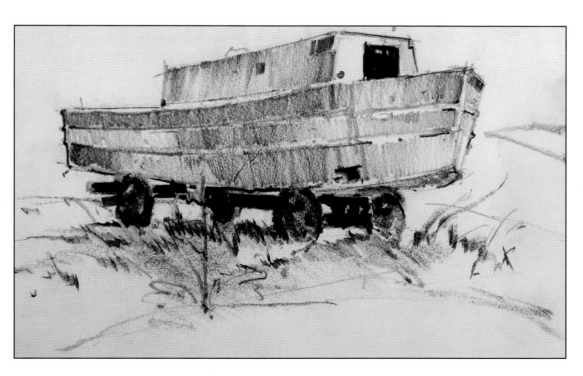

Untitled. Boat on trailer. Pencil drawing on paper. 8" X 11". C. 1930. *Private collection.*

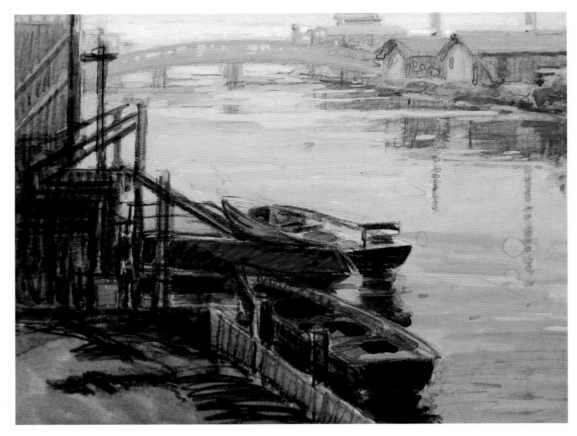

Untitled. Early San Pedro. Pencil and watercolor. 8" x 6". *Private collection.*

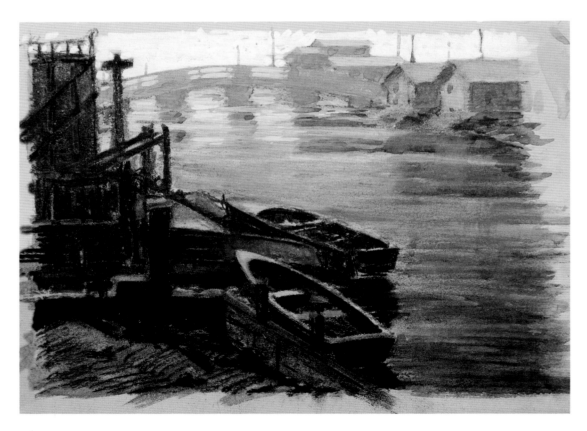

Untitled. Early San Pedro. Pencil and watercolor. 8" x 10". *Private collection.*

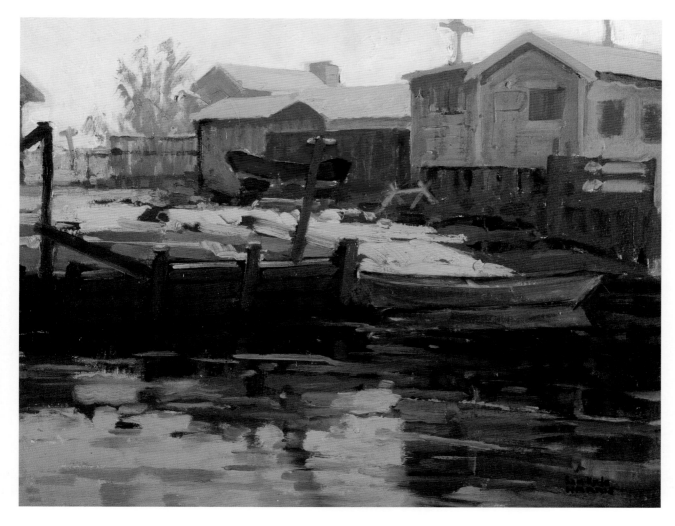

"Sunset Beach Lagoon." Oil on board. 16" x 20". *Collection of Charles F. Redinger.*

"Sunset Beach." Oil on board. 16" x 20".
Collection of Harris Estate.

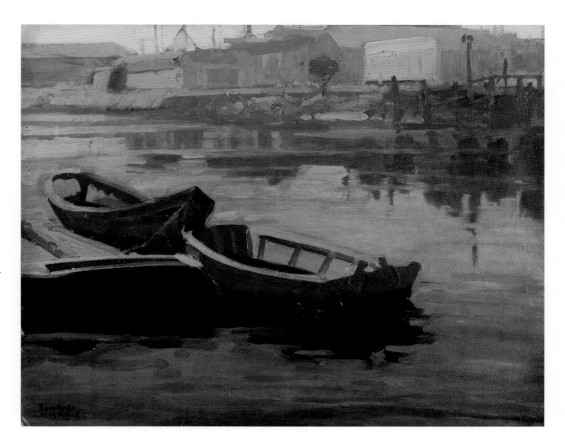

A Diversity In Style
Gary Lang, artist and collector

There are many elements that work together in composing a great Harris painting. Always a huge underlying factor, composition is just one of Harris's trademarks. While most painters would be satisfied with an "S" composition or the traditional "view through the trees," Harris pushed the envelope and, from very early in his career, experimented with progressive compositions, some even bordering on the avant-garde. He pushed the viewer's eye to an unexpected place, whether it be to the outer edge of the canvas or a lonely corner.

Harris used this approach in the majority of his harbor paintings. The outer edge of the canvas holds the main focus of the subject matter, whether it be diminished in a heavy atmosphere or funneled into interesting geometric shapes formed with confident brushwork and harmony through color. By this forced composition, it creates unrest and agitation. This forces the eye to seek rest, a peaceful, expansive space, which, combined with contrasting delicate brushwork and gentle reflections, strongly enhances the illusion of tranquility. The water becomes meaningful and inviting instead of a mere solution to a composition problem. This full use of the outer edges of the canvas for focal attention, dramatically contrasting the large areas of space, is reminiscent of the abstract expressionists of the late forties and early fifties. Though their subjects were primarily non-objective and paint was applied freely, the basic principles of composition don't change.

Harris did not always push the composition to an extreme horizon or low horizon. He also found ways to pull you into the painting, almost entice you. This was accomplished by the particular angle he incorporated with the main subject. For example, a boat may be resting at a three-quarter pose with a mere hint of the wooden docks, leading you to the negative space of the water with its reflections. Its effect is to lead you into the painting showing the nobility of the boat at rest, not just another boat portrait. This same nobility is what I find to be one of the keys to Harris's success as a painter. A few lonely eucalyptuses on a sand spit, far in the distance, deep in the mist, humble, yet grounded with his sensitive brushwork – a poetic ensemble.

One can't say the name Sam Hyde Harris without thinking of atmosphere. Even his quick field sketches have this very distinct quality. He calculated a precise angle of foreground shadow. This helped build the composition, but that was not its sole purpose. The foreground shadow brings the viewer to a comfortable place, though it doesn't end there. This same shadow, with its intense color saturation, helps to dictate the palette of the painting. This same saturation acts as a strong contrast, giving the atmosphere its intense drama. If we were to void color completely and use these principles we would have a painting similar to an oriental ink wash, darker in the foreground and lighter in the diminishing distance. Most early California painters would have been satisfied with this effect, but this was

just the start for Harris. He then would carefully calculate how to achieve the maximum amount of depth, through atmosphere, using color. A fine example of this is seen in the painting "Back Waters," (*see page 138-139*). The tree in the foreground has a deep green shadow base set off by the yellow green highlights. He then used a very warm purple shadow base on the eucalyptuses to back drop these highlights, knowing very well that this combination is opposite on the color scale. As the eucalyptuses fade in the distance the warm purple becomes cooler in an almost scientific manner, as though with every 20 feet you could see a subtle color change. Good draftsmanship help accentuate this effect, and so does a very important harmony in the use of rich grays. He did not just add white to achieve distance through atmosphere. He used complex color combinations, those shades in between colors, juxtaposing to create depth. The final element Harris applied in "Back Waters" was the complete change in color by distance. Notice the space between the eucalyptuses. If they continued in a line the viewer would see a subtle gradation of color from mauve to purple to blue. Harris was aware of this, but the sky dividing the trees made it impossible to juxtapose these colors. I believe the more obvious choice would have been to use a cooler purple on the eucalyptus trees to the right as he did in other areas of the painting. He, however, didn't conform. He chose a rich blue gray showing that these trees were on the same plain, yet they were indeed further away. This distinct blue also indicates a heavy sky, letting one understand why the eucalyptuses might be so plush. With a few hazy clouds acting as a subtle veil, the entire composition becomes a complete success.

Harris obviously had a great understanding of depth through atmosphere. As we discussed, he used composition, color, and good draftsmanship to accomplish this. However, one of Harris's true gifts was his use of light in atmosphere to create an amazing quality all his own. The painting "Lucky Baldwin Ranch" (*see page 131*) is an excellent example of this. For the foliage in the foreground, he used underhanded brushstrokes, while toward the top of the trees he used downward thrusting strokes, and in the distant hills his brushwork was more horizontal. In all this brushwork, the structure of the impasto was extremely important to Harris. As color diminished, Harris wanted to still have strength in the distance. With this poignant brushwork, a raking light will capture this depth through this use of impasto. Harris was taking an incredible approach. It shows how important atmospheric strength was to him. The painting may be void of most color in the distance, but he was literally sculpting paint to catch the majesty of depth. This is apparent in the way he handled the cabin in the far distance between the eucalyptuses. It's the heavy paint that indicates this cabin, not color. This same impasto also describes most of the details in the distance. What's unusual here is that most artists would paint the heavier impasto in the foreground with a thin impasto in the distance, but Harris did just the opposite. He was more concerned with the distance. That's why I believe this painting, with its incredible glowing light, might be one of the greatest examples of atmospheric light by any early

California painter, even those that painted in Giverny.

I have used the phrase "pushing the envelope" in regards to composition, although that isn't the only time Harris pushed against conventions. He also took certain risks in the department of subject matter. Titles like "The Poor House," "Depression Era," "The Old Shanties," describe the subjects that intrigued Harris. At a time in California when most painters were painting plush landscapes, poppies and lupines, or glamorous portraits, Harris was more enticed by the decrepit shacks at Sunset Beach, the huge cargo cranes and oil derricks of San Pedro, the abandoned factory just outside of Wilmington; or, for that matter, a working factory in full bloom adorned, with its walls and fences undisguised and the enormous smoke stacks as an ominous backdrop emitting smoke in the elegant matter, a gentle veil of atmosphere softening the harshness of reality. Only a handful of California painters of that era would attempt to paint such subjects, and usually they met with little success. Yet, these were Harris's subjects, his domain! The true diamonds in the rough, and I believe they even exceed the grandeur of his noblest eucalyptus standing tall in the glowing atmosphere. Though the eucalyptus may be beautiful, it is the section of industry, the coastal salvage yard, or the lagoon shack, that Sam painted so well, with his distinct brushwork, his progressive composition, and an atmospheric harmony in grays catching a richness where time stops, that one wonders what it would have been like to walk down that path and look inside.

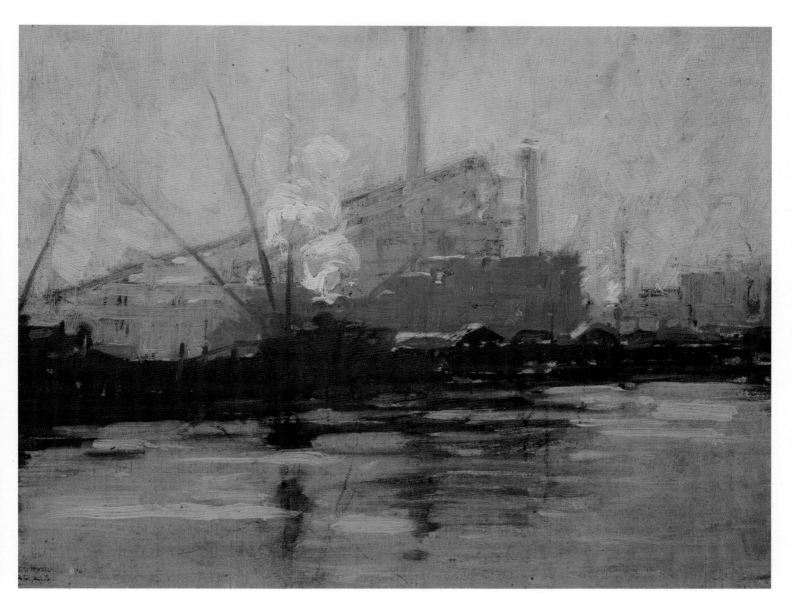

"Industrial Romance."

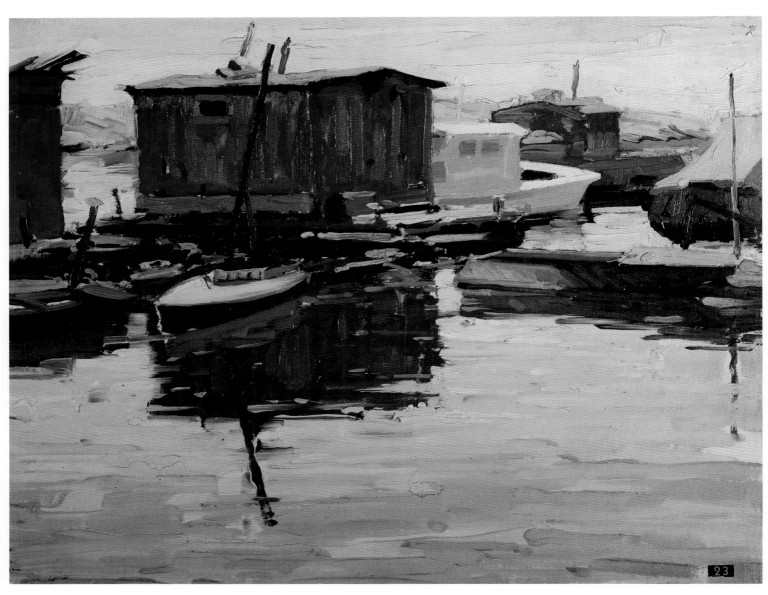

"Floating Palace." Oil on board. 16" x 20". *Collection of Harris Estate*.

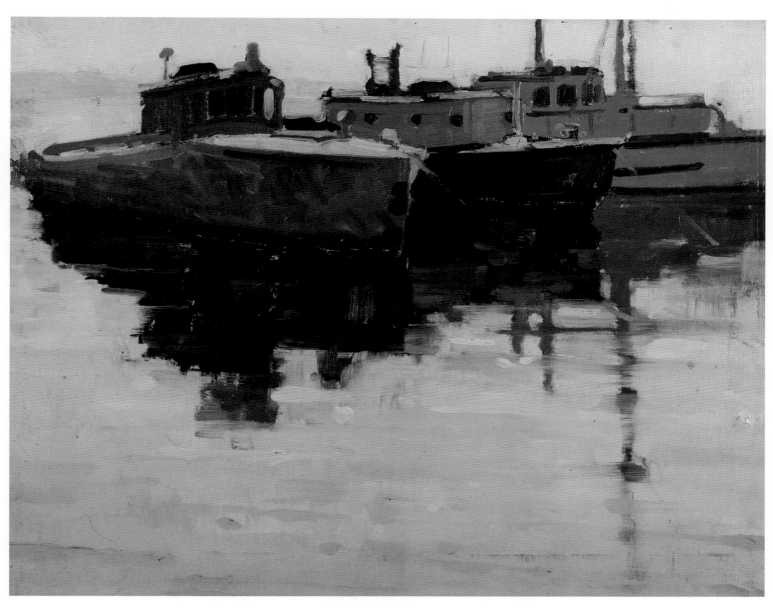

"Three Old Boats." Oil on board. 16" x 20". *Collection of Harris Estate.*

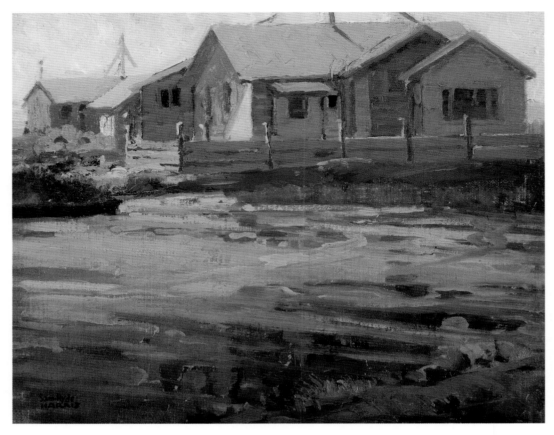

"Lagoon Shack" Sunset Beach. Oil on board. 16" x 20". *Collection of Gary Lang.*

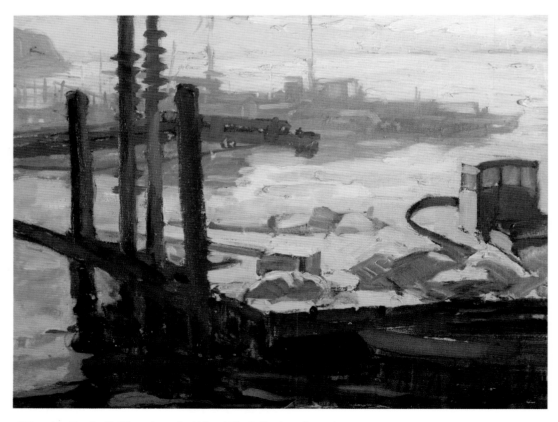

"Floating Docks." Oil on board. 12" x 16". *Collection of Harris Estate.*

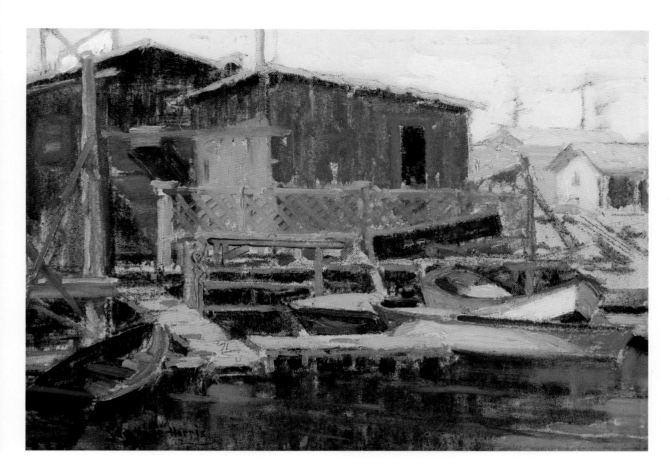

"Sunset Beach, Depression Era," sketch for Depression Days. Oil on board. 10" x 14". *Collection of Gary Lang.*

Sam's placement of row-boats against piers almost becomes abstract designs.

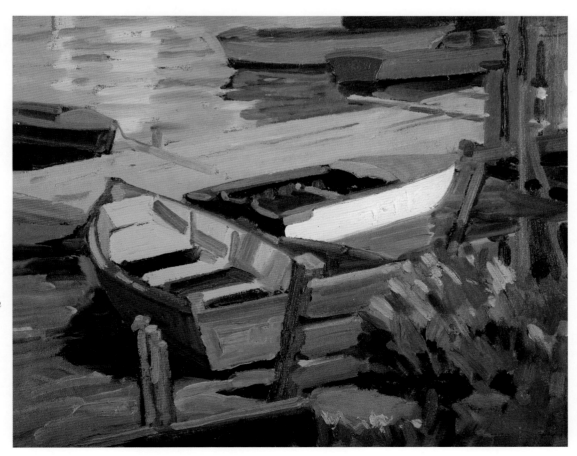

Untitled, colorful boats. Oil on board. 16" x 20". *Collection of Harris Estate.*

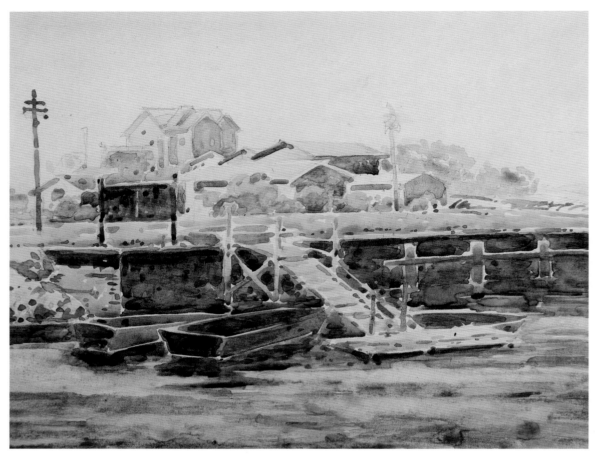

Untitled. Watercolor on paper. 10" x 12". *Collection of Charles N. Mauch.*

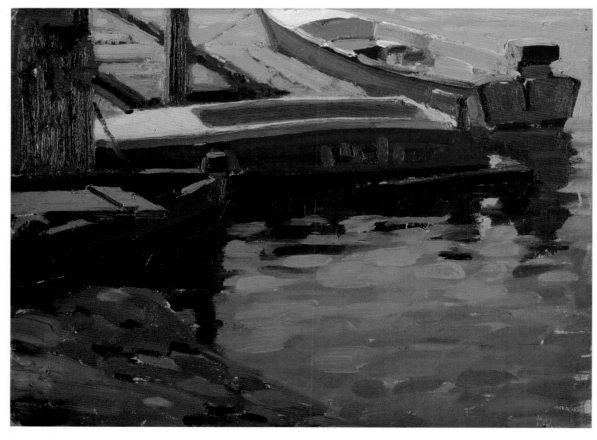

"Boat design." Oil on canvas on board. 12" x 16". *Collection of Harris Estate.*

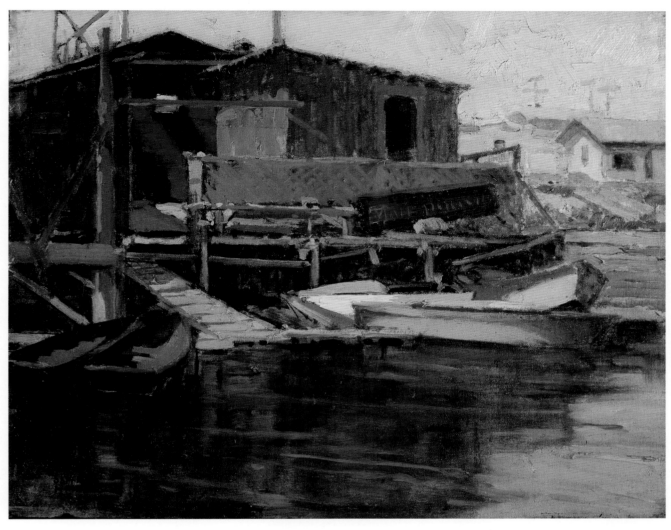

"Depression Days." Oil on board. 16" x 20". *Collection of Charles N. Mauch.*

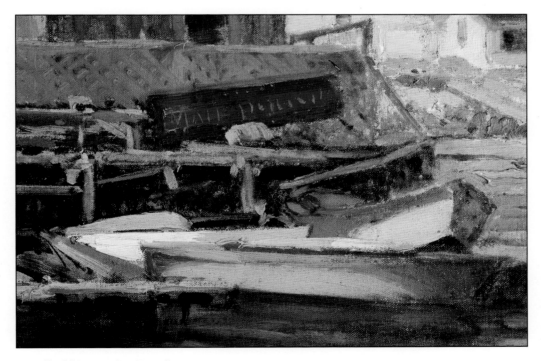

Detail of "Depression Days."

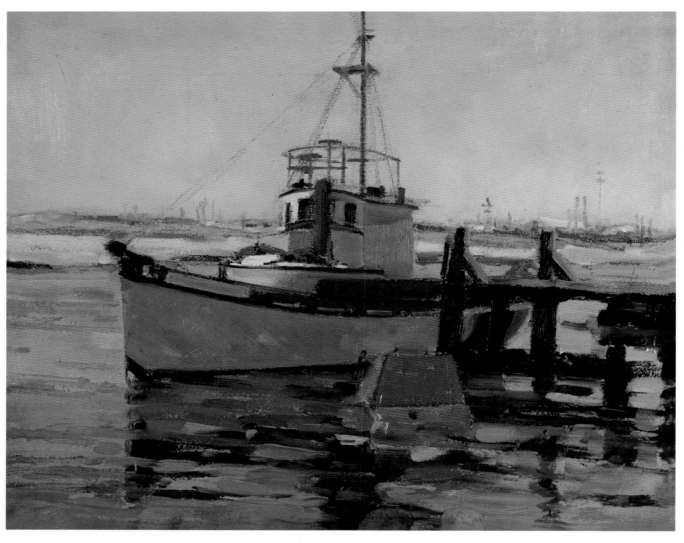

"The Red Buoy." Oil on board. 16" x 20". *Collection of Harris Estate.*

Detail of "The Red Buoy." Industrial area in background created with dabs and dashes of color.

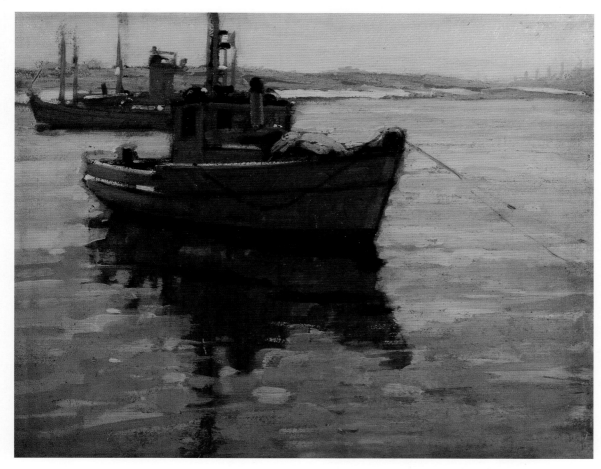

"Yellow boat." Oil on board. 16" x 20". *Private collection.*

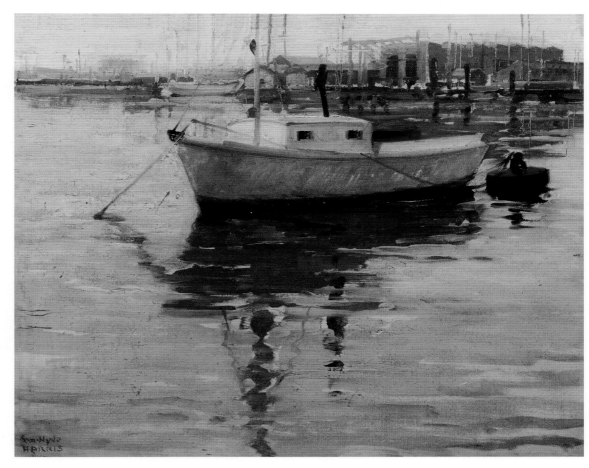

"Morning." Oil on board. 16" x 20". *Collection of Harris Estate. Provenance: Personal collection of Marion Dodge Harris. Exhibited: April-May Exhibit, Laguna Beach Art Association (Honorable Mention).*

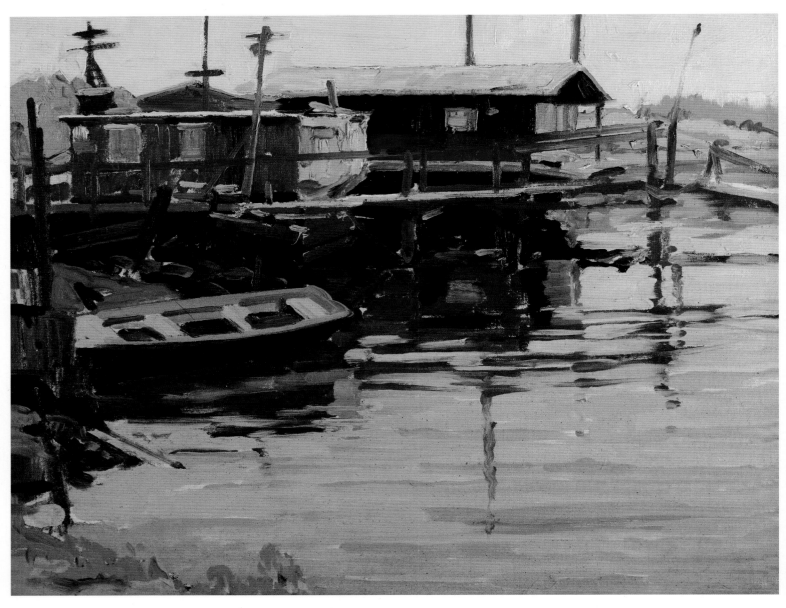

"Andy Landing." Oil on canvas on board. 16" x 20". *Collection of Harris Estate.*

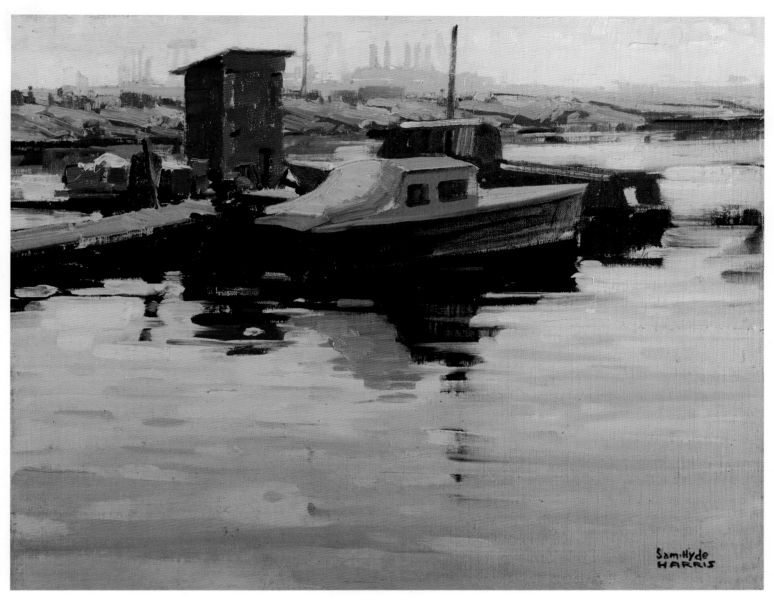

"Boats Moored." Oil on board. 16" x 20". *Collection of Harris Estate.*

Detail capturing the industrial background in "Boats Moored."

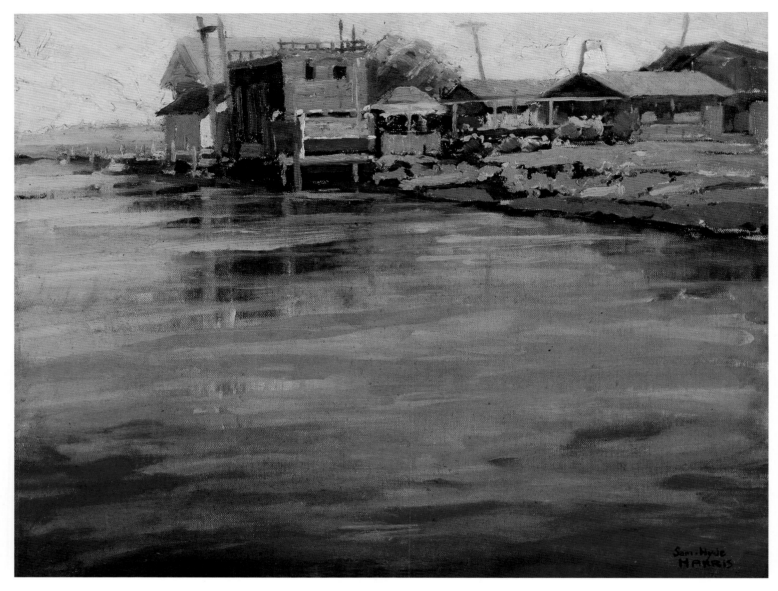

"Sunset Beach." Oil on board. 16" x 20". C. 1930. *Collection of Roger Renick.*

Detail of unusual architecture in "Sunset Beach."

Detail of garden and architecture in "Sunset Beach."

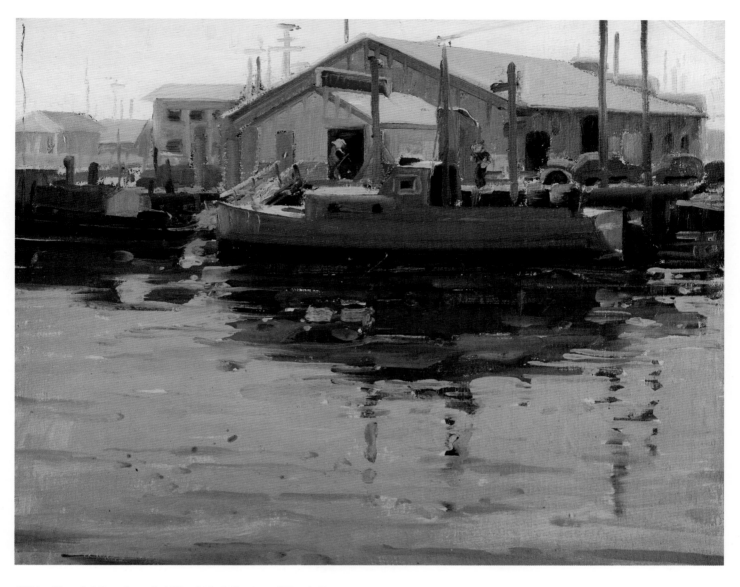

"Ship Ahoy." Oil on board. 16" x 20". *Collection of Harris Estate.*

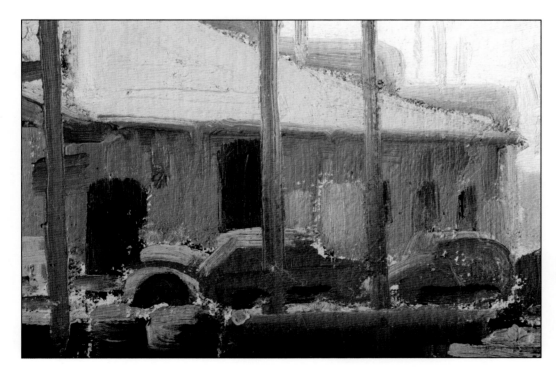

Detail of "Ship Ahoy," showing cars parked on the wharf.

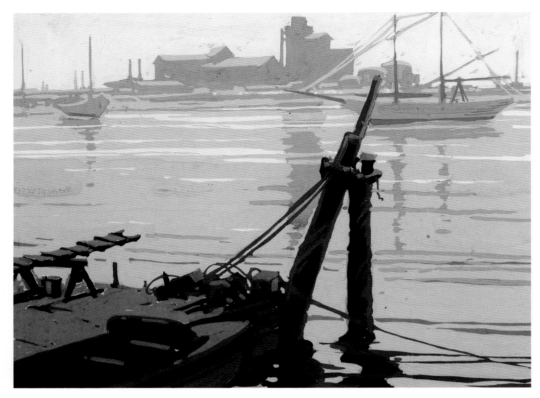

"Aquatint Sketch." Pencil and Tempera on poster board. *Collection of Charles N. Mauch.*

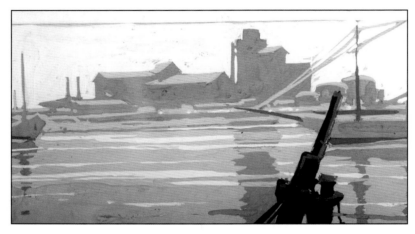

Detail of the old Ford plant in the distance of "Aquatint Sketch."

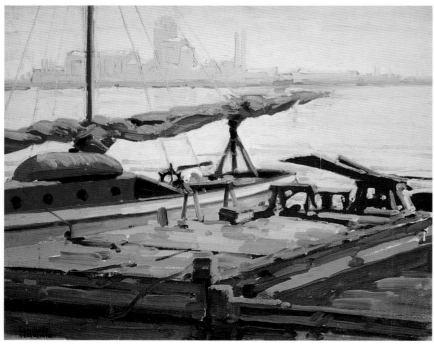

Untitled. Oil on canvas board. 16" x 20". *Collection of De Ru's Fine Art, Laguna Beach.*

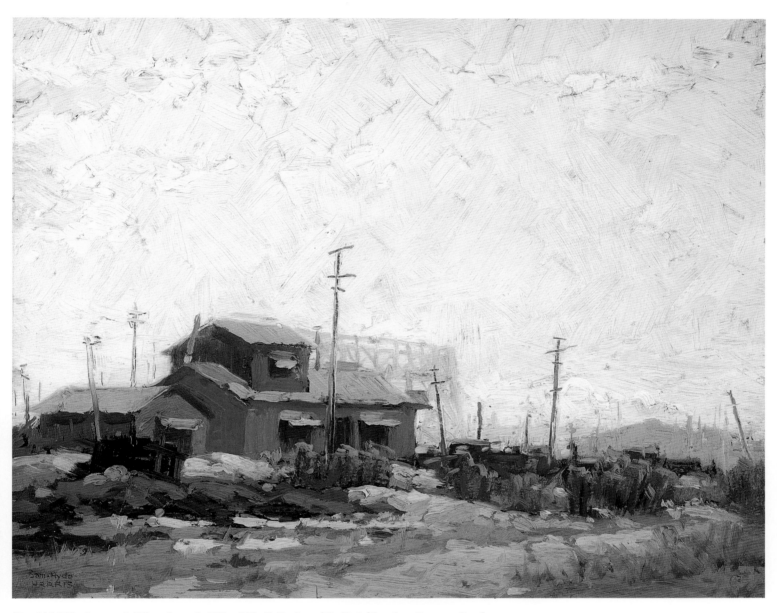

"In Old Wilmington." Oil on board. 16" x 20". *Collection of De Ru's Fine Arts, Laguna Beach.*

Center medallion of a tablecloth design (*see page 52*). Colored pencil on paper, C. 1935.

Old Chavez Ravine, the scene before Dodger Stadium was constructed.

"Chavez No. 1." Pencil sketch on paper.
3" x 4". *Private collection.*

"Chavez No. 2." Pencil sketch on
paper. 4" x 3". *Private collection.*

"Chavez No. 3." Pencil sketch on paper.
3" x 4". *Collection of Charles N. Mauch.*

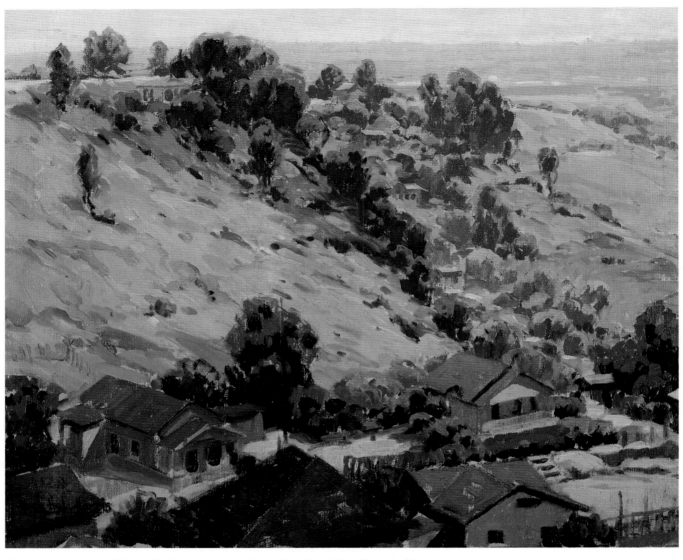

"Chavez Ravine, California." Oil on canvas on board. 20" x 24". *Collection of Gary Lang.*

Sketch for "Chavez Ravine, California." Pencil on paper. 4" x 3". *Private collection.*

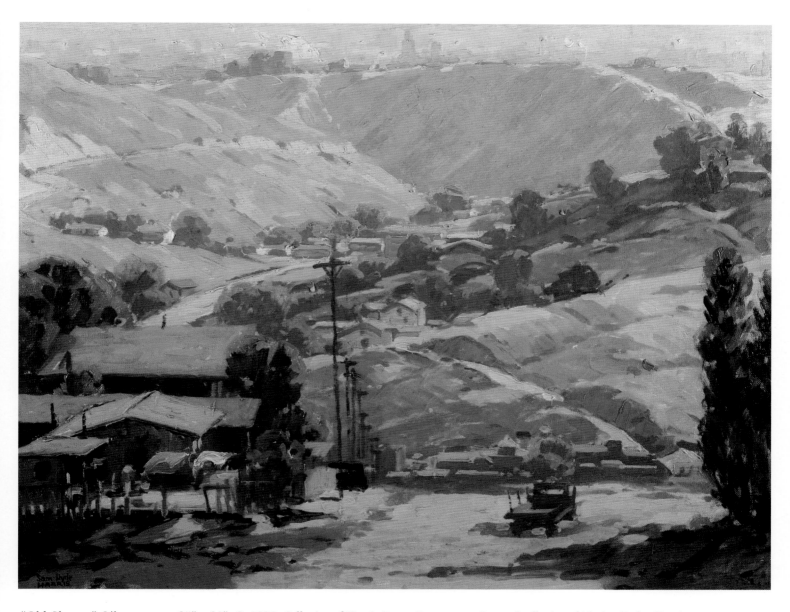

"Old Chavez." Oil on canvas. 25" x 30". C. 1938. *Collection of Harris Estate. Provenance: Personal collection of Marion Dodge Harris.*

Detail of the Los Angeles skyline in "Old Chavez."

Examples of his graphic skills; the simplicity and the complexity of lines.

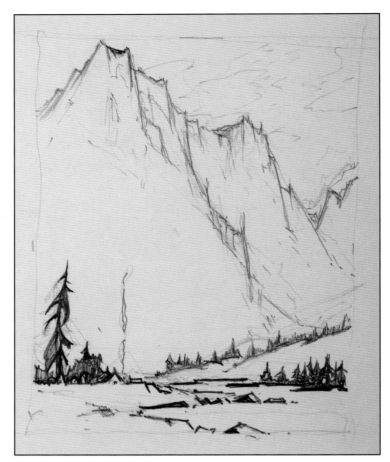

Untitled. Pencil drawing on paper. 8" x 7". *Private collection.*

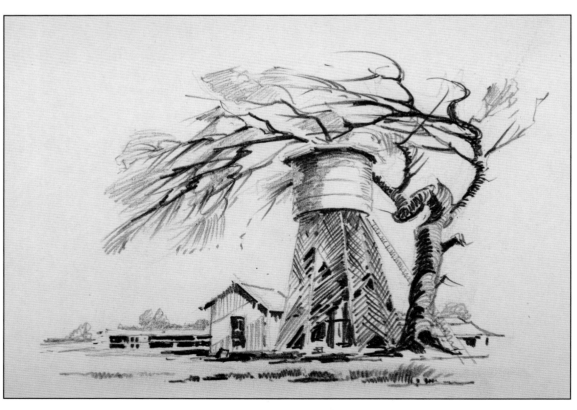

Untitled. Pencil drawing on paper. 8" x 10". *Private collection.*

During the forties and fifties, Sam's style became looser, with broader strokes, frequently leaving areas for the underpainting, consisting of a thin wash of color, to show. Here he used these thinly washed areas to create depth. It is in these paintings that we can clearly see his characteristic charcoal underdrawing. Sam always drew his composition on the surface before applying paint.

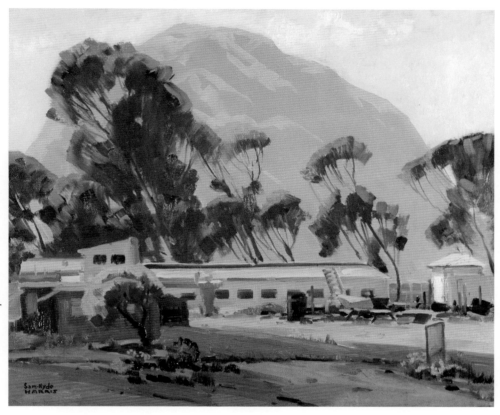

"Morro Rock Environment." 22" x 28". C 1938. *Collection of Richard and Christina Doren.*

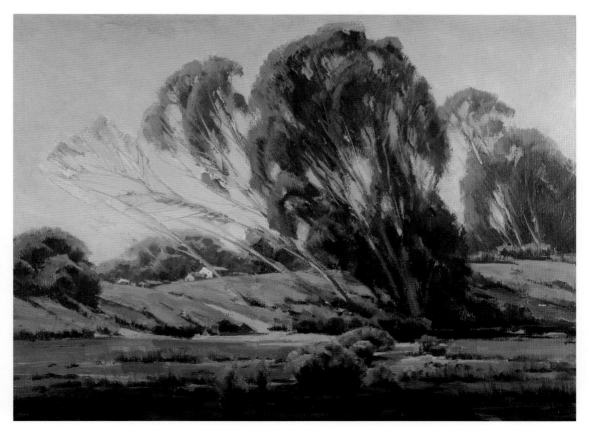

"Enchanting Memory." South Pasadena, Alhambra, California. Oil on masonite. 22" x 28". *Collection of Harris Estate.*

181

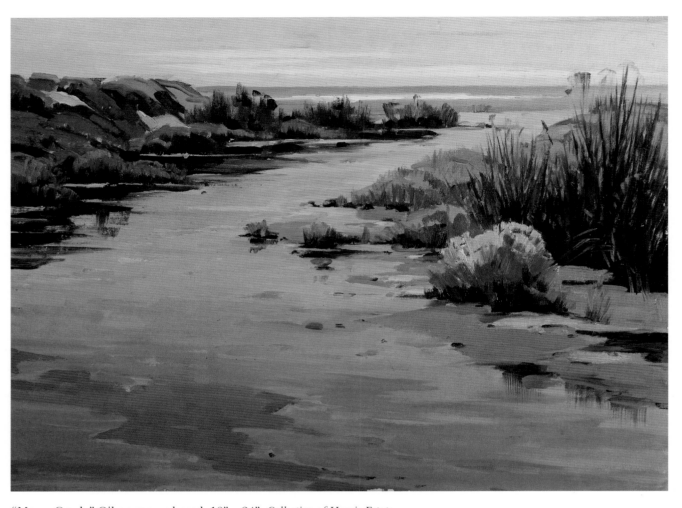

"Morro Creek." Oil on canvas board. 18" x 24". *Collection of Harris Estate.*

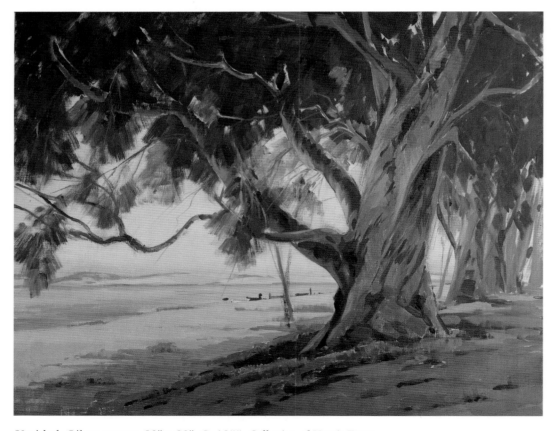

Untitled. Oil on canvas. 22" x 28". C. 1955. *Collection of Harris Estate.*

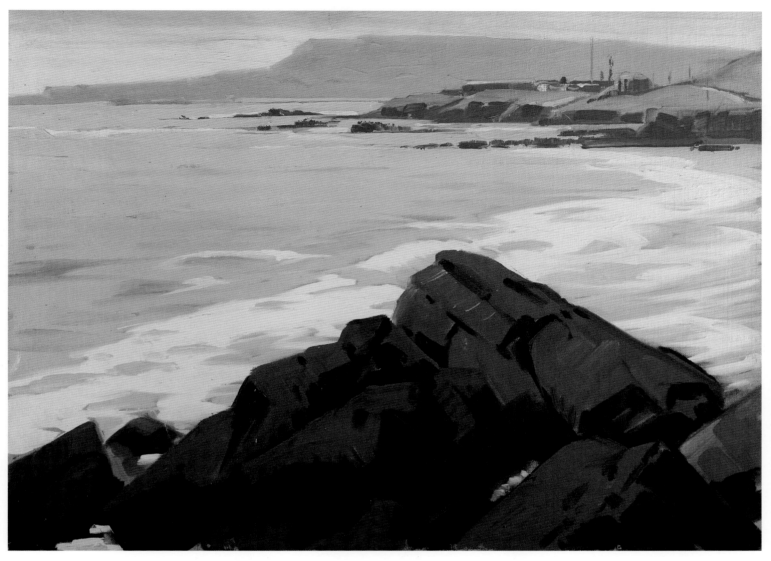

"Mexican Coast." Oil on canvas on board. 18" x 24". *Collection of Harris Estate.*

This detail of "Mexican Coast" shows Harris's application of paint in creating the structures in distance.

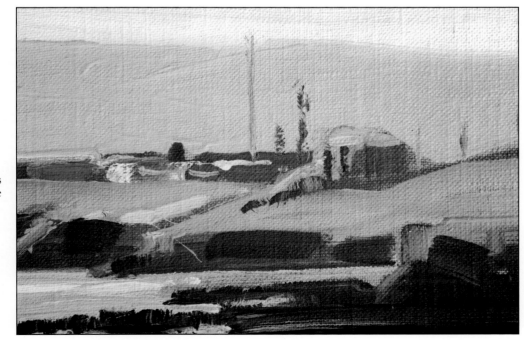

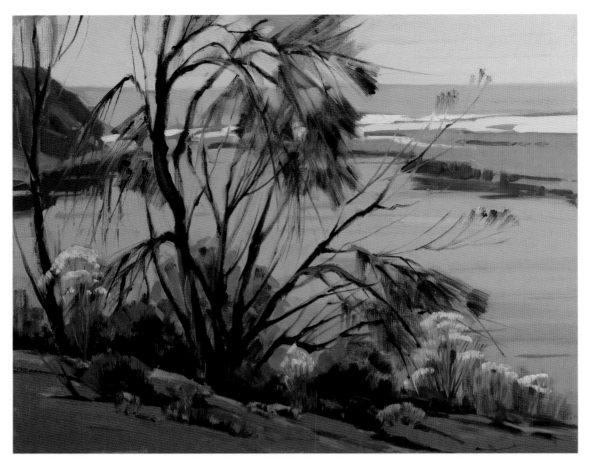

"Near Carlsbad." Oil on masonite. 16" x 20". *Collection of Harris Estate.*

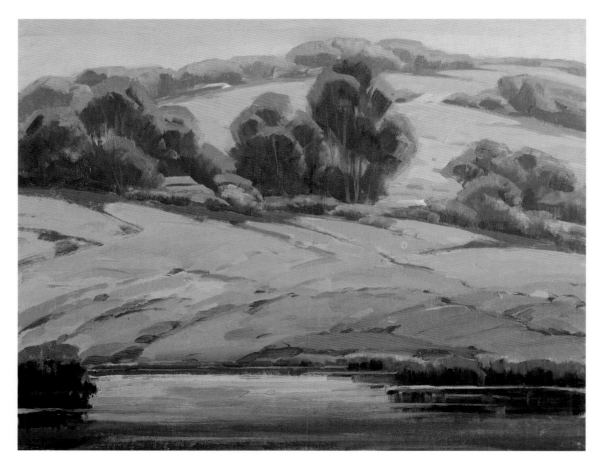

"Carlsbad Contrasts." Oil on artist board. 16" x 20". *Collection of Harris Estate.*

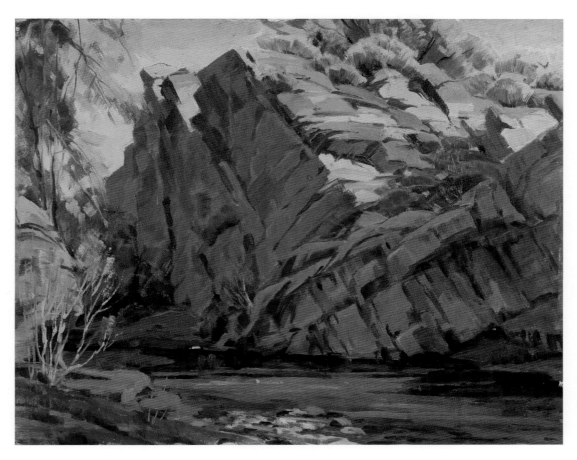

"The Narrows." Oil on masonite. 16" x 20". *Collection of Harris Estate.*

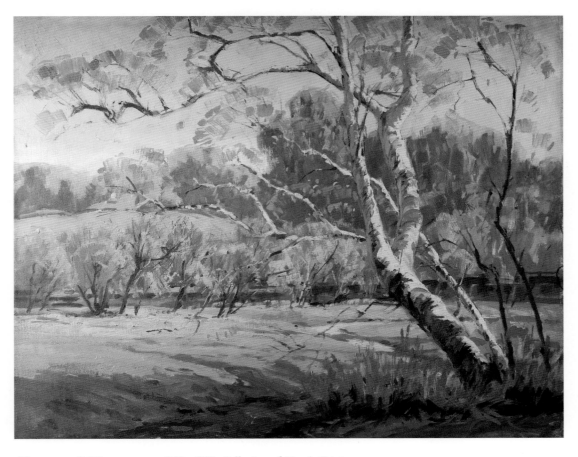

"Sycamore." Oil on canvas. 25" x 30". *Collection of Harris Estate.*

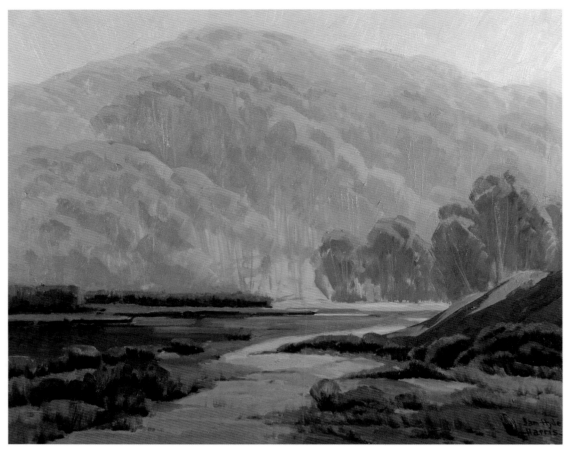

"Enchanted Lagoon." Oil on canvas. 22" x 28". *Collection of Harris Estate.*

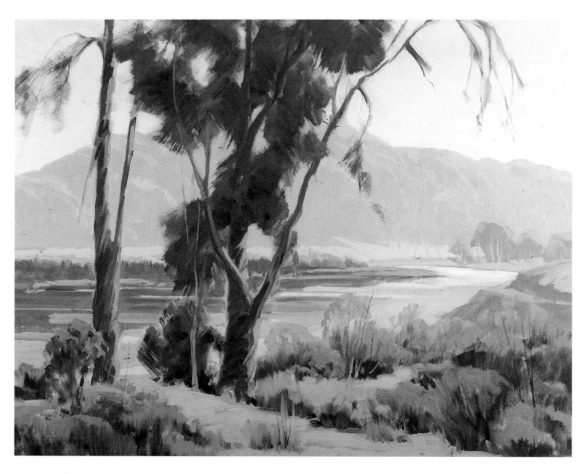

"Carlsbad Sanctuary." Oil on canvas. 24" x 30". *Collection of Harris Estate.*

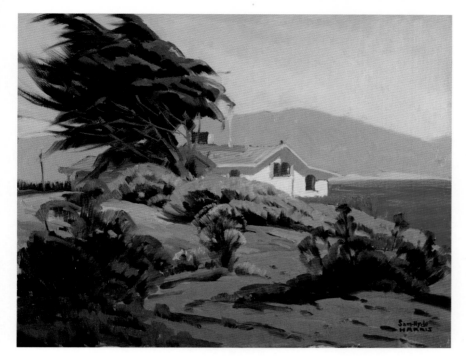

"Prevailing Breeze." Oil on canvas on board.
16" x 20". *Collection of Charles F. Redinger.*

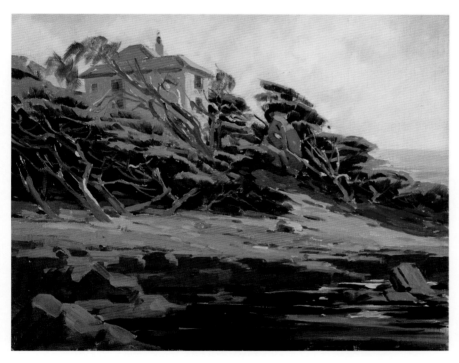

"Monterey Mansion." Oil on canvas on board.
16" x 20". *Collection of Harris Estate.*

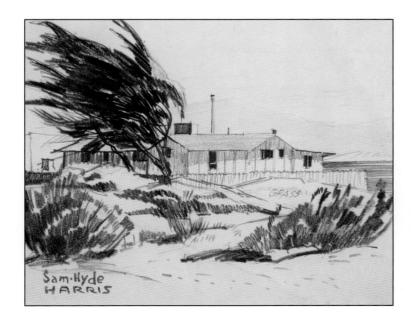

Pencil sketch for "Prevailing Breeze." 7" x 9".
Collection of Charles F. Redinger.

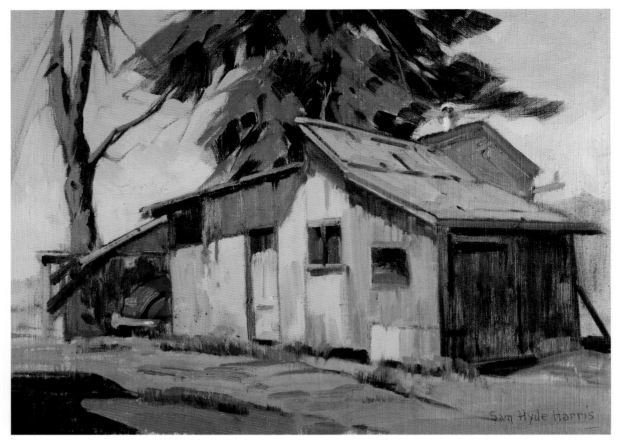

"Weather Worn." Oil on canvas on board. 18" x 24". *Collection of Harris Estate.*

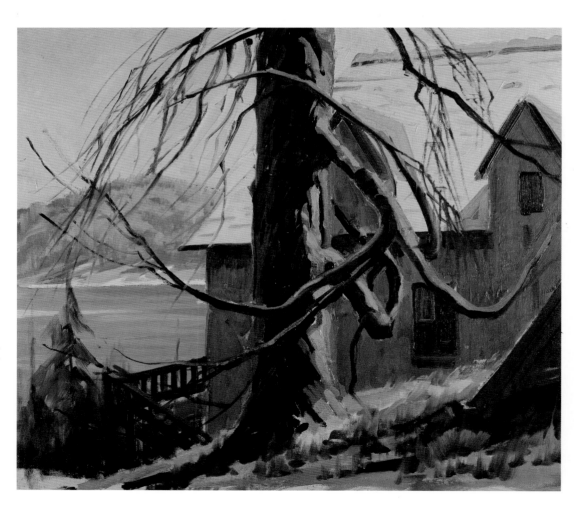

"Knarled Veteran." Big Bear. Oil on artist board. 18" x 24". *Collection of Harris Estate.*

BARNS AND SHACKS By SAM HYDE HARRIS

Pictures of barns and shacks can, in a sense, be portraits. A painting of some of the characters in our city squares, those characters on the retired or just the tired side of life, show the strains of heredity, environment and battle with the elements. Shacks, and in many instances barns, likewise reflect hopes and plans of their owners, the targets of their sights, the favor or disfavor of mother nature; whether the owners hoped to share an ample bounty or merely intended to protect a penurious portion. Look at these structures, study them, and your imagination will lead you.

A most paintable subject, and in the earlier days listed on BMAI's location sheet was barn A. It was in the Montrose district. Originally it possessed the conventional dull red, but perhaps the lean part of an economic cycle or the subdividers' avarice cut into its sustaining area so that it fell into quite a state of disrepair. Never-

theless the erectness of posture and the remnants of a self-sufficiency show through.

The little shacks (B) backed up on the lagoon at Sunset Beach and cast a furtive and roguish role. They were constructed of almost anything, and one could imagine that during prohibition a fair grade of liquor was obtainable if one knew the right words. Recently, while making a 12 x 16 sketch of this subject from across the lagoon, a lady took a peek at my sketch and remarked, "Well, we have always looked on that place as an eyesore. I never realized, until I saw your work, there was something picturesque about it."

Utah has a barn that seems to be typical of that state. A sharply pitched roof and "air-conditioned," that is, it practically has no sides worth mentioning. "Utah Gothic" is the title of C, and

in color, with golden hay in the barn, the time-worn roof against the reddish mountains and semi-desert foreground, make a combination that is a thrill to attempt to put on canvas. It heroically and sympathetically interprets the struggle of its inhabitants to live their lives.

They had previously lived in the lands of plenty, but experienced persecution there. In Utah they found less than average of nature's bounty. Those who were to live there must be content with less than a life of ease. Frugality was stamped on most human work. the barn typifies frugality. The air-conditioning is not modern design, but austerity in construction materials.

These barns and shacks tell a part of a great story. Here, they are not intended to be complete essays of economic, social or religious significance. They are intended to prove that there is a story in each barn and shack, just as there is similarly a story in every human life. The story teller with words produces a literary achievement. The story teller with brush and paints produces a true picture. Not just a documentary, simple, declarative thing, but something higher — an interpretation, in a sense a portrait, a character study.

(To be continued)

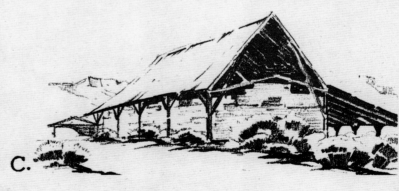

"Barns and Shacks" by Sam Hyde Harris.

BARNS AND SHACKS . . . By SAM HYDE HARRIS

(Continued from March issue)

Some barns and shacks dominate while others are dominated by their surroundings. Simple things like the direction of the roof's slope will show in the growth of the nearby trees. A shack with a single plane roof, if it slopes toward the trees may provide additional run off of rain and this may show in the trees' vitality. If the roof slopes away, depriving the trees of water, it may produce an obvious opposite effect. In turn the nearness of the trees to the building may produce actual chafing of trunk or branches on the shack. The dropping of foliage will show in the aging of roofs depending on materials. Constant shade may produce parasitical growth on the roof and sides. The above in addition to the reflection of light and the absorption of color suggest possibilities of domination.

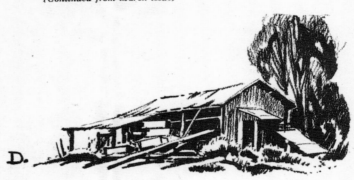

D.

Sketch D. A little old shack on the Anita Baldwin estate that was interesting to paint from many different angles. For years it was known as project No. 1 for the young painter. It was a dull blue green, framed with beautiful eucalyptus, and many times proud peacocks preened themselves in the sun, a rare combination, unfortunately no longer available since the ruthless subdivider has taken over.

Aside from dominating or being dominated, trees and buildings may exist in harmony. Winds of destructive force may be tempered by wind-breaking trees. Flash floods that roar out of mountainous or hilly areas may have their courses diverted by root systems that hold the ground intact. Barns that might otherwise have their tops blown off or their footing washed from under them owe continued existence to the "mother-

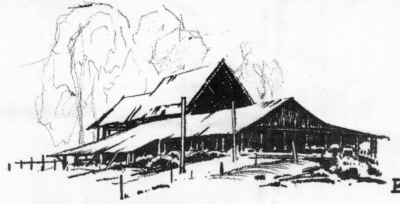

hen" qualities of protective trees.

Just a little way out of St. George, Utah, is the location of pencil sketch E. The barn is a riot of color, backed right up against the red-orange hills, and framed with yellow-green and dark green trees. The sharp pitched roof is yellow-orange and grey. The closely flattened roof is light turquoise blue with some yellow-orange (rust, no doubt). A typical blue, blue Utah sky and vari-colored bushes in the foreground complete the picture. Quite a challenge for anyone to tackle!

Barns are not always the protected. They are protectors. In some cases, of the brawny, muscular type. Those harboring heavy produce have to be such. A multipurpose barn combining shelter for grain, burly farm animals or grapes has to be strong.

The Southern California barn (sketch F)—a memory sketch—was, I believe, originally a winery, but is now used for horses. It perhaps comes as close as any to being a "TYPICAL" Southern California barn. Some unusual and particularly interesting barn material is located in the San Luis Obispo and Morro Bay country, but perhaps this is enough "Barnstorming" for now.

E.

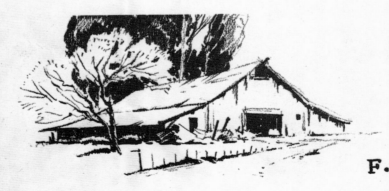

F.

"Barns and Shacks" by Sam Hyde Harris.

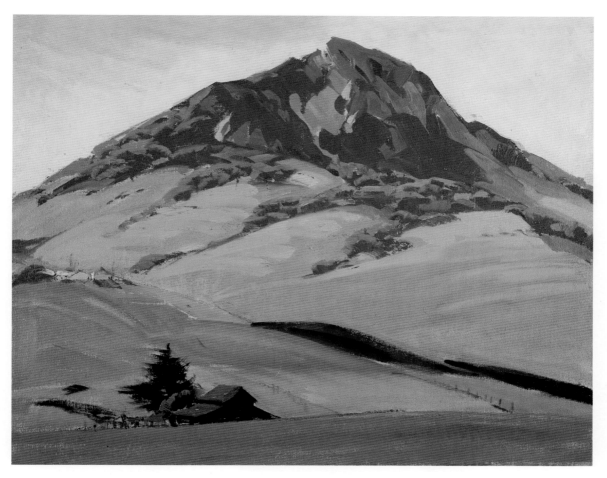

"Sheltered Ranch." Oil on canvas on board. 16" x 20". *Collection of Harris Estate.*

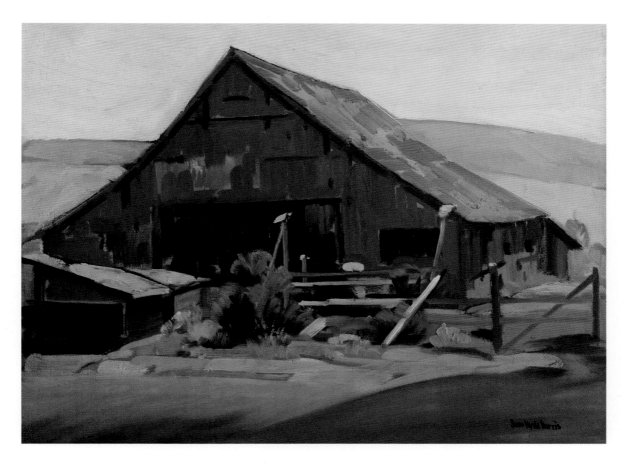

"Weathered." Oil on masonite. 18" x 24". *Collection of Harris Estate.*

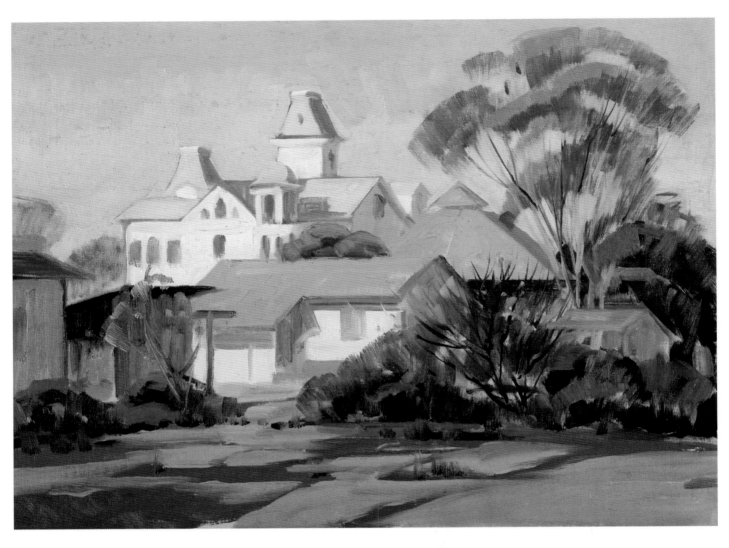

"Twin Inns, Carlsbad." Oil on canvas on board. 18" x 24". *Collection of Gary Lang.*

Photograph of Sam teaching a class. *Collection of Harris Family.*

Section VII: The Deserts & Mountains

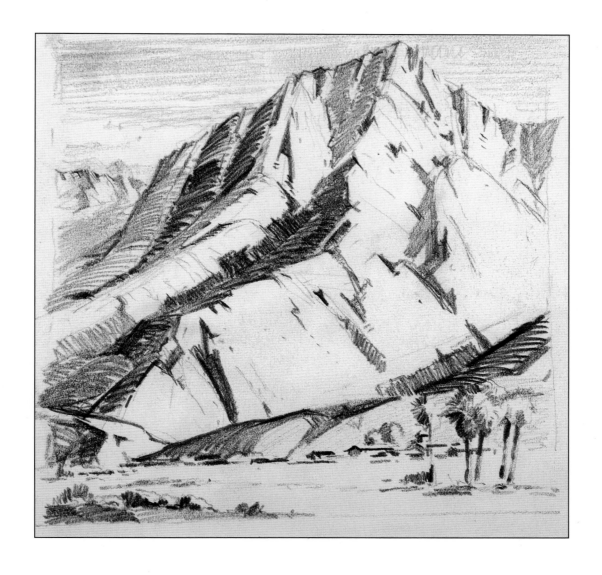

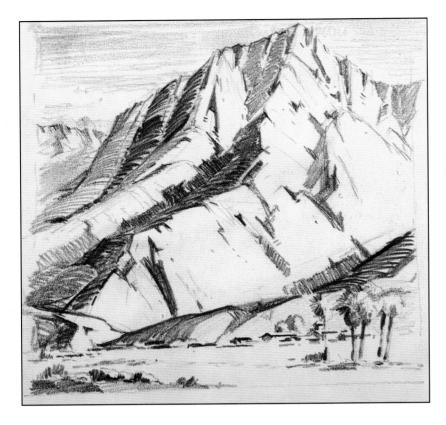

Untitled. Drawing of Palm Springs. Pencil on paper. 8" x 10". *Private collection.*

Untitled. Pencil drawing of Palm Springs. Pencil on tissue. 8" x 5". *Private collection.*

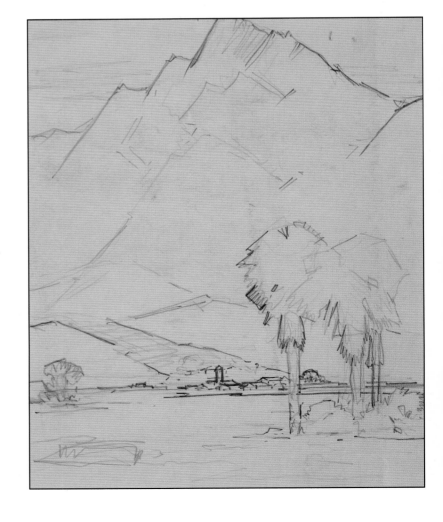

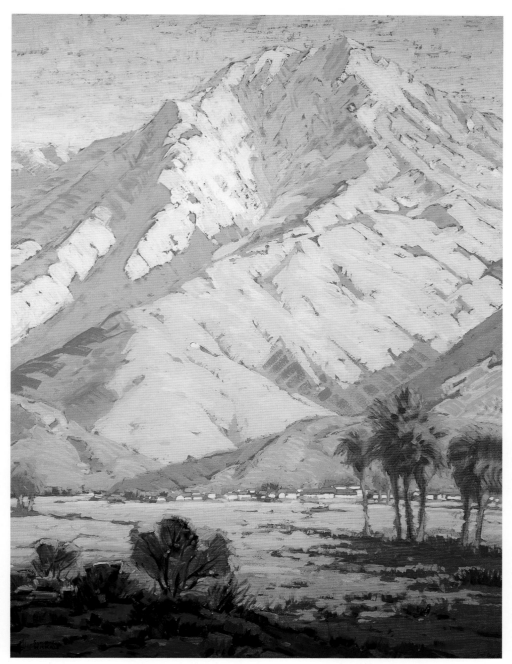

"Early Palm Springs." Oil on board. 40" x 30".
C. 1928. *Collection of Edenhurst Gallery, Thom Gianetto, Don Merrill and Dan Nicodemo.*

Detail of "Early Palm Springs."

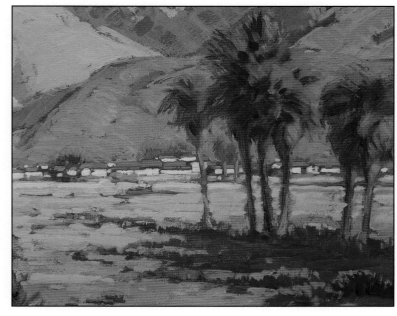

"Harris's Brush Imparts Drama"

Howard Burke

Los Angeles Examiner, June 5, 1960

If popularity makes a painter, and art is the catalyst, then Sam Hyde Harris is one of the finest artists in the Southland.

His paintings are of qualities that classify them among the choicest. This debonair artist has a sunny personality that is transmuted directly to his paintings, reflecting the light, atmosphere and cheerful California scene to the fullest.

There are no problems to solve. No one has to learn to like his restful offerings.

Harris studied with Hanson Puthuff one of the greatest Southland landscape painters, and is a sound craftsman, having learned his lessons well.

He is particularly strong in composition, subtle with color. His formula for painting produces a consistently pleasing picture.

Lester Bonar, top water colorist, and long time friend, praising Harris as a portrayer of desert and mountain scenery, says,

"He imparts a sense of drama to each painting, producing the effect of drawing you into the picture."

A native of Middlesex, England, where he began his art education, Harris has lived here since 1904. Later, he was abroad to study the old masters and further his studies in art schools of Paris, and London. He also attended the school of Will Foster, the noted illustrator, here.

Harris now has a collection of 43 top award ribbons and "purchase prize" awards. He continues to paint pictures for art patrons and for his many one-man shows.

His paintings have been chosen for Southland high school and college buildings, such as Berendo Junior High School, Pierce College in San Fernando Valley, Alhambra High School, San Pedro High School, Gardena High, Clearwater High and Dixie College, St. George, Utah.

Harris has three sons, two of them artists in the Carmel Monterey area. Another son is a businessman of Seaside, California.

Life member and former Director, Laguna Beach Art Association, and Whittier Art Association.

Listed in "Who's Who in American Art" and Western Division of "Who's Who."

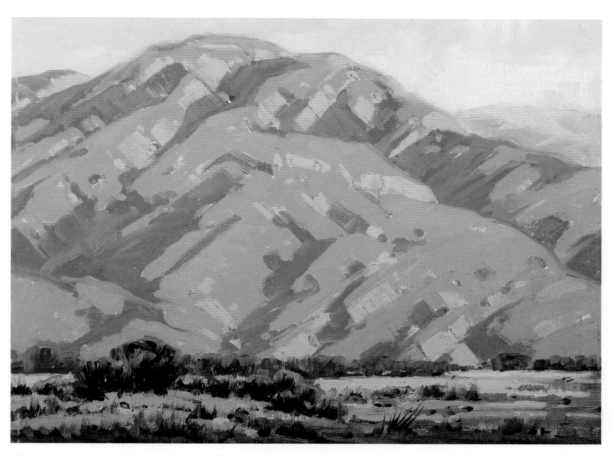

Harris was a master of mountains, up close and far in the distance.

"A Mountain." Oil on canvas on board. 12" x 16". *Collection of Gary Lang.*

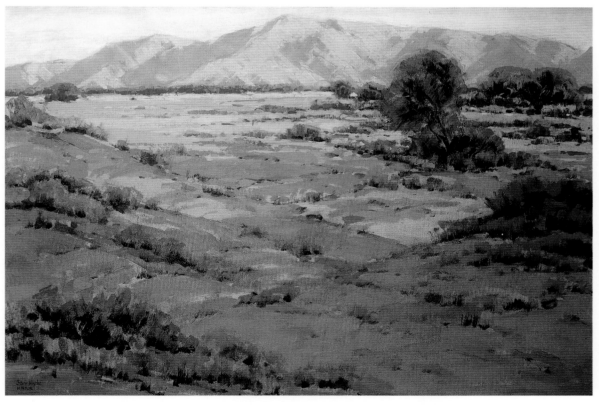

"Desert Design." Oil on canvas on board. 18" x 26". *Collection of DeRu's Fine Art, Laguna Beach.*

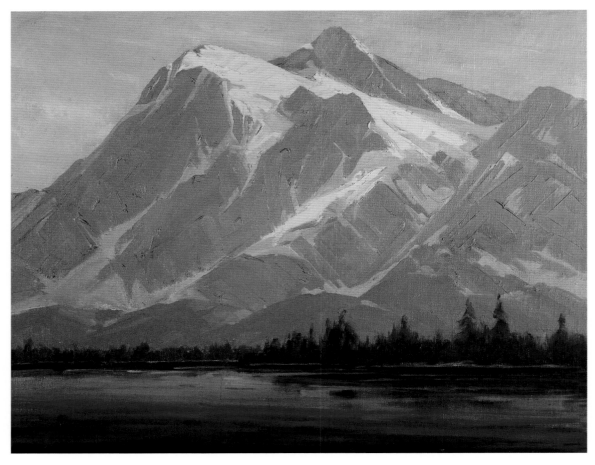

"Cascades." Oil on canvas on board.16" x 20". *Collection of Harris Estate.*

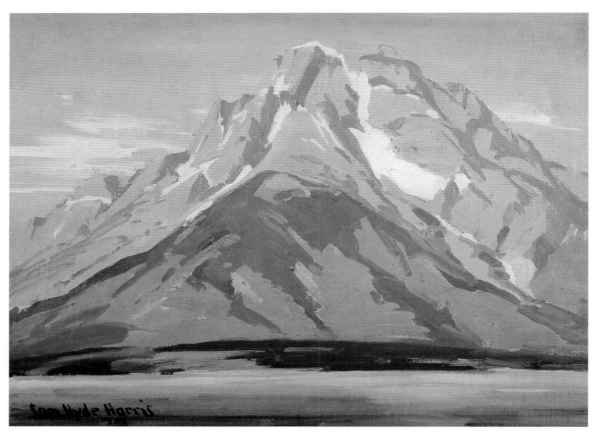

"Regal Heights." Oil on canvas on board. 12" x 16". *Collection of Harris Estate.*

198

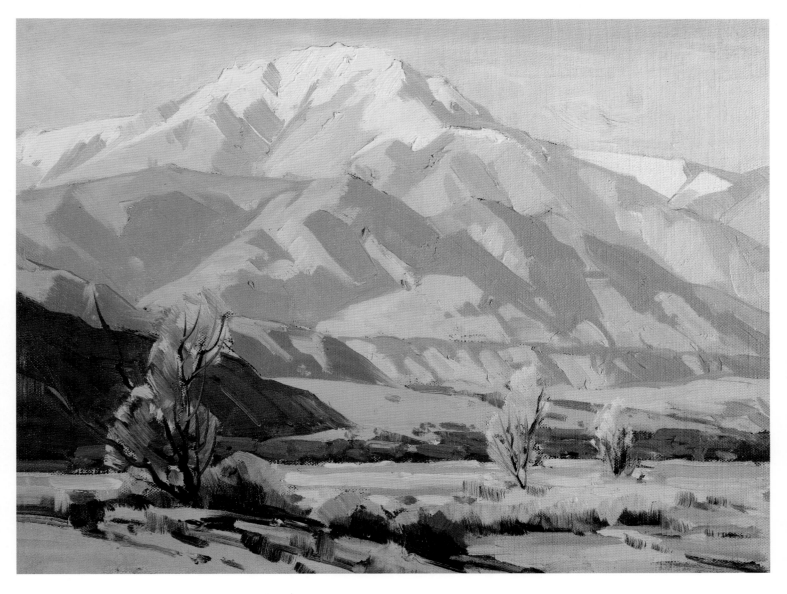

"Snow Capped." Oil on canvas on board. 12" x 16". *Collection of Harris Estate.*

Sam on location. *Collection of Harris Family.*

THE ART SPIRIT AND GRAND CANYON
by SAM HYDE HARRIS

"What do you mean, we can't take our trunks into Arizona?"

"Too bad, boys. Hoof and mouth disease!"

Pasadena station, July, 1924. Two artists — or at least one and a half—rarin' to go on a four weeks' painting jaunt to the Grand Canyon and at the last minute we discovered one trunk containing easels and painting equipment could not be taken into Arizona from California for fear of carrying the hoof and mouth disease.

After a hurried conference we decided to go ahead and hope for the best; to pull the proper wires to get our stuff through when we arrived at El Tovar, Grand Canyon.

Hanson Puthuff, the distinguished painter of Southern California's foothills and mountains, had a commission to make a large painting of the canyon for the Santa Fe, and urged me to tag along. (It took little urging!)

The hotel manager immediately took steps to get our trunks through. After a week of more or less exasperation, they arrived unopened. Hanson had brought along a copy of Robert Henri's "Art Spirit," one of the most inspirational books on painting I have ever perused. (Highly recommended for all young painters. Out of print, I understand, but most libraries have a copy or two.) Here, I am full of Henri's art spirit, with this magnificent panorama before me and nothing to work with.

On one occasion we took a Fred Harvey car trip to the Painted Desert Indian Trading Post and various other points. Noontime we pulled into a kind of oasis with cottonwood trees for shade and a big table for lunch. About the time we arrived, John D. Rockefeller Jr., his secretary and three sons came in and we had lunch together — a very pleasant visit. John D. was a very excellent fellow, except he wore suspenders instead of a belt.

In attempting to describe the canyon, one realizes the futility of words. We worked from the rim for the following two weeks where the preliminary sketches for the big painting were made. After studying the canyon for a while, one feels about the size of a small peanut.

The last week we spent at Hermit's Rest at the bottom of the canyon — sent our stuff down by mule and walked it. The first part of the trip was not too bad, but with 113 in the shade and no shade for the last leg, I learned about that "last mile." Next time, if ever, I take me a mule.

The little sketch, more or less from memory, is Hermit's Rest. Going back up we went via mule.

HERMIT'S REST — by Sam Hyde Harris

"The Art Spirit and Grand Canyon" by Sam Hyde Harris, an article (BMAI, November 1951).

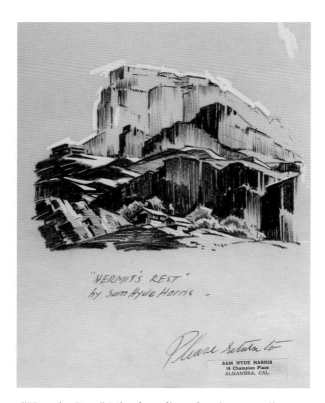

"Hermits Rest." Mixed medium drawing: pencil, charcoal, tempera on paper. 10.5" x 8". *Collection of Charles N. Mauch.*

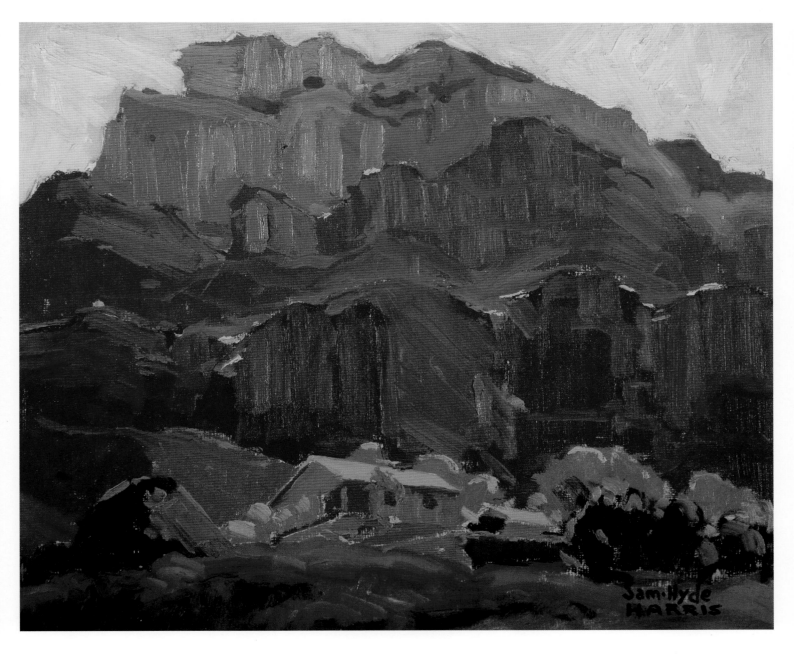

"Canyon Shelter," small oil of "Hermits Rest." Oil on board. 10" x 12". *Collection of Gary Lang.*

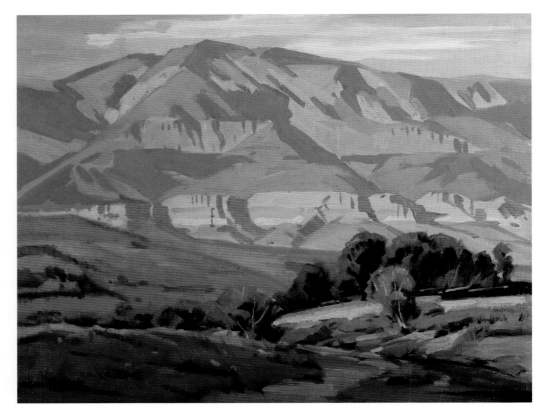

"Utah Vista." Oil on board. 16" x 20".
Collection of Harris Estate.

"Utah Fortress Sketch." Oil on artist board.
16" x 20". *Collection of Harris Estate.*

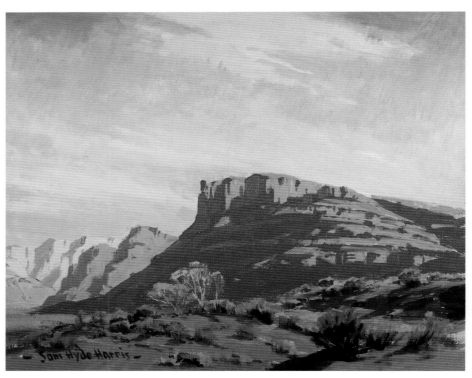

Photo of Sam and friends painting by
Utah Fortress. *Collection of Harris Family.*

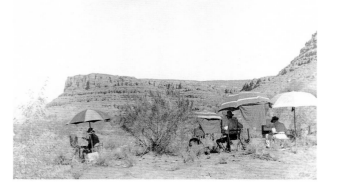

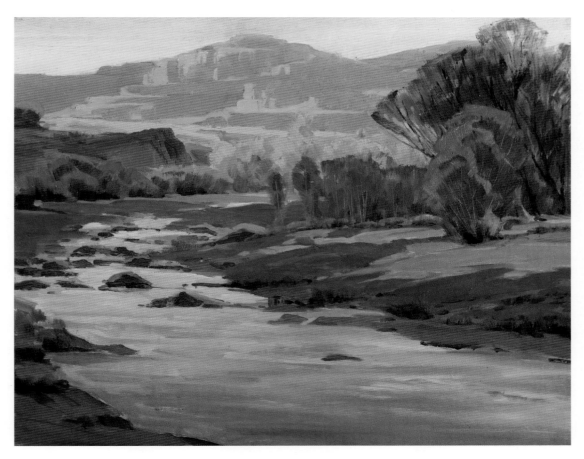

"Virgin River Utah." Oil on board. 16" x 20". *Collection of Harris Estate.*

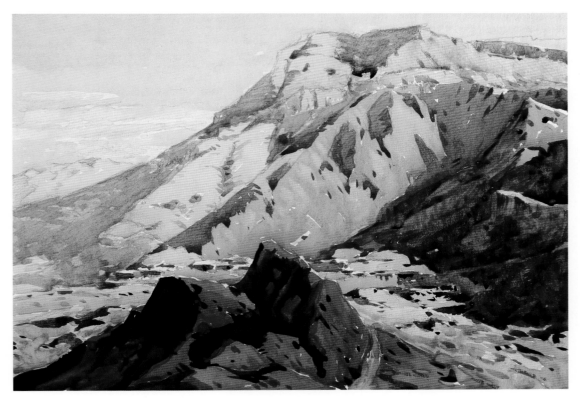

"Mountain Town." Watercolor on paper. 7.5" x 10.5". *Private collection.*

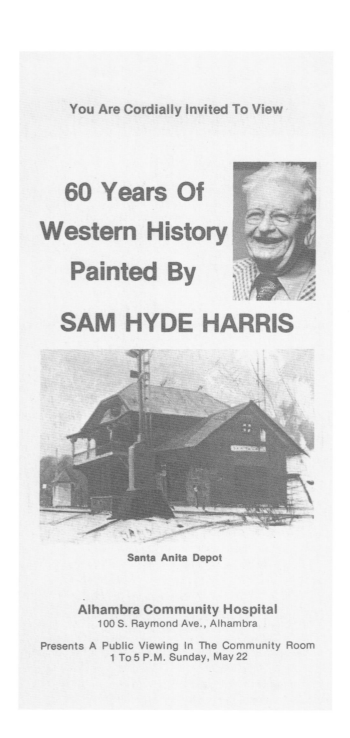

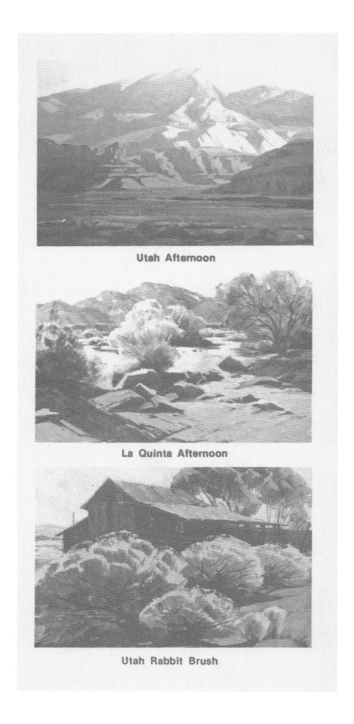

Brochure – 60 years of Western History.

SAM HYDE HARRIS . . .

The last living link between the present and the glamorous Bohemian artistic past of Alhambra when Charlie Chaplin, Gloria Swanson, Tom Mix, Will Rogers and Norman Rockwell were part of the artist colony-movie star set that centered around Alhambra— is Sam Hyde Harris.

Sam, along with fellow Western painter, the late Frank Tenney Johnson, was part of the celebrity-studded crowd that flocked to little Champion Place in Alhambra and made it an art center topped only in the 20s and 30s by Greenwich Village.

Today, Sam Hyde Harris is 88. He is a Life Member of Alhambra Community Hospital, and from his long-time Alhambra studio, he is still doing what he has done for most of his 88 years—recording the West with brush and pallette.

His canvases have the smell of mesquite in them, the clear air of high Western desert and mountains, the breath of the rugged California coast, the loneliness of a long-deserted railroad station, the battered beauty of a farmhouse, the low sprawling skyline of the Los Angeles of a half-century ago—the simple, beautiful face of the unadorned West.

Howard Burke has written of Sam: "If popularity makes a painter, and art is the catalyst, then Sam Hyde Harris is one of the finest artists in the Southland. His paintings are of a quality that classify them among the choicest . . . He is particularly strong in composition, subtle with color. His formula for painting produces a consistently pleasing picture."

Another writer has described Sam as "the Dean of Southern California landscape painters."

Born in England, Sam began his art career at 14 when he came to California and began sketching and painting what he found around him. In his earlier days, he designed award-winning posters, murals and advertising artwork for several of the largest railroads and financial institutions in the nation.

During his twenty-fourth year, he traveled across the United States and went to Europe, where he studied the works of the Great Masters in museums and galleries.

Back in California, he began teaching aspiring artists at the Chouinard Art Institute, the Long Beach Spectrum Club, and the Business Men's Art Institute. He also earned many purchase prizes and awards, and is honored with inclusion in "Who's Who In American Art."

For information about his paintings
phone Mr. Harris at (213) 281-7715

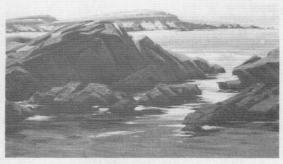

Calm Interval

Chavez Ravine

Carlsbad Depot

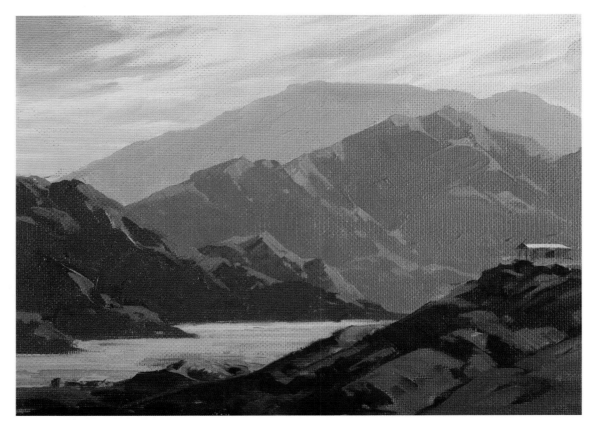

"Desert Retreat," Death Valley. Oil on masonite. 12" x 16". *Collection of Harris Estate.*

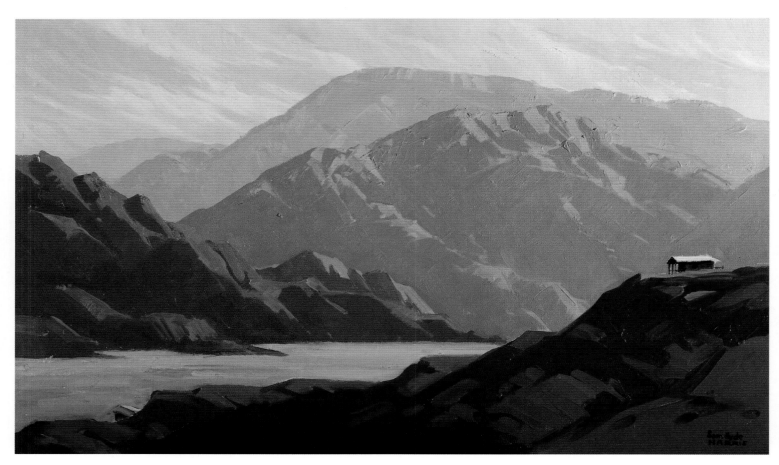

"Death Valley." Oil on canvas. 18" x 30". *Collection of Harris Estate.*

It is possible that this is a painting of the Calico Mining District in Death Valley, California.

Watercolor sketch for "Borax Mine." Watercolor on paper. 8.5" x 10.5". *Collection of Harris Estate.*

"Borax Mine." Oil on canvas. 24" x 32". *Collection of Moe Parniani.*

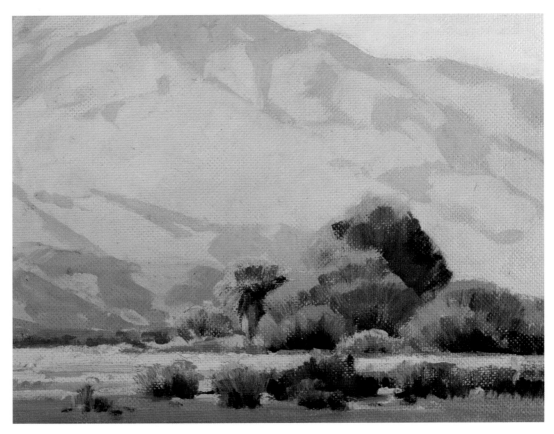

"Palm Springs." Oil on masonite. 12" x 16". *Collection of Harris Estate.*

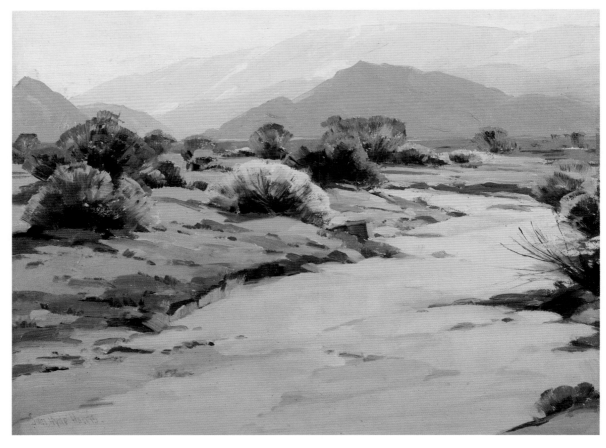

"Desert." Wash sketch for "Receding Snow." *Collection of Gary Lang.*

208

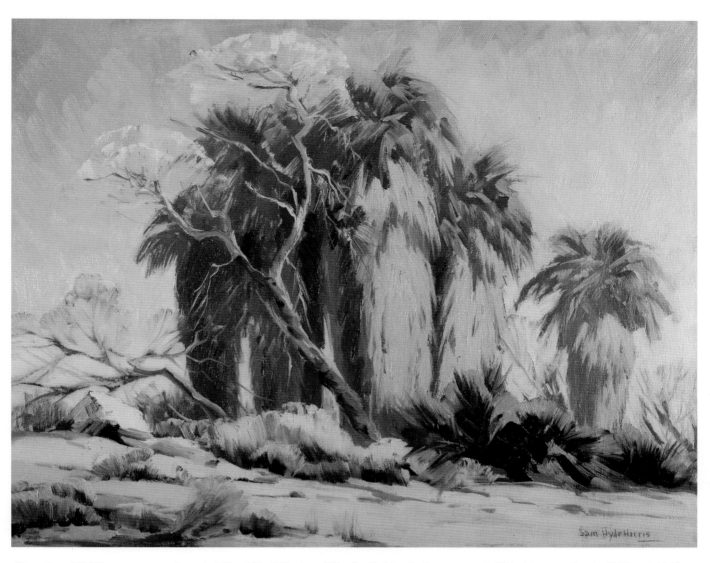

"Last Stand." Oil on canvas on board. 16" x 20". *Collection of Charles N. Mauch. Provenance: Exhibited Laguna Beach, 1952 and 1960.*

Verso, exhibition tag for "Last Stand."

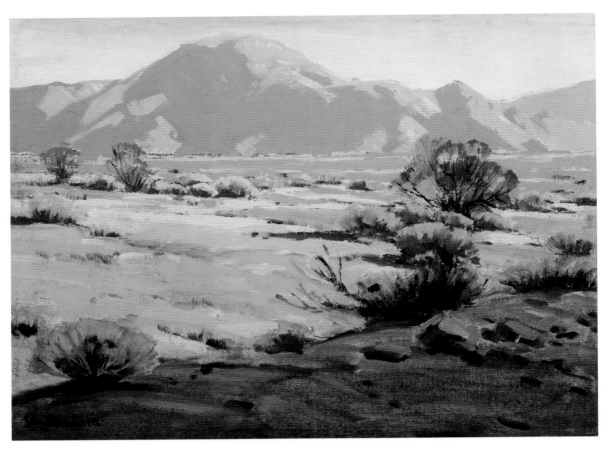

"Changing Shadows." Oil on board. 12" x 16". C. 1930. *Collection of Gary Lang.*

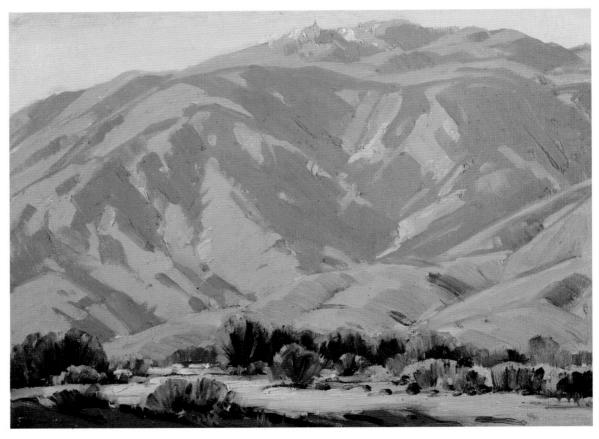

"Guarded Approach." Oil on canvas on board. 18" x 24". *Collection of Harris Estate.*

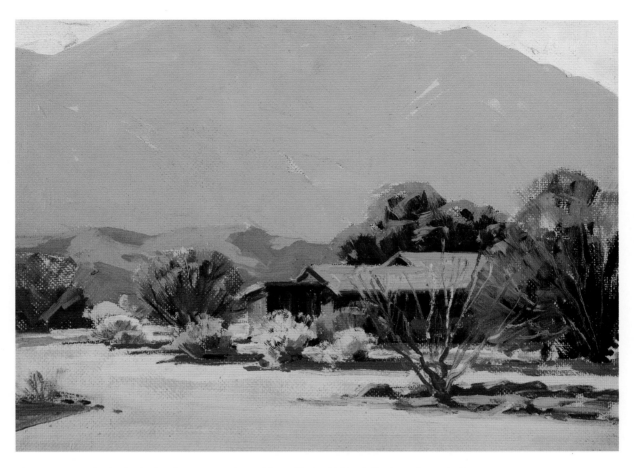

"Retreat – Cathedral City." Oil on masonite. 12" x 16". C. 1938. *Collection of Harris Estate.*

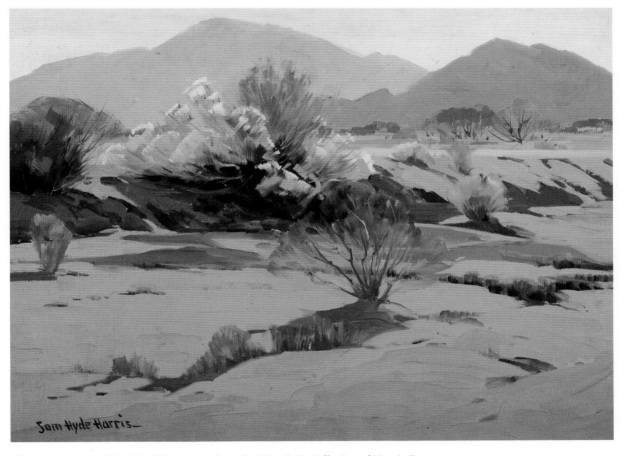

Sam Hyde Harris

"Desert Bouquet No. 2." Oil on artist board. 18" x 24". *Collection of Harris Estate.*

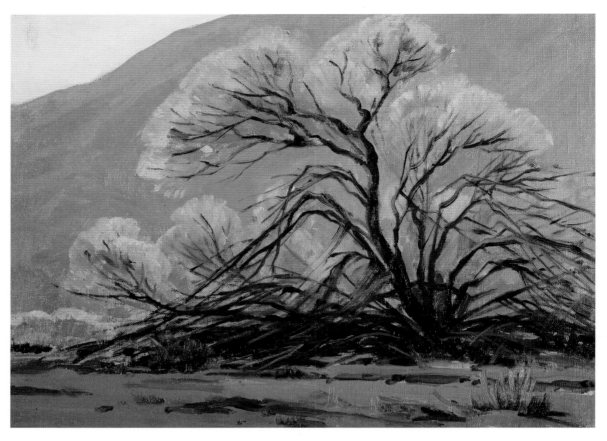

"Desert Amber." Oil on canvas on board. 12" x 16". C. late 40s. *Collection of Harris Estate.*

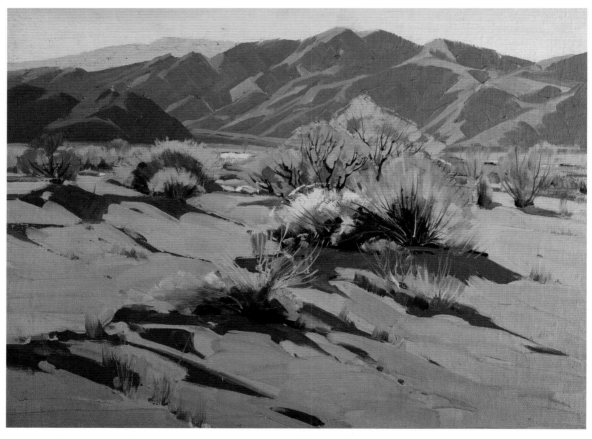

"Desert Destiny." Oil on canvas on board. 18" x 24". *Collection of Harris Estate.*

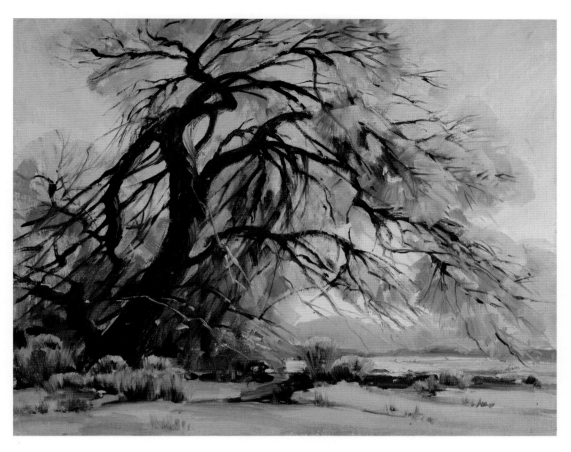

"Unvanquished." Oil on canvas on board. 16" x 20". *Collection of Harris Estate.*

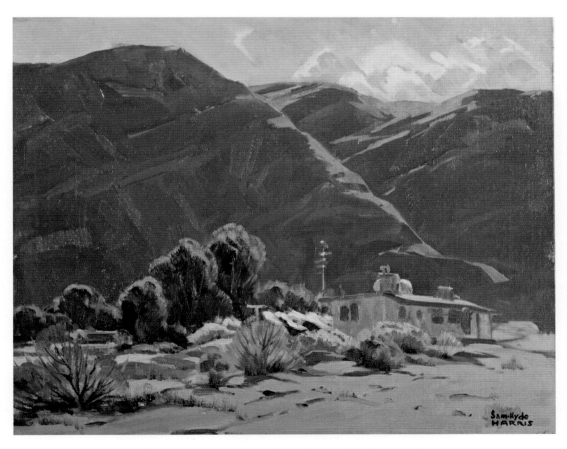

"Sheltering Heights." Oil on canvas on board. 16" x 20". C. 1945. *Private collection.*

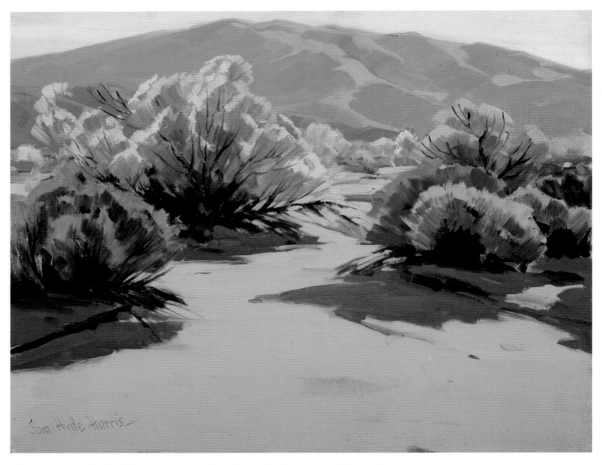

"Desert New Year." Oil on artist board. 16" x 20". *Collection of Harris Estate.*

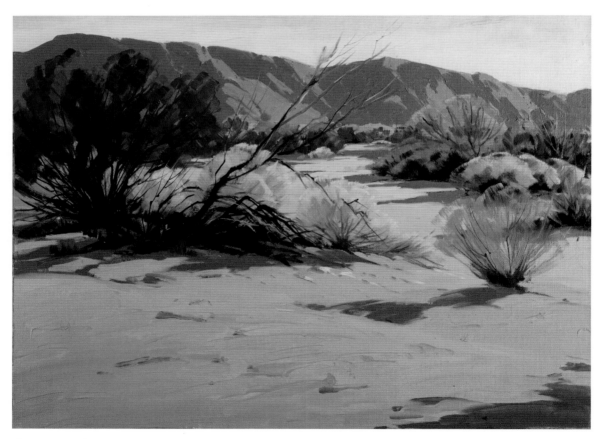

"Passage." Oil on canvas on board. 22" x 28". *Collection of Harris Estate.*

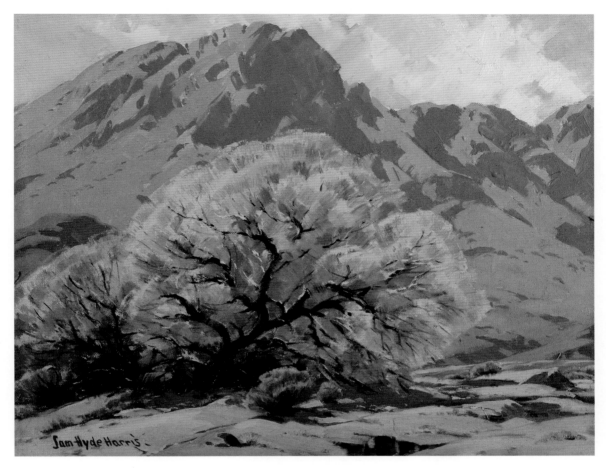

"Desert Symphony." Oil on canvas on board. 16" x 20". C. 1948. *Collection of Harris Estate.*

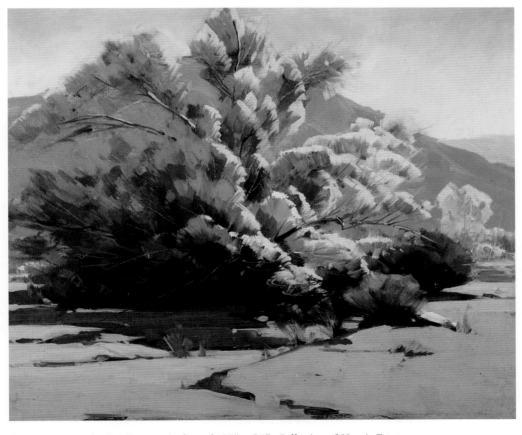

"Desert Lavender." Oil on artist board. 20" x 24". *Collection of Harris Estate.*
Provenance: Personal collection of Marion Dodge Harris.

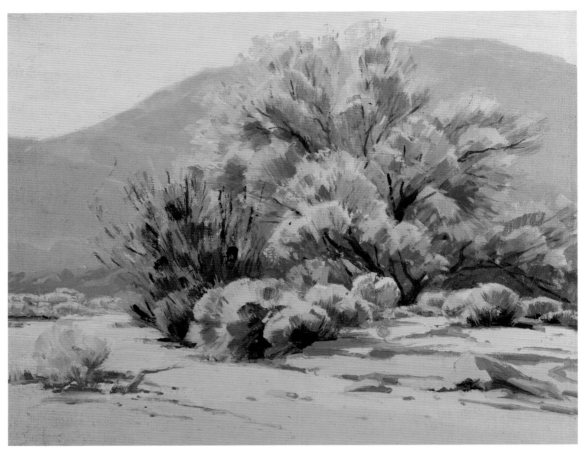

"Noon – Palm Desert." Oil on canvas on board. 16" x 20" *Collection of Harris Estate.*

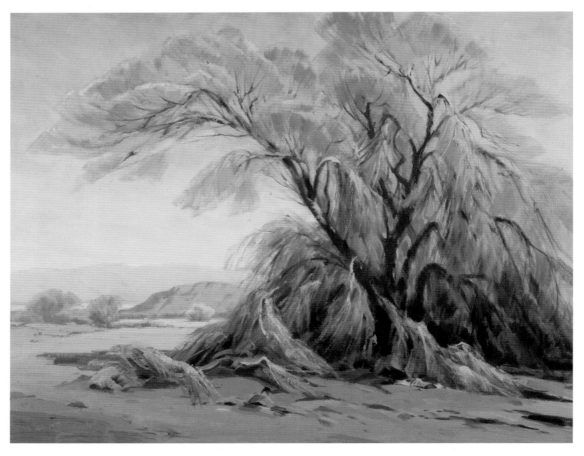

"Palo Verde Bloom." Oil on canvas. 22" x 28". *Collection of Harris Estate.*

216

THE SAN GABRIEL FINE ARTS GALLERY

PRESENTS

Sam Hyde Harris

FEBRUARY 6, 1972 TO MARCH 5, 1972

Gallery Hours: Monday through Sundays

ten a.m. to four p.m.

Evenings by appointment

343 So. Mission Dr.
San Gabriel, California

Exhibition Pamphlet, San Gabriel Fine Art Gallery, February 1972 – March 1972. Includes a photograph of Sam and a list of works exhibited. *Collection of Harris Estate.*

SAM HYDE HARRIS
"Who's Who In American Art", 1959 Edition

Sam Hyde Harris
ARTIST

222 North Hidalgo Ave.
Alhambra, Calif. 91801
(213) 281-7715

Business Card. *Collection of Harris Family.*

Sam Hyde Harris Paintings

1.	Flash Flood Wake	$ 400
2.	Morning Clouds	150
3.	Desert Edge	1000
4.	Desert Sanctuary	175
5.	Palo Verde	350
6.	Trail's End	350
7.	Morning Mist	300
8.	Chavez Ravine	1000
9.	Desert Fortress	1000
10.	Spring Interlude	350
11.	Newport Reflections	250
12.	Palm Desert Retreat	350
13.	Rain Sculpture	300
14.	Desert Grandeur Sketch	150
15.	Pine Mountain, Utah	300
16.	Serene Moment	175
17.	Desert Victory	150
18.	Newport	150
19.	Invictus	200
20.	Mountain Majesty	175
21.	Wyoming Sentinels	200
22.	Resistance	175
23.	Carlsbad Veteran	250
24.	The Rains Came	350
25.	Desert Wash	200
26.	Desert Variation	150
27.	Last Stand	150
28.	Tranquil Interlude	100
29.	South Pasadena	100
30.	Desert Barranca	100
31.	Lakeside	100
32.	Gray Day	125
33.	Arizona Morning	250
34.	Movie Set	150
35.	Zion Approach	100
36.	The Big Snow	200
37.	Sierra Sketch	100
38.	Desert Gold	75
39.	Utah Gothic	200
40.	Blue Door	150

Continued on Back Page

Exhibition Pamphlet, San Gabriel Fine Art Gallery, February 1972 – March 1972. Includes a photograph of Sam and a list of works exhibited. *Collection of Harris Estate.*

41.	Radiance	85
42.	Desert Magic	85
43.	Sketch for Desert Bronze and Silver	100
44.	Valley Springtime	100
45.	Gay Morning	100
46.	Newport Sketch	100
47.	Utah Glory	100
48.	Haystack Vista	95
49.	Morro Bay Memory	95
50.	Red and Gold	200
51.	Smoke Tree Sketch	75
52.	Monterey Coast Sketch	75
53.	Utah Morning	150
54.	Early Newport	100
55.	Timeworn	150
56.	Monterey Cypress	150
57.	Early California	150
58.	Laguna Coast Sketch	150
59.	Hillcrest	150
60.	Desert Retreat	350
61.	Sheltered Retreat	350
62.	Lone Survivor	225
63.	Utah Contrasts	250
64.	Morro Bay Sketch	100
65.	Wayward Trail	350
66.	La Quinta Sentinels	300

Self sketch. Pencil on paper. 4" x 3". *Private collection.*

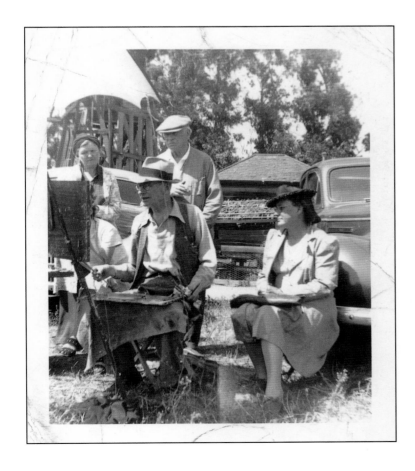

Sam with students. *Collection of Harris Family.*

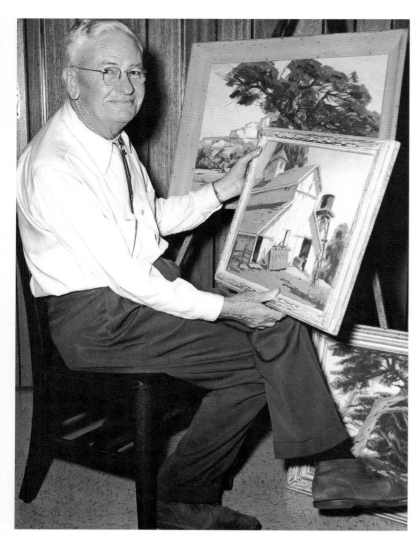

Sam would hope this has been enjoyable and that we all have learned a little something about art.

Collection of Harris Family.

Collection of Harris Family

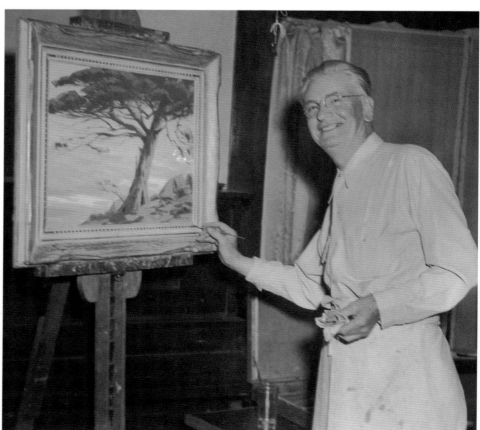

Photograph of Sam asleep. *Collection of Harris Family.*

Detail of a tablecloth design (*see page 52*). *Collection of Harris Estate.*

Harris' death breaks link to glorious era

By LARRY PALMER

A portion of one definition of art has something to do with enduring through the ages. Artists, however, don't happen to fit into the definition of the works they produce. Sam Hyde Harris was an artist.

His death Monday broke one of the final links between today and those gloriously Bohemian days that once brought life to Southern California. Sam Hyde Harris, along with fellow Western painter,

art scene

the late Frank Tenney Johnson, was a part of that celebrity-studded crowd that in many years past flocked to Champion Place in Alhambra and made it an art center that some say was topped only in the 20s and 30s by Greenwich Village.

"His canvases", says a brochure for his final show — only 12 days ago," have the smell of mesquite in them, the clean air of high Western desert and mountains, the breath of the rugged California coast the loneliness of a long-deserted railroad station, the battered beauty of a farmhouse, the low skyline of the Los Angeles of a half-century ago — the simple, beautiful face of the unadorned West."

Born in England in 1889, Sam Hyde Harris died in 1977 a spokesman for "old" America.

SAM HYDE HARRIS
. . .spirit of West

Star News Obiturary, June 3, 1977.

Cover of pamphlet with a church "In Remembrance." *Collection of Harris Family.*

A service of memory for

SAMUEL HYDE HARRIS

Born

BRENTFORD, MIDDLESEX, ENGLAND

Passed away

MAY 30, 1977
ALHAMBRA, CALIFORNIA

Services held

CHAPEL OF TURNER & STEVENS, ALHAMBRA
JUNE 3, 1977

Clergyman

DR. GEORGE E. JENKINS
ALHAMBRA FRIENDS COMMUNITY CHURCH

Organist

ANN MALJANIAN

Soloist

OLIVE MAE PIERCE

Entombment

ROSE HILLS MEMORIAL PARK
WHITTIER, CALIFORNIA

TURNER & STEVENS, ALHAMBRA
DIRECTORS

"In Remembrance" inside of the pamphlet.

Detail of a tablecloth (*see page 52*). Sleep hombre.

Appendix I

Sam Hyde Harris Exhibition Record
Compiled by Marian Yoshiki-Kovinick

1920

11th Annual Exhibition, California Art Club, Los Angeles County Museum, October 7-November 15
 49. *Sand Dunes*

California Art Club, Fine Arts Gallery, Balboa Park, San Diego, November 21-December 21
 Sand Dunes

1921

2nd Annual Exhibition, Painters and Sculptors of Southern California, Los Angeles County Museum, April 7-May 15
 36. *Autumn Glory*
 37. *Montrose*

1922

13th Annual Exhibition, California Art Club, Los Angeles County Museum, October 19-November 19
 31. *Sunlit Peaks*

3rd Annual Exhibition, Painters and Sculptors of Southern California, Los Angeles County Museum, April 21-May 28
 28. *Sunlit Arroyo*

Laguna Beach Art Association July Exhibit
 32. *Sunlit Canyon*
 33. *Wayside Path*

1923

14th Annual Exhibition, California Art Club, Los Angeles County Museum, November 8-December 10
 24. *Shady Hollow*

1924

15th Annual Exhibition, California Art Club, Los Angeles County Museum, November 6-December 10
 27. *Morning Shadows*

Exhibition of Painting by Sam Hyde Harris, Little Gallery, San Diego, May 24
 Twelve Landscapes

1928

Exhibition of Paintings by California Artists, Probst-Taylor Decorating Company, Los Angeles, (exhibition arranged by the Kanst Art Galleries, Los Angeles), May 22-29

1929

Pacific Advertising Club Association – 1929, Advertising Exhibits held in conjunction with the 26th Anniversary Convention in Los Angeles. Title: "California Company" Bonds.

1930

21st Annual Exhibition, California Art Club, Los Angeles County Museum, November 7-December 31
 32. *Green Hillside*

9th Annual Exhibition, Painters of the West, Biltmore Salon, Los Angeles, December 8, 1930-January 3, 1931
 21. *Sycamores*

1931

5th Purchase Prize Exhibit, Gardena High School, Los Angeles, March 29-April 17
 42. *Sycamores*

Artists' Fiesta, Barker Brothers and Along Art Lane, September 1-15
 124. *Sycamores*
 125. *Arcadia*

1932

Art Exhibition, Tennis Club, Pasadena, August

1935

2nd Annual Exhibition of Paintings, Clearwater Junior High School, April 1-14
 21. *Fish Harbor*

Exhibition of Paintings for June, San Gabriel Artists'
Guild, The Art Gallery, June
 11. *The River*
 12. *Morning Fog*
 13. *Arcadia*
 14. *Laguna Sketch*
 15. *Alhambra Landscape*
6th Monthly Exhibit of San Gabriel Artists Guild,
August
 32. *Fish Harbor Boats*
 33. *Brush*
 34. *The Marshes*
 35. *Industrial Romance*
7th Monthly Exhibit of San Gabriel Artists Guild,
September
 17. *Boat Landing*

1936
1st Anniversary Exhibition, San Gabriel Artists Guild,
February
Exhibition of Paintings by Sam Hyde Harris, San Ga-
briel Artists Guild Art Gallery March 29-May 3
 1. *Monterey Coast*
 2. *Laguna*
 3. *Arcadia Sycamores*
 4. *Arroyo Seco*
 5. *Morning*
 6. *Boat Landing*
 7. *Spring*
 8. *Hilltop*
 9. *Abandoned Farm*
 10. *Sheltered*
 11. *Eucalyptus*
 12. *Shacks – Sunset Beach*
 13. *Newport Sketch*
 14. *Andy's Dock*
 15. *Harbor Sketch*
 16. *Grand Canyon*
 17. *Brush*
 18. *Clouds*
 19. *Marshes*
 20. *Lagoon – Sunset Beach*
 21. *Industrial Romance*
 22. *Between Showers*
 23. *Eucalypti*
 24. *Sketch*

 25. *Sketch*
 26. *Sunlit Arroyo*
 27. *Sycamore*
Exhibition, Hollywood Riviera Beach Club, Septem-
ber 26
 After the Rain (2nd Prize)
1st Exhibition, The Artists Guild of California (a group
of illustrators and advertising artists and industrial
designers), Los Angeles, September
Exhibition of Paintings for September, 1936, Present-
ed by the San Gabriel Artists Guild, San Gabriel
Artists Guild Art Gallery, September 7-October 4
 12. *Serenity*
Exhibition of Paintings by Sam Hyde Harris, South
Pasadena Public Library, October

1937
4th Annual Exhibit of Paintings, Clearwater Junior
High School, March 8-21
 20. *Hilltop*

1938
Three-Person Exhibition with Loren Barton and
Martha Wheeler Baxter, Friday Morning Club,
March
 Miniatures by Baxter, watercolors by Barton;
 oils by Harris
Exhibition of Paintings, San Gabriel Artists Guild,
March 6-April 2
 1. *January*
 2. *California Ranch Sketch*
 3. *Sketch*
5th Annual Exhibition, Clearwater Junior High School,
March 20-April 3
 32. *Manana*
19th Annual Exhibition, Painters and Sculptors of
Southern California, Los Angeles County Museum,
April 15- May 12
 33. *Distant Heights*
Paintings by Sam Hyde Harris and Lithographs, Aqua-
tints, and Sculpture by Velma Adams, San Gabriel
Artists Guild Art Gallery, June 5-July 3
 1. *After Rain*
 2. *Industry*(1)
 3. *Hillside*
 4. *Reflections*

5. *Early Spring*
6. *Hillrop*
7. *Andy's Dock*
8. *Atmosphere*
9. *Brush*
10. *Anchorage Sketch*
11. *Silhouette*
12. *Abandoned*
13. *Indian Summer*
14. *Arroyo Seco*
15. *Shacks, Sunset Beach*
16. *Industry* (2)
17. *Sunset Sketch*
18. *Sketch*
19. *Sketch*
20. *Sketch*
21. *Spring Morning*
22. *Manana*
23. *Afternoon*
24. *Spring*
25. *Landscape*
26. *Landscape*
27. *Sketch*

Exhibition of Paintings, San Gabriel Artists Guild, July 10-August 6
 1. *Laguna Coast*

1939

Exhibition of Paintings by Sam Hyde Harris, California State Exposition Building, Exposition Park, March 1-31
 Paintings
6th Annual Exhibition of Paintings, Clearwater Junior High School, March 14-28
 33. *Landscape*
21st Anniversary Prize Exhibition, Laguna Beach Art Association, August-September
 28. *Distant Heights* (**2nd** Honorable Mention)
October-November Exhibition, Laguna Beach Art Association
 9. *Jim Smith's Farm*
December-January 1940 Exhibition, Laguna Beach Art Association
 6. *Manana*

1940

Paintings by Sam Hyde Harris, Pasadena Women's Club, February
Paintings by Sam Hyde Harris, Pottenger Galleries, Pasadena, February
7th Annual Exhibit of Paintings, Clearwater Junior High School, Feb 26-March 12
 40. *The Summit*
13th Annual Purchase Prize Exhibit, Gardena High School, Los Angeles, March 26-April 10
 47. *Rain*
April-May Exhibition, Laguna Beach Art Association
 11. *Landscape* (Honorable Mention)
1st Exhibition of Paintings, Sculpture and Crafts, Artists of Los Angeles and Vicinity, Greek Theatre, Griffith Park, May 15- June 25
 26. *Negress – Nude*
Art Exhibition by California Artists, Golden Gate International Exposition, Treasure Island, San Francisco, May 25-September 29
 45. *Morning Glory*
Exhibition of Painting and Sculpture by the San Francisco Chapter of the Society for Sanity in Art, Inc., California Palace of the Legion of Honor, San Francisco, August 10-October 6
 66. *Afternoon Horizon*
 67. *Landscape*
Salon of Art, The Ebell Club of Los Angeles, October
 113. *Atmosphere*
Society for Sanity in Art, San Gabriel Artists Guild Gallery, October
Salon of Art, The Ebell Club of Los Angeles, November
 103. *Distant Heights*
Three-person Exhibition of Sam Hyde Harris, Sam Hugh Harris, and Donald Hyde Harris, San Gabriel Artists Guild, November
Society of Western Artists, Los Angeles
 Medal

1941

Exhibit of Oil Paintings by Members of The Society for

Sanity in Art, Municipal Art Galleries, Los Angeles City Hall, January
 Morning Glory
2nd National Exhibition of The Society for the Sanity in Art, Inc., Stevens Hotel, Chicago, Illinois, February 1-March 1
 78. *Distant Heights*
Painters and Sculptors Club, Stendahl Art Galleries, Los Angeles, February 1-March 16
 36. *Morning*
 37. *Arcadia*
Exhibition, Friday Morning Club, February
2nd Annual Exhibition, Artists of Los Angeles and Vicinity, Mar 15-May 15
 54. *Poetic Lands*
8th Annual Exhibition of Paintings, Clearwater Junior High School, March 19-April 1
 48. *Sheltered* (Purchase Prize)
14th Annual Purchase Prize Exhibit, Gardena High School, Los Angeles, April 22-May 7
 50. *Hilltop Barn*
Exhibition of Paintings by Members of the San Gabriel Artists Guild, The Art Gallery, June 8-July 13
 13. *Sheltered*
5th Annual Art Exhibit, Santa Paula Union High School, August 21-September 1
 10. *Harvesting*
Paintings by Sam Hyde Harris, Armand Duvannes Gallery, La Cienega Blvd. August-September. (landscapes, harbor and city scenes are among works)
 Rain
 The Grove
 Arcadia
Salon of Art, The Ebell Club of Los Angeles, October
 106. *Landscape* (2nd Award in Oils)
California Art Club
 Special Award
Exhibition of Painting and Sculpture by the San Francisco Chapter of the Society for Sanity in Art, Inc., California Place of the Legion of Honor, San Francisco, November 1, 1941-January 4, 1942.
 48. *Golden Afternoon*
 49. *Harvesting*

1942
Society for Sanity in Art exhibition, Los Angeles Branch, Ebell Club, Los Angeles, January
Painters and Sculptors Club of Los Angeles Exhibition, Stendahl Art Galleries, February
 15. *Morning Glory*
9th Annual Exhibit of Paintings, Clearwater Junior High School, March 9-March 24
 44. *Desert Grandeur*
April-May Exhibit, Laguna Beach Art Association (served on Jury of Acceptance and Award)
 33. *Golden Afternoon*
15th Annual Purchase Prize Exhibit, Gardena High School, Los Angeles, April 15-May 3
 30. *Morning Glory*
Salon of Art, The Ebell Club of Los Angeles, May
 141. *Desert Pattern* (2nd Prize in Oils)
June-July Exhibit, Laguna Beach Art Association
 41. *Morning Glory*
3rd Exhibition of The Los Angeles Branch of the Society for Sanity in Art, Inc., Los Angeles County Museum, August 20
 13. *Distant Heights*
6th Annual Art Exhibit, Santa Paula Union High School, August 28-September 7
 65. *Atmosphere*
Exhibition of Paintings by Sam Hyde Harris, San Gabriel Artists Guild Art Gallery, September 3-30
In the Main Gallery
 1. *Clear Lake*
 2. *San Jacinto*
 3. *Desert Granduer*
 4. *Desert Morning*
 5. *Lower Lake*
 6. *The Grove*
 7. *Late Afternoon*
 8. *Gorgonio*
 9. *Smoke Tree*
 10. *Windswept*
 11. *Sketch of Desert Design*
 12. *Lake County*
 13. *Tranquility*
 14. *Desert Silver*
 15. *Highland Springs*
 16. *Thunderbird Ranch*
 17. *Elephant Mountain*

18. *Golden Afternoon*
19. *Still Waters*
20. *Atmosphere*
21. *Desert Sentinels*
22. *Mt. Knochti*
23. *Desert Afternoon*

In the Print Room
1. *The New Road*
2. *Cloud Patterns*
3. *Desert Symphony*
4. *Between Showers*
5. *Edge of the Lake*
6. *Approaching Storm*
7. *La Jolla Sand Dunes*
8. *Cathedral City*
9. *Rock of Ages*
10. *Desert Edge*

Salon of Art, Ebell Club of Los Angeles, October
101. *The Grove*

October-November Exhibit, Laguna Beach Art Association
8. *Industry*

Exhibition of Paintings by San Gabriel Artists Guild Members, San Gabriel Artists Guild Art Gallery, December 1-31
19. *Little House on the Hill*

1943

April-May Exhibit, Laguna Beach Art Association
Boat Sketch

16th Annual Purchase Prize Exhibit, Gardena High School, Los Angeles, May 3-16
10. *Desert Pattern*

Painters and Sculptors Club, San Gabriel Artists Guild Art Gallery, June

August-September Exhibit, Laguna Beach Art Association
22. *Desert Patterns* (3rd Most Popular Prize)

Sanity in Art Society, Ebell Club of Los Angeles
Hilltop Barn

Exhibition of Paintings of Sam Hyde Harris, San Gabriel Artists Guild Art Gallery, November 1-December 1
1. *Distance*
2. *Harbor Sketch*
3. *Retreat*

4. *The Valley*
5. *Atmosphere*
6. *Gorgonia Sketch*
7. *Desert Design*
8. *Hill Top Barn*
9. *Industry*
10. *Autumn*
11. *Rain*
12. *The Grove*
13. *Blue and Gold*
14. *Jim Smith's Farm*
15. *Desert Granduer*
16. *Newport Boats*
17. *Desert Pattern*
18. *Morning Mist*
19. *Desert*
20. *Distant Heights*
21. *La Jolla*
22. *Sketch*
23. *Mable Burnett's Garden*

Exhibition of Paintings by Members of the Guild, San Gabriel Artists Guild, December 1, 1943-January 1, 1944
14. *Distance*

1944

April-May Exhibit, Laguna Beach Art Association
Morning (Honorable Mention)

17th Annual Purchase Prize Exhibit, Gardena High School, Los Angeles, April
17. *Early Spring*

Painters and Sculptors Club, Los Angeles Art Club, December
Manana (Silver Medal)

Los Angeles Art League, Pasadena
1st Award

6th Annual Exhibition of Painting and Sculpture by The Society for Sanity in Art, Inc., California Palace of the Legion of Honor, San Francisco, November 4-December 31
38. *Desert Pattern* (1st Prize in oils)

Exhibition by the Los Angeles Branch of The Society for Sanity in Art, Inc., Los Angeles County Museum, December 3-24
10. *Rain*

1945

Paintings by Sam Hyde Harris, Paddock's Bookshop, Glendale, April
 Paintings

18th Annual Purchase Prize Exhibit, Gardena High School, Los Angeles, April 8-21
 18. *Desert Design* (Purchase Prize, Summer Class)

San Fernando Art Club, Municipal Gallery, Los Angeles City Hall, May

7th Annual Art Exhibit, Santa Paula Union High School, August 6-16
 15. *Receding Snow*

Paintings by Sam Hyde Harris, San Gabriel Artists Guild, September

Exhibition of Painting and Sculpture by Artists of Los Angeles and Vicinity, Greek Theater, Griffith Park, November 1-11th
 25. *Early Spring*

1946

Exhibition of Paintings by The Painters' and Sculptors' Club of Los Angeles, San Gabriel Artists Guild Art Gallery, February 3-28
 17. *Distant Heights*

7th Annual Exhibition, Artist of Los Angeles and Vicinity, Los Angeles County Museum, June 2-July 14
 42. *Hindu Mystic*

Purchase Prize Exhibit, San Fernando High School, June 3-14
 34. *Desert Afternoon*

8th Annual Exhibition of Painting and Sculpture by The Society for Sanity in Art, California Palace of the Legion of Honor, San Francisco, December 7, 1946-January 26, 1947
 51. *Desert Afternoon*

1947

San Pedro Exhibit of California Art, 2nd Annual Purchase Prize Exhibit, San Pedro High School, March 25-30
 14. *Landscape*

Exhibition of Painting and Sculpture by Artists of Los Angeles and Vicinity, Greek Theater, Griffith Park, October 19-November 2
 67. *Arroyo Edge*

Exhibition of Mr. Sam Hyde Harris, Long Beach Typewriter and Desk Company, Long Beach
 1. *Afternoon Horizon*
 2. *Smoke Tree*
 3. *Elephant Mountain*
 4. *Atmosphere*
 5. *Desert Contrast*
 6. *The Cannery*
 7. *Harbor Sketch*
 8. *Desert Sketch*
 9. *Desert Design*
 10. *Desert Road*
 11. *Anchorage*
 12. *Desert Distance*
 13. *Mount Knochti*
 14. *Clear Lake*
 15. *Windswept*
 16. *Newport Sketch*
 17. *Lower Oak*
 18. *Morning Mist*
 19. *Distant Heights*
 20. *Desert Sentinels*

Friday Morning Club, Los Angeles
 2nd Award in oils

1948

Exhibition of Painting and Sculpture by Artists of Los Angeles and Vicinity, Greek Theater, Griffith Park, October 17-31
 151. *Monterey After Noon*

Painting and Sculpture by Painters and Sculptors Club, Artists of the Southwest, and Women Painters of the West, Greek Theatre, Griffith Park, November 14-28
 73. *Desert Afternoon*

Paintings by Sam Hyde Harris, Tuesday Afternoon Club, Glendale, September

3rd Annual Purchase Prize Exhibit, San Pedro Exhibit of California Art, Richard Henry Dana Junior High School
 13. *Arroyo Edge*

1949

Exhibition of Painting and Sculpture by Artists of Los Angeles and Vicinity, Greek Theater, Griffith Park, October 16-30

100. *Canyon Shelter*
December-January 1950 Exhibit, Laguna Beach Art
 Association
 34. *Canyon Shelter*
Friday Morning Club, Los Angeles
 1st Award in Landscape

1950

Exhibition of Paintings and Sketches by Sam Hyde
 Harris, White's Art Store, Montrose, January 3-
 31
Exhibition of Painting and Sculpture, California Art
 Club, Greek Theatre, Griffith Park, February 12-
 26
 114. *Utah Autumn*
Exhibition of Paintings by Sam Hyde Harris, Tuesday
 Morning Club, Glendale, May
Painting and Sculpture by the Artists of the Southwest,
 Painters and Sculptors Club, Women Painters of
 the West, Greek Theatre, Griffith Park, November
 12-26
Painters and Sculptors Club
 35. *Morning Glory*
Exhibition of Landscapes by Sam Hyde Harris, Sun-
 land Park Recreation Building, November
Ebell Salon of Art, December 1950-January 1951
 65. *Boat Landing*

1951

An Exhibit by Sam Hyde Harris, Glendale Public
 Library, January
 1. *Drying Nets*
 2. *Wyoming Sentinels*
 3. *Utah Gothic*
 4. *Arcadia*
 5. *Jim Smith's Farm*
 6. *Timeworn*
 7. *Windswept*
 8. *Desert Road*
 9. *Indian Summer*
 10. *Atmosphere*
 11. *Resistance*
 12. *Monterey Afternoon*
 13. *Newport Sketch*
 15. *Desert Majesty*
 16. *Utah Morning*

 17. *New Road*
 18. *Reflections*
 19. *Coast Guardian*
 20. *Canyon Shelter*
 21. *Desert Fantasy*
 22. *Newport Sunday*
 23. *Oasis*
 24. *March of Time*
 25. *Gold and Silver*
 26. *Pine Mountain Utah*
 27. *Morning Clouds*
 28. *Painted Canyon*
 29. *Utah Contrasts*
Exhibition of Paintings by Sam Hyde Harris, Tuesday
 Morning Club, Glendale, May
 Paintings
Glendale Art Association
 Special Jury Award
Friday Morning Club, Los Angeles
 2nd Award in oils
Laguna Beach Art Association Exhibit
 Honorable Mention

1952

February-March Exhibit, Laguna Beach Art Associa-
 tion
 Last Stand
Two-person Exhibition with Jimmy Swinnerton, Tues-
 day Morning Club, Glendale, May
Laguna Beach Art Association Exhibition, July 26-
 September 1
 Silver Symphony (3rd Prize)
34th Anniversary Prize Exhibition, Laguna Beach Art
 Association, September 2-28
 19. *Silver Symphony* (1st Award)
Painting and Sculpture by Painters and Sculptors of
 Los Angeles, Women Painters of the West, Artists
 of the Southwest, Inc., Greek Theatre, Griffith
 Park, November 9-30,
Artists of the Southwest, Inc.
 15. *Silver Symphony*
Friday Morning Club, Los Angeles
 1st Award in Landscape
Dixie College, St. George, Utah
 Purchase Prize

1953

Monterey Park Woman's Club, Monterey Park Public Library, January
> Twelve paintings

Laguna Beach Art Association with Exhibit by the California Watercolor Society, January 28-February 27
22. *Pine Valley Mountain*

California Art Club Annual Exhibition, Greek Theatre, Griffith Park, March 15-31

29th Annual Exhibition, Pasadena Society of Artists, May 10-June 7
50. *Utah Radiance*

17th Annual Santa Paula City Art Show, August

August-September Exhibit, Laguna Beach Art Association

Utah Radiance (Honorable Mention)

6th Annual Tri-Club Exhibition (Artists of the Southwest, Painters and Sculptors Club and Valley Artists Guild), Greek Theatre, Griffith Park, October

October-November Exhibit, Laguna Beach Art Association
> 2. *Desert Solitude*

Painters and Sculptors Guild of the Desert Art Center, Duncan Vail Gallery, Los Angeles, December 13-30

December-January Exhibit, Laguna Beach Art Association
> *Desert Sentinels*
> *Young's Beach Camp*

1954

30th Annual Exhibition, Pasadena Society of Artists
> 5. *Sandswept* (Most Popular award)

California Art Club Exhibition of Painting and Sculpture, Greek Theatre, Griffith Park, March 14-28
> 165. *San Jacinto*

Exhibition of Paintings by Sam Hyde Harris, Southwest Museum, March

Exhibition of Paintings by Sam Hyde Harris, Glendale Public Library, July
> California Desert and Utah paintings

Santa Paula Civic Art Show, Santa Paula, August
> *Whitewater Retreat* (1st Prize)
> *Late Afternoon* (Purchase Prize)

Country Fair Art Exhibit, Temple City, September

Exhibition of Paintings, San Gabriel Women's Clubhouse, October
> Sixteen paintings including *Sandswept* and *Whitewater Retreat*

Festival of Arts and Crafts, San Gabriel, California
> 1st Award in Landscape

1955

February-March Exhibit, Laguna Beach Art Association
> *Desert – February* (Honorable Mention)

Exhibition of Painting and Sculpture, The California Art Club, Greek Theatre, Griffith Park, March 13-27
> 8. *Desert Solitude*
> 101. *Off the Beaten Path*
> 114. *Receding Snow*

31st Annual Exhibition, Pasadena Society of Artists, Pasadena Art Museum, April 10-May 8

25th Annual State-Wide Exhibition, Santa Cruz Art Association, Santa Cruz Art League Gallery, April

Exhibition of Paintings by Sam Hyde Harris, Tuesday Afternoon Club, November

Friday Morning Club, Los Angeles
> 2nd Award in Landscape
> Honorable Mention

San Gabriel Festival of Arts
> Honorable Mention and 2nd Popular Award

Artists of the Southwest, Los Angeles
> 2nd Award in Marines

1956

26th Annual State-Wide Exhibition, Santa Cruz Art Association, Santa Cruz Art League Gallery, April
> 22. *Between Showers* (2nd Prize)

Annual Spring Festival of Art, Southland Art Association, Taylor Ranch House, Montebello, April

August-September Award Exhibition, Laguna Beach Art Association
> 37. *Manana*

Valley Art Association
> Honorable Mention in Landscape

Friday Morning Club, Los Angeles
> 1st Award

San Gabriel Festival of Arts
> 1st Award in Oils

1957

Annual Spring Festival of Arts, Southland Art Association, Montebello, April

33rd Annual Exhibition of Painting and Sculpture, Pasadena Society of Artists, June 16-July 4
 56. *Deep Canyon Veteran*
 57. *Desert February*

Anniversary Award Exhibition, Laguna Beach Art Association, August
 55. *Deep Canyon Veteran*

Friday Morning Club, Los Angeles
 Second Popular Award

1958

Salon on Art Desert Painters, Ebell Club of Los Angeles, March
 67. *After Rain*

Exhibition of Painting and Sculpture, California Art Club, Greek Theatre, Griffith Park, March 16-30
 126. *Utah Radiance*

Anniversary Exhibition, Laguna Beach Art Association, August-September
 22. *Flash Flood Wake*

1958 California State Fair and Exposition, Sacramento, September
 Manana

San Gabriel Festival of Arts
 1st Cash Award

11th Annual Tri-Club Art Exhibition of the Valley Artists' Guild, Artists of the Southwest, and Painters' and Sculptors' Club, Greek Theatre, Griffith Park, October 4-26
 Valley Artists' Guild
 18. *Desert Sentinels* (1st Landscape)
 76. *Blue Lagoon*

Artists of the Southwest, Los Angeles, October
 122. *Young's Beach Camp* (3rd Landscape)
 155. *Red and Gold*

Friday Morning Club, Los Angeles
 2nd Award

1959

Salon of Art Desert Paintings, Ebell Club of Los Angeles, March
 52. *Cathedral City Wash*

California Art Club
 2nd Award in Landscape

1960

March Exhibit, Laguna Beach Art Association

Artists of the Southwest, Inc., Los Angeles, Friday Morning Club, April-May
 3rd Award for Landscape

April Exhibit, Laguna Beach Art Association,

Exhibition of Paintings by Sam Hyde Harris in the Entresol room of the Laguna Beach Art Association Gallery
 127. *Invictus*
 128. *Cathedral Veteran*
 129. *Jim Smith's Farm*
 130. *White Water Sentinel*
 131. *Utah Radiance*
 132. *Red and Gold*
 133. *Morning*
 134. *Paris Department*
 135. *Desert Solitude*
 136. *Haystack Mountains*
 137. *Reflections*
 138. *Before Smog*
 139. *Palo Verde*
 140. *La Quinta Vista*
 141. *Last Stand*
 142. *Pine Valley Mountain*
 143. *St. Michael's by the Sea*
 144. *Receding Snow*
 145. *Newport Reflections*
 146. *Desert Patriarch*
 147. *Afternoon Horizon*

April-May Exhibit, Laguna Beach Art Association

8th Annual Arts Festival, Mid-Valley Artists League, West Arcadia Shopping Center, May

Three-person Exhibition with Karl Albert and Norman Hall, Alhambra City Hall, May

8th Annual Arts Festival of Arts, Mid-Valley Artists League, West Arcadia Shopping Center, May

Tri-Club Exhibition (Painters and Sculptors Club, Valley Artists Guild and Artists of the Southwest, Inc., Greek Theatre, Griffith Park, October

Exhibit of Oils and Water Colors: Oils by Sam Hyde Harris and Water Colors by Lester M. Bonar, Carls-

bad Art Gallery, Carlsbad, November 17-30
Friday Morning Club, Los Angeles
 3rd Award in Landscape
Valley Art Association
 1st Award in Landscape

1961
Salon of Art, Exhibition of The Desert Painters, Ebell
 Club, Los Angeles, January
 18. *Desert Edge* (Popular Cash Award)
A Three-Artist Show, Karl Albert, Norman Hall, Sam
 Hyde Harris, Alhambra City Hall, May 5-June 5
 20. *Desert Sanctuary*
 21. *Afternoon Horizon*
 22. *Cathedral Vista*
 23. *Desert Gradations*
 24. *Red and Gold*
 25. *Palo Verde*
 26. *Haystack Mountains*
 27. *Clouds over Wyoming*
 28. *Desert Horizon*
 29. *Flash Flood Wake*
 30. *Deep Canyon Veteran*
Valley Artists Guild, June
 Honorable Mention
25th Annual Art Exhibit, Santa Paula Union High
 School, August 16-20
 226. *Maystack Mt.*
Artists of the Southwest, Los Angeles, October
 1st Award in Landscape
San Fernando Valley Art Club, October
 1st Award in Landscape
An Exhibition of Paintings by Sam Hyde Harris, Glen-
 dale Public Library Gallery, December 1-31
San Fernando Valley Art Club
 3rd Award in Landscape
Valley Art Guild
 1st Prize
Friday Morning Club, Los Angeles
 Honorable Mention

1962
San Gabriel Artists Guild, Greek Theater, Griffith
 Park, ca. April
 Desert Victory
 Big Shot

 Tumbledown Shack
San Fernando Art Club, Greek Theatre, Griffith Park,
 April
 Landscape prize: 3rd
Artists of the Southwest, Los Angeles, May
 1st Award in Oils
Friday Morning Club, Los Angeles, May
 Second Cash Award
Artists of the Southwest, Los Angeles, Friday Morning
 Club, March 26-May 7
 1st Award for Landscape
San Fernando Valley Art Club
 1st in Oils
San Fernando Valley Art Club
 Special Jury Award
An Exhibition of Paintings by the Contributing Artists,
 Pacoima Memorial Lutheran Hospital, December
 17
 11. *Palo Verde*

1963
Painters and Sculptors Club Exhibition, February
 1st Award
Friday Morning Club, February
 2nd Award in Oils
Artists of the Southwest, Inc. Exhibition, Pasadena
 Public Library, September
48th National Orange Show All California Art Exhibi-
 tion, San Bernardino, California, March
 13. *Distant Rain*

1964
Paintings in the California Theme by Some Noted Art-
 ists of Southern California, The Waldorf-Astoria,
 New York, February
 9. *Tranquil Morning*
 10. *Morning Mist*
Two-person Exhibition with Emil Kosa, Jr., Desert-
 Southwest Art Gallery, Palm Desert, April
Salon of Art, Ebell Club of Los Angeles, May
 15. *Palo Verde Serenade*
Paintings by Sam Hyde Harris, Desert Art Center,
 October

1965
Exhibition of Paintings by Sam Hyde Harris, Alham-

bra City Hall, February
Salon of Art, Ebell Club of Los Angeles, February
 10. *Chavez Ravine*
 25. *Desert Mood*
Annual Gold Medal Award Exhibition, California Art
 Club, Greek Theatre, Griffith Park, March 15-28
 101. *La Quinta*
 116. *Sanctuary Morning*
 153. *Sheltered Retreat*
Oil Paintings by Sam Hyde Harris and Water Color
 Paintings by Lester M. Bonar, El Establo Gallery,
 Montecito, California, June 13-July 15
Exhibition of Paintings by Sam Hyde Harris, El Es-
 tablo Gallery, Montebello, June
Two-person Exhibition with Lester Bonar, El Establo
 Gallery, Montecito, August
17th annual Tri-Club Art Exhibition of the Valley Art-
 ists' Guild, Artists of the Southwest, and Painters
 and Sculptors Club, Greek Theater, Griffith Park,
 Los Angeles, October 8-31
Artists of the Southwest
 146. *Bypath*
Valley Artists' Guild
 100-AJ. *The Rains Came* (1st Prize/Landscape)
 100-AO. *Arizona Morning*
Painters and Sculptors Club
 211. *Lone Wolf* (1st Prize/Landscape)

1966
Salon of Art, Ebell Club of Los Angeles, April
 20. *San Jacinto*

1967
Salon of Art May Competitive Exhibition, Ebell Club
 of Los Angeles
 Deep Canyon Morning
Exhibition of Paintings by Sam Hyde Harris, Tuesday
 Morning Club of Glendale, May
 Paintings of the sea and landscapes
Council of Traditional Artists Societies, Galleria of
 Fine Arts, 22nd Annual Los Angeles Home Show,
 Pan-Pacific Auditorium, Los Angeles, July 13-23
 30. *Manana*
Exhibition of Mid-Valley Arts League, Inc., Alhambra
 City Hall, November-December
 3. *Manana*

1968
Eastland Art Festival, Mid-West Valley Art Association,
 October
 Traditional Oil Art Award: 2nd place

1970
 California Art Club
 1st Award in Landscape
 San Gabriel Valley Fine Art Guild
 Gold Medal (Best in Show)

 1971
 Artists of the Southwest, Inc., Glendale Fed-
 eral Savings and Loan Association, February
 8-19
 47. *Young's Beach Camp*
 Artists of the Southwest
 Merit Award
 Gold Medal Award Exhibition, California Art
 Club, Equitable Plaza, Los Angeles, April
 2-16
 47. *Rain Trails*
 48. *Flash Flood Wake* (1st Award/Landscape)
 Artists of the Southwest, Inc., Santa Ana
 Young's Beach Camp

 1972
 Paintings by Sam Hyde Harris, San Gabriel
 Fine Arts Gallery, February 6-March 3
 California Art Club Exhibition, California Art
 Club Gallery, Westwood, June
 7th Annual Fiesta Art Show, San Gabriel Fine
 Arts Association, September 2-4
 138. *Calm Interval* (1st Marine/Seascape)
 139. *Distant Range* (Judges' Award)

1973
Salon of Art, Ebell Club of Los Angeles, March
 10. *Snowfall*
Spring Membership Award Exhibit, Laguna Beach
 Museum of Art, April 7-27
 9. *601 Canyon Solitude*
 10. *1940 Chavez Ravine*
 11. *Desert Edge*
 12. *Flash Flood Wake*
8th Annual Fiesta Art Show, San Gabriel Fine Arts As-

sociation, September 1-3
 192. *Distant Rain* (2nd Award in Landscape)

1974
California Design 1910, Pasadena Center, October 15-December 1
 Hillside

1975
Exhibition of Paintings by Sam Hyde Harris, Alhambra Public Library, January 4-February 8
 23. *Deep Canyon*
 24. *The 1940 Chavez Ravine*
 25. *Calm Interval*
 26. *Snowfall*
 27. *The Rains Came*
 28. *Newport Harbor*
 29. *Spring Interlude*
 30. *Desert Edge*
 31. *San Luis Rey Mission*
 32. *Spring*
 33. *Chavez Ravine*
 34. *Desert Friends*
 35. *Desert Sketch*
 36. *Morro Bay Lagoon*
Exhibition of Paintings and Sketches by Sam Hyde Harris, White's Art Store and Galleries, Montrose, California, May 1-31

1976
Salon of Art, Ebell Club of Los Angeles, May 1-31
 Flash Flood Wake
San Hyde Harris, San Gabriel Fine Arts Association, October 1-31

1977
Retrospective Exhibition of Paintings, Alhambra Community Hospital, May 21

1979
Southern California Artists, 1890-1940, Laguna Beach Museum of Art, July 10-August 28
 Hillside

1980
The Paintings of Sam Hyde Harris, Petersen Galleries,

Beverly Hills, California, November 7-December 6

1986
California on Canvas: The Gardena Collection, Ventura County Historical Museum, San Buenaventura, California, June 27-August 24
 6. *Desert Design*
Early Artists in Laguna: The Impressionists, Laguna Art Museum, September 23-November 5
 24. *Beach Flora*
 25. *The Poor House*
 26. *Spring Romance*
 27. *Sunshine and Shadows*

1997
Sam Hyde Harris: Railroad Advertising Artist, California State Railroad Museum, Sacramento, May 3-November 2

1998/99
Sam Hyde Harris: Railroad Advertising Artist, Nevada State Railroad Museum, Carson, Nevada. November 11, 1998-May 1999

2000
Sam Hyde Harris: Railroad Advertising Artist, Nevada Northern Railroad Museum, Ely, Nevada, March-November

2002/03
Travel by Train: The American Railroad Poster, New York Transit Museum, New York, New York, February 13, 2002-July 2003

2005
Where to Go and What to See, California State Railroad Museum, Sacramento, March 2005

2005/06
Trains: Tracks of the Iron Horse, George H.W. Bush Presidential Library and Museum, College Station, Texas, 7 November 2005-30 July 2006

SAM HYDE HARRIS CHRONOLOGY
Complied by Marian Yoshiki-Kovinick

1889
- Born on February 9 in Brentford, Middlesex, England

1903
- Works in the Artists Department for 8 or 9 months for Andre and Sleigh, Limited, Photo-Engravers, Busbey, Herts, London
- Departs from Liverpool with family aboard *The Cedric*; they arrive at Ellis Island on November 27, then go to Los Angeles

1904
- Lives in Los Angeles; father and brothers establish a slate tile and roofing company

1905-06
- Lives at 993 Buena Vista, Los Angeles; works as a sign painter for Charles B. Mogle and Aaron Kilpatrick (sign painters)

ca. 1905-07
- Is a student of Hanson Puthuff's at his studio, continues his association after Puthuff and Antony Anderson form the Art Students League of Los Angeles in 1906

1909
- Lives at 224 South Flower Street; lists occupation as sign painter; designs poster for 1st Exhibition of the California Art Club at Blanchard Hall; designs poster for Mrs. Louise Elizabeth Garden MacLeods's Los Angeles School of Art and Design

ca. 1910-13
- Studies at the Cannon School of Art, Los Angeles, with Henry W. Cannon

1913
- Travels to Europe to study art for 5-½ months (England, Holland, France, Germany, Belgium)

1914-1916
- Lives at 332 W. 31st Street, with studio at 113 W. 6th Street; continues to list occupation in Los Angeles City Directory as painter of show cards

1917
- Marries Phoebe Katherine Mulholland (1895/96-1978) on January 15; moves to 4307 Marmion Way, Los Angeles

1918
- moves to 4200 Latona Avenue, Los Angeles, with studio still at 113 W. 6th Street; son, Donald Hyde Harris, is born in Los Angeles on February 6

1919
- Establishes new studio at Realty Board Building, 631 Spring Street; a second son, Samuel Hugh Harris, is born in Los Angeles on August 14

1920
- Moves to 1316 Maycrest, Los Angeles; joins California Art Club;-serves as president of the Commercial Artists Association of Southern California-

1921
- Serves as president of the Commercial Artists Association of Southern California; third son, Bruce Richard Harris, is born in Los Angeles on March 21

1923
- Serves a president of the Commercial Artists Association of Southern California

1924
- Travels with Hanson Puthuff to the Grand Canyon

1926
- Painting, *Sunlit Arroyo*, is selected for August cover of *California Southland*

1927
- Serves as juror for Otis Art Institute Student Design Poster Contest for Catholic Charities and for Painters of the West exhibition, Biltmore Salon, Los Angeles

ca. 1930s
- Studies with Lawrence Murphy

1930-31
- Moves to 118 Duarte Road, San Marino while retaining his studio at 631 Spring Street, rm. 603

1932-34
- Moves to Sunset Beach while maintaining his studio at 631 S. Spring Street, rm. 603

ca. 1934
- Studies with Stanton Macdonald-Wright at Chouinard School of Art and at his private studio

1935-36
- Teaches commercial art (advertising illustration) at Chouinard School of Art

1936
- Moves to 2011 7th, Alhambra; studio continues at 631 S. Spring, room 603

1938
- Moves studio after Realty Board Building is destroyed by fire to Printing Center Building, 1220 Maple Avenue, Los Angeles

1940-41
- Moves to 8901 Ashcroft Avenue, Los Angeles, with studio at 1220 Maple Avenue, room 1211

ca. 1940-45
- Studies with Will Foster

1942
- Serves as juror for War Production Board's Poster Contest

c. 1942
- Divorces Phoebe Mulholland; Harris meets Jimmy Swinnerton and several desert painters

1943
- Is guest of honor at California Art Club's June dinner; gives landscape painting demonstration

1945
- Marries Marion Dodge (1904-1998), UCLA librarian, on August 28; studio at 1220 Maple Avenue, rm. 1211; begins association with Business Men's Art Institute in Los Angeles

1946
- Resides at 222 N. Hidalgo Avenue; studio continues at 1220 Maple Avenue, room 1211; lectures on "The Classic Influence in Painting" and gives a painting demonstration at the California Art Club October dinner; serves as judge of costumes for the 5th Annual Beaux Arts Costume Ball, Ebell Club of Los Angeles

1947
- Travels to paint with and instruct the Business Men's Art Institute in area around St. George, Utah

1950
- Purchases Jack Wilkinson Smith's studio at 16 Champion Place in Alhambra's "Artists' Alley"

1951
- Conducts art class at Friday Morning Club, Los Angeles

1952
- Serves as juror for the National Society of Arts and Letters Exhibition, Los Angeles Branch

1955

- Holds demonstrations in landscape painting for the Los Angeles Adult School and for the Laguna Beach Art Association

1961

- Lectures at a luncheon, Mid-Valley Arts League, Azusa; conducts classes at Tuesday Afternoon Club, Glendale

1962

- Serves as juror for Friends of the Arcadia Library Art Festival

1964

- Conducts art classes in landscape painting during the Festival of Arts, Friends of Arcadia Library, Arcadia, in July

1969

- Lectures at luncheon, National Association of American Pen Women, Pasadena Branch

1970

- Lectures at luncheon, National Association of American Pen Women, Pasadena Branch; receives American Institute of Fine Arts Fellowship

1977

- Dies on May 30th at Alhambra Convalescent Home, 415 Garfield Avenue, Alhambra

Appendix III

Estate Signatures

Sam Hyde Harris only signed about half of his oeuvre, or body of art works, and many of those were signed on the back or verso of the work.

A HEREBY CERTIFY THAT
THIS IS AN ORIGINAL OIL
PAINTING BY SAM HYDE HARRIS

SIGNED *Mrs. Sam Hyde Harris*

A. Estate Stamp to certify authenticity by Marion Dodge Harris appears from 1977 to 1998.

I certify this painting to be an authentic SAM HYDE HARRIS

Maurine St. Gaudens Estate Appraiser

C. Estate Stamp which certifies authenticity of a Sam Hyde Harris work of art not directly left in the Estate of Marion Dodge Harris signed by Maurine St. Gaudens.

I hereby certify that this is an original painting from the estate of Sam Hyde Harris and was painted by Sam Hyde Harris. This painting bears the certified estate inventory number and is on record with the State of California

Court Appointed Appraiser

B. Estate Stamp which appears after 1998 on all art works from the Estate of Marion Dodge Harris, signed by Maurine St. Gaudens, Estate Appraiser.

D. Estate Signature Stamp, style used by Sam Hyde Harris as early as 1925.

Sam Hyde Harris

Sam Hyde HARRIS

E. Estate Signature Stamp, style used as early as 1905.

Endnotes

[1]Harris's mother passed away when he was three, not his father.

[2]"Artist Captures Magic of Desert," *Los Angeles Times*, 30 April 1952, pg. G-13.

[3]Handwritten notes of Thomas McNeill, 7 July 1972. [location of McNeill's archives is unknown]

[4]McClannahan, Earl, "Know More About Our Instructors," *Art Beacon, Business Men's Art Institute, June-July 1954.*

[5]Burke, Howard, "Harris's Brush Imparts Drama," *Los Angeles Examiner*, 5 June 1960, Section 5, pg. 7.

[6]Handwritten notes by Sam Hyde Harris, Harris Family Papers.

[7]Zega, Michael E., *Travel by Train: The American Railroad Poster, 1870-1950*, Bloomington, IN: Indiana University of Press, 2002, pg. 1.

[8]Zega, pg. 50.

[9]Zega, pg. 52.

[10]Halteman, Ellen, "Sam Hyde Harris: Railroad Advertising Artist," *Vintage Rails*, pg. 44.

[11]Halteman, pg. 45.

[12]Crump, Spencer, *Ride the Big Red Cars: The Pacific Electric Story*, Glendale, CA: Trans-Anglo Books, 1983, pgs. 168-169.

[13]Sam Hyde Harris interview, KMTR, under the auspices of the P.R. Advertising Company and Tripolay Club, n.d.

[14]Sam Hyde Harris interview, Fidel Danieli Papers, 1872-1976, Archives of American Art/Smithsonian Institution, audio taped interviews.

[16]Handwritten notes by Harris.

[16]Millier, Arthur, "Art Parade Reviewed," *Los Angeles Times*, 31 August 1941, pg. C-8.

[17]"Alhambra Artist, 82, continues in career begun 67 years ago," *Alhambra Post-Advocate*, 16 February 1971, pg. B-1.

[18]Information about Harris's family after his divorce from Phoebe Harris was obtained through telephone interviews of Sam Hugh Harris, Jean Harris and Judith Leavelle-King, April 2006.

[19]Millier, Arthur, "Thrill of the West in Swinnerton's Art," *Los Angeles Times*, 23 January 1927, pg. C-28.

[20]"Artist Captures Magic of Desert," *Los Angeles Times*, 16 October 1975, pg. G-13.

[21]McPhillips, William, "'Artists' Alley' a Tranquil Place," *Los Angeles Times*, 16 October 1975, pg. SG-1.

[22]"Harris's Death Breaks Link To Glorious Era," *Pasadena Star-News*, 3 June 1977, pg. A-11.

[23]Harris, Marion Dodge, "Sam Hyde Harris: A Short Biography," 14 March 1977.

[24]*Art Beacon*, Business Men's Art Institute, April 1949.

[25]*Los Angeles Times* (1886-current file) February 21, 1921; ProQuest Historical Newspaper, *Los Angeles Times* (1881-1985), pg. I, II, III.

[26]Huntington Lake Big Creek Historical Conservatory.

[27]*Art Beacon*, Business Men's Art Institute, March-April 1951.